José Moya del Pino lived two distinct lives as an artist.
He dedicated the first, in Spain (Priego de Córdoba, 1890 – Madrid, 1925)
to the graphic arts, and to making the only complete copy that has been done in history
of the works of Velázquez in the Prado Museum, destined for an international cultural mission.
He lived the second life in California (San Francisco, 1925 – Ross, 1969),
where he became a well-known muralist and portrait painter.

Those who knew his first life were in great part unaware of the second;
and those who knew him in the United States had little knowledge of his previous life in Spain.
Today, in a city in California, there's a memorial library
that bears the name of Moya del Pino; but in his homeland, until very recently,
he was mostly unknown. This book aims to put an end to these incomplete perspectives,
uniting into one biography the painter's two artistic lives.

Acknowledgments by Paola Coda Nunziante

My enormous gratitude to:

- Miguel Forcada Serrano, the driving engine behind this book that had been a dream of mine for years. Without him, my grandfather's life and work would be forgotten.
- My aunt, Clementina Moya Kun, for sharing boxes of sketches, photographs, newspaper clippings, letters and other treasures lovingly kept from so many decades ago; and my mother Beatrice Diana Moya Coda Nunziante for her patience as I asked her the same questions over and over again.
- Fran Cappelletti, who offered his knowledge and made available the archives of the José Moya del Pino Library in Ross, California; and Gary Scales, who shared his extensive research and his photographs of so much of my grand-father's artwork, including paintings in private collections that are not available for public viewing.

Many thanks also to Diane Prioleau who provided the first biographical documents that sparked my interest; and to my husband Andrew Brown who reviewed early drafts and provided moral support during the late nights I spent on this project.

Acknowledgments by Miguel Forcada Serrano

My sincere thanks to:

- Paola Coda Nunziante, granddaughter of José Moya del Pino. And to Beatrice Diana and Clementina, daughters of the artist. They have made available to me not only the family archive, but also their memories.
- Amparo (Persi) Forcada Granados, who during a stay in Washington sent me copies of hundreds of documents related to José Moya del Pino from the archives of the Smithsonian Institution.

And also to the following people and entities, because their always generous collaboration has enriched the content of this book: Leticia Azcué Brea, Ana Ruiz Arjona, Inmaculada Corcho Gómez, Joaquín del Valle Inclán, Antonio González Millán, Antonio Luis Galiano, María Teresa Murcia Cano, Fran Cappelletti, Maruja Encuentra de Ibáñez, José Manuel Calderón, Juan Manuel Segura Bueno, Carlos Forcada Foguer, Chris West, Cristina Blanco, Inmaculada Oliver.

Contents

Preface

I have one clear memory of my grandfather. It's actually more of a mental photograph than a complete memory. We are in my grandparents' house in Ross, California, where my family is visiting from Italy. I think it's winter, because I'm wearing a white long sleeve cardigan—probably Christmas, since the only times we were able to travel to the United States would have been in between school semesters, either Christmas or summer time. I must have been 6-7 years old.

I'm sitting on the rug, my legs bent backwards, near a couch where my grandmother Helen (whom we called Mamita) is sitting. Next to her is my grandfather, Moya, in his own chair, with a dark green plaid blanket on his lap. I'm playing with something on the floor, I'm not sure what; I think my brother is also on the rug behind me, but I can't see him. I'm just looking up at my grandfather, who is laughing... not a big laugh, but an enthusiastic one, with his head tilted upwards and back.

What was he laughing about? I have no other context for that snapshot moment in time. But he looked happy.

In retrospect, the chair Moya was sitting in must have been a wheelchair, and the plaid blanket was intended to hide his missing leg. By the time I was 6 years old he was in his last years, already slowed down by the disease that would soon take his life.

I don't recall ever calling him grandfather—to my mother and my aunt he was Papa, to everybody else he was Moya. I didn't have big conversations with him... we lived an ocean apart, and even when we did see each other, to tell the truth, I couldn't really understand him. My English was very basic, and his was heavily accented. I am told his brain was already slowing down in those years; I wouldn't have been able to tell. It's amazing that I wasn't even observant enough to register the wheelchair. I fear I was not the most rewarding of grandchildren.

And yet I always felt an affinity for him. Maybe it was because my parents kept telling me that "talent skips a generation" and that I had inherited my grandfather's artistic talent. They always encouraged my drawing and painting—in fact I am now a graphic designer (though since my work consists of commercial art, I have mostly abandoned fine art: a hobby needs to feel more like a distraction than a continuation of work). But being compared to him made me proud, and always curious to hear stories about this grandfather we rarely saw.

And the stories I heard were so fascinating, they almost sounded like a novel or a movie! They involved running away from home as a child, meetings with the king of Spain, a trip across the world where he was then abandoned by his homeland, and the prospect of poverty turned around by his ability to forge connections into San Francisco's high society... There were tales from the two world wars, murals in various buildings (including one of the most visited monuments of San Francisco), and a library in his honor (that I had never visited). So fascinating. As a child I simply wanted to hear the amazing stories; as an adult I started feeling that his life needed to be retold, and not just to us grandchildren—in part because of his contributions to the figurative art of the 20th century, but also because his story opens a small window into a crucial moment in Spain's history and into the Federal Works Projects Administration (WPA) world of Roosevelt's New Deal during the Great Depression, and because it intersects with other artists like Modigliani, Juan Gris, Diego Rivera, Otis Oldfield. It's a story of twists and turns, with a lively protagonist at its core.

When Miguel Forcada Serrano found out that his home town of Priego, Spain, had also given birth to a painter who had been quite well-known in in the 1920s, only to (apparently) disappear from Spain's art history books without a trace at age 35, he started to research him and, via the José Moya del Pino library in Ross, California, contacted my family to obtain more information. By then I had already been collecting short biographies and essays from other authors, with the intention of turning them into a book of some sort. But mine would have been only a partial biography—aside from family anecdotes, nobody in California knew much of my grandfather's previous life in Spain. The fact that Moya had produced copies of all the Velazquez paintings in the Prado Museum, under the patronage of the king of Spain, was mainly recounted as an explanation of how he came to live in the United States. So the information that Forcada was trying to put together was of real interest to me, and I eagerly joined in his quest to gather enough concrete facts to create a cohesive book that could represent both parts of my grandfather's life.

We weren't the first ones, it turns out. Gary Scales, a photographer and founding member of the Ross Historical Society, had already been working for some time on documenting all of the Moya murals that are still intact in the San Francisco Bay area, photographing as many portraits as he could find, and collecting research from a vast number of sources. He had help from Fran Cappelletti, director of the Moya Library. Both were willing to share all the information they had gathered, which, combined with my long interviews with my mother and aunt and the new details from Forcada about the first half of my grandfather's life in Spain, allowed the book to start taking shape.

Miguel Forcada wrote the first draft; but the more we researched specific details, the more new information we found! We edited and edited until the last minute when the Spanish manuscript had to go to press. Since then, I have again corrected some things and expanded on many others to create this English version; a couple of chapters needed extensive rework. But the result offers a more well-rounded view of this semi-forgotten artist, as well as some insights into the Spain and California of the first half of the 20th century; it should be of interest to art historians as well as biographers.

This book is more of a straight biography than a novel; but in my head, it still reads like a movie.

<div style="text-align: right">

– Paola Coda Nunziante
September 2021

</div>

CHAPTER 1

Family, Hometown and the First Years

José Moya del Pino was born on March 3, 1890, in Priego de Córdoba, a town in Andalusía in the southern part of Spain. His parents, Miguel Moya Garrido and María del Carmen del Pino Codes, had married in the town of Frailes in the province of Jaen, on June 17, 1886. His birth already starts with a mystery: something unusual in the names on the birth certificate made us inquire further into his genealogy.

1.1 Moya del Pino's Ancestors

On the father's side,[1] the Moyas are documented in Frailes starting from the early years of the seventeenth century as mostly day laborers or small agricultural owners. After the dethronement of Queen Isabella II in 1868, José Moya Ortiz was elected president of the Liberal Junta and mayor of Frailes; his children were Justiniano, Francisco (who would later hold positions among the town's trustees and with the police), three sisters (one of whom, Gabriela, married a subsequent mayor of Frailes), and Miguel Moya Garrido, father of the subject of this book. One biography[2] suggest that José Moya del Pino may have been a descendant of the painter Pedro de Moya (1610-1674), whose art with mostly religious themes is found in Europe's cathedrals and museums; but nothing exists to document this—among other reasons because there is very little information about the life and offspring of the painter from Granada.[3] It is possible that Moya alluded to this ancestor while in Madrid or during portrait sittings with the author of that biography, but generally in California his daughters recall that he denied knowledge of any connection.

The Garridos had been in Frailes since the reconquest of this area by Alfonso XI in the mid-fourteenth century; it is a common surname in this locality, and a member of this family, David Garrido Serrano, had been the town's mayor in the second half of the nineteenth century, doing an outstanding job in the management of municipal affairs; no doubt he was a relative of Petra Garrido Serrano, grandmother of our painter.

For their part, on the mother's side, the del Pino and Codes families were both well-known in Priego. They held public offices and could be considered affluent—especially the Codes family, who had arrived in Priego from La Rioja in the eighteenth century and were manufacturers and merchants of silk, whose production brought great wealth to the population of Priego at that time. An ancestor of this family, named Blas Manuel de Codes and born in Lumbreras (La Rioja), was Priego's *síndico personero* (people's representative) and wrote an important report on the "popular industry" of silk fabrics, proposing improvements for its development.

[1] The data about the Moya and the Garrido families in Frailes have been taken from the writings of María Teresa Murcia, Official Chronicler of Frailes.

[2] GREER THIEL, Y. *Artist and People*. Philosophical Library, New York, 1959.

[3] Pedro de Moya was born in Granada in 1610. He traveled to Flanders and was a disciple of Van Dyck; later he returned to Spain, residing in Seville and Granada. He authored many paintings with religious themes and portraits. His biographers lament a great lack of documentation about his life and his work, to the point that there are doubts about the date of his death, which probably occurred in Granada in 1674.

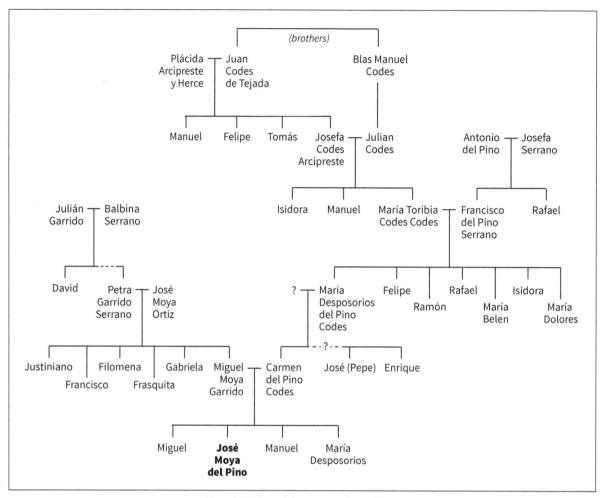

Fig. 1.1.1. Moya-del Pino genealogical tree

We were curious to understand this family history because we noticed that the birth certificate[4] of José Moya del Pino did not show the name of his maternal grandfather, as is customary. Thus we arrived at the marriage certificate of his parents, dated July 17, 1886, in the parish of Frailes; in it we find that the bride is referred to as: *"María del Carmen del Pino, of the same state, nature and neighborhood, 20 years old, natural daughter of María de los Desposorios del Pino y Codes."* The surnames of the daughter and of the mother being the same indicate that the mother was unmarried, which explains why the name of the father (our artist's maternal grandfather) did not appear in the document. A few days later we were able to find the baptismal certificate of the painter's grandmother in the parish of La Asunción in Priego, a record dated 29 November 1832; therefore María de los Desposorios del Pino Codes was 34 years old and unmarried when she became pregnant. There is no record of a subsequent marriage, although Moya del Pino's sister's memoir mentions uncles on the mother's side so it appears there were additional children. (Figure 1.1.1) [5]

4 Archive of the Parish of Our Lady of the Assumption in Priego de Córdoba. Baptism Record Book no. 91, sheet 171.
5 Among the family papers retained by the descendants of José Moya del Pino in California is a handwritten note in English that reads as follows: *"Conception del Llano was born in the City of the Queen of the Angels* [i.e. Los Angeles] *when Spain owned California. When Mexico owned California, her father was transferred to the Philippines in an official position (Mamita Carmen always thought he was viceroy). She married an officer of the fleet during a visit of the fleet, his name was Borado, who took her to*

We believe that this is why Carmen del Pino's birth occurred in Frailes rather than in Priego, where her family was from. Let's place ourselves in that period. Maria de los Desposorios del Pino Codes, maternal grandmother of our protagonist, was the daughter of Francisco del Pino Serrano, whose brother Rafael was a priest. She was the granddaughter of Josefa Codes y Arcipreste whose brother Felipe was also a priest. In 1866, when Maria de los Desposorios became pregnant, Isabella II still reigned and Priego was immersed in a deeply religious and puritanical environment, which would have been felt even more strongly in a family in which there were two priests, one of whom was

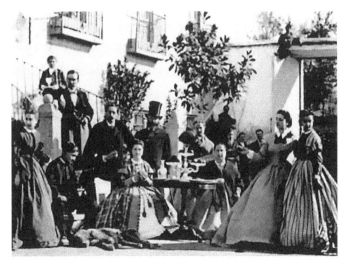

Fig. 1.1.2. Social life in the resort of Frailes during the last decade of the nineteenth century. Photo courtesy of Maria Teresa Murcia.

Brother Superior in the brotherhood of Jesús en la Columna. In such a conservative environment, the decision for a family of means to send the unwed pregnant woman away was a prudent move in order to avoid the scandal inherent in the situation.

Now, why Frailes? We haven't found any previous family ties between this town and the Priego family to explain this choice; but there may be a social reason. Located in the South Sierra of the province of Jaén, about 40 km from Priego, the population of Frailes, of Muslim origin, was experiencing a phase of growth at that time (Fig. 1.1.2). A powerful spring of sulfurous waters had inspired the establishment of a spa that by 1830 had three large baths and a capacious structure to accommodate guests; in 1863 a new owner (Gregorio Abril, a resident of Almedinilla, very close to Priego), built 20 additional housing units creating a series of accommodations with bath buildings as well as a chapel dedicated to the Virgin of Mercy. The Frailes spa specialized in the treatment of nervous and skin diseases, and had become the most important social and rest center in the region; a suitable place for the process of gestation of Maria de los Desposorios to go unnoticed, at least from Priego. This may be why the birth of her daughter Maria del Carmen took place in that town.

Twenty years later, Maria del Carmen would marry Miguel Moya Garrido. It is interesting to note that, although Miguel's father had previously been the town's mayor and the Moyas were a family of good standing in Frailes, the bride seems to have been accepted in that society despite having an unwed mother. This could have to do with the affluence of her mother's family in nearby Priego.

Frailes, in the southern Sierra of Jaén, is still today a small town with about 1700 inhabitants (Fig. 1.1.3). The main source of the economy is agriculture. The surname Moya can still be found here, and the current mayor is another member of the Garrido lineage, named José Manuel Garrido Romero.

Spain. Moya's grandmother Maria de los Desposorios Perez de Borados married del Pino in Priego." This note adds another point of mystery to the genealogy of José Moya del Pino. According to the painter's daughters, Carmen del Pino Codes (José's mother, whom they affectionately called Mamita Carmen and who spent her last years in California), frequently told stories of this grandmother and her maid Conchita. It is possible that these tales refer to María Desposorios del Pino Codes herself, who may have married a man surnamed Perez de Borados after the birth of her first daughter—or perhaps the protagonist of these stories may have been a more distant relative, because those surnames, or very close ones such as the "Serrano Barradas," did exist in Priego at that time; but we have scrutinized the _Heraldry and Genealogy of Priego de Córdoba_ by Manuel Peláez del Rosal and we have not been able to connect Carmen del Pino with them. The data taken from the Civil Registry of Priego and the archives of the parishes of Frailes and Priego, on the other hand, seems incontrovertible.

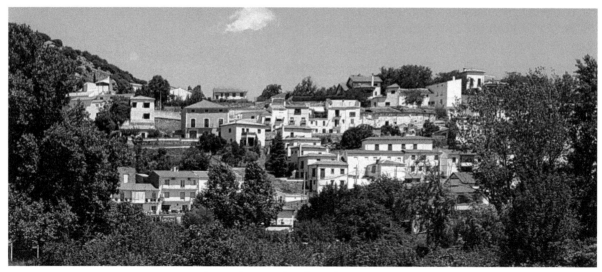

Fig. 1.1.3. View of Frailes in the present day

1.2. The Moya del Pinos in Priego

The town of Priego de Córdoba (Fig. 1.2.1), nestled in olive groves, is known as "Ciudad del agua" for the multitude of springs in its surroundings, as well as "Joya del Barroco Cordobés" for the large number of Baroque-style buildings it encloses. We don't know the date in which José Moya del Pino's parents moved there. It could have been a return to the bosom of the maternal family now that there was nothing to hide; or perhaps the search for better economic prospects, since in the last years of the nineteenth century Priego was experiencing considerable economic development—this time based on the cotton textile industry, which helped the town grow into a true industrial city by the beginning of the twentieth century.[6]

[6] See: *La industria textil del algodón en Priego de Córdoba* (The Cotton Textile Industry in Priego de Córdoba), by Miguel Forcada Serrano. 266 pgs. Author's edition. Priego, 2016.

Fig. 1.2.1. Panoramic view of Priego de Córdoba in the present day

The couple's first son, Miguel, was born in 1888; the second son, José (protagonist of this biography), came to the world on March 3, 1890[7] and was inscribed in the civil registry of Priego as José Manuel Emeterio de San Cayetano. In the baptismal certificate of the Parish of the Asunción (Fig. 1.2.2) he appears with the names José María Manuel Emeterio de San Cayetano, and the godparents are indicated as Justiniano Moya Garrido, brother of the father, and his wife, María Serrano Líndez. In the following years two other siblings were born, Manuel in 1892 and María de los Desposorios in 1894; the latter was nicknamed "Esposita" to distinguish her from her grandmother of the same name, whom they called "Mama Esposa."

Fig. 1.2.2. Parish of the Asunción in Priego

In Priego, the family took up residence on Solana street where they set up a Castile soap factory and shop;[8] the soap was manufactured by traditional methods with residues from the production of olive oil, and the family invested all its economic resources in this business, including the mother's family jewelry. But the manufacture and sale of soap did not provide enough to support the family; in addition, misfortune would fall on them in the following years: two of the children, Miguel and Manuel, died in a measles epidemic while still very young. José, who was also ill with the same disease and bed-ridden at that time, remembered waking up one day to find the house crowded with people: that's how he discovered that his brother had died, and the guests had come for the wake. The shock this produced in the mind of our protagonist remained one of the most vivid and dramatic memories from his childhood.

1.3. Young José Discovers His Vocation

Around 1894 the family may have moved back to Frailes, in order to be closer to their relatives; or at a minimum, visited quite often. María de los Desposorios, the artist's sister, writes that they lived in *"a small house of adobe, bricks and stone. A big living room with fireplace, two bedrooms (one small), a lavatory but no bath[room]."* At the back of the house was a door with stained glass *"like windows in churches"* that gave onto *"a tiny orchard, a garden for the vegetables."*[9] José himself recalled that *"on cold winter days his family sat in the kitchen around a table encircled by a woolen skirt. The skirt was used to hold the warmth which emanated from a lighted brazier which was in the center, underneath the table. There was no other means of heat in the house."*[10]

In her memoir the artist's sister mentioned quite often the relatives on the father's side in Frailes, but seldom those in Priego. However, it was their uncle José (*Tío Pepe*) from Priego who inspired the still very

[7] This date of the birth of José Moya del Pino, which matches in both the baptismal records of the Parish of the Asunción of Priego and in the Civil Registry of Priego, obliges us to rectify the biographical notes that have been published about him until now, in which the date of March 3, 1891 appears wrongly.

[8] It is unclear whether the soap factory was set up in Priego, Frailes or later in nearby Alcalá la Real, as there are no records other than family stories. The artist himself simply recounted that he was from Priego and that his family operated a soap factory; however, among the family's papers are the memoirs of his younger sister which state that the family lived in Frailes when she was a child, and that they started making Castile soap after they moved to Alcalá la Reál in the last couple of years of the 19th century. The children would have been very young in any case, so some inconsistency in their personal memories is understandable.

[9] Unpublished memoir by Maria de los Desposorios Moya del Pino.

[10] GREER THIEL, Y. *Artists and People*. Philosophical Library, New York, 1959.

young José to start drawing. Tío Pepe had been a cavalry officer, but had retired after suffering injuries in a train accident; he liked to draw battles and subjects from Roman antiquity, and had written and illustrated a book. The uncle died young, but while he was alive he visited often, and young José was fascinated by his work and avidly copied all the drawings.

When the boy was 8 years old, the family moved to Alcalá la Real,[11] a larger city located between Priego and Frailes (Fig. 1.3.1); and it is here that he discovered his vocation, with a passion. This is one of the episodes that changed Moya del Pino's life; he recounted, over sixty years later but in great detail, how that discovery took place:

As a boy of eleven or twelve, on his way to school he would pass by the house of a painter whose workshop had a window onto the street; José often peered in, curious and attracted by what he saw, and as a result *"was always late for school. Paddlings for his tardiness became numerous and paddles used by teachers in those days were sticks studded with iron nails."*[12] One day the painter invited him in, and a friendly relationship established between the two. Months later when that painter, named Carlos Mantón,[13] went on tour through the villages and farmhouses of the region as an itinerant painter, little José did not hesitate to run away from home, without the consent of his parents, to travel the countryside as the rural painter's assistant and apprentice.

To put into context this crucial episode in Moya del Pino's formative years, let's look at the role of the visual arts in Andalusía at that time, and how an itinerant painter made his living.

Painting and the visual arts in general were quite a regular activity in that region at the turn of the century. In the seventeenth and eighteenth centuries a powerful school of artists and craftsmen had evolved (painters, sculptors, architects, altar makers, carvers, gilders, cabinetmakers), financed by the profits of the silk industry. Even in Priego itself, a small town at the time, they built as many as nine churches and other civil buildings in baroque style, which today form a monumental ensemble of incalculable value. Stunning

[11] This move to Alcalá La Real was noted in only one of the biographical accounts of Moya del Pino's life, written by Yvonne Greer Thiel who interviewed the artist in 1959; because it wasn't mentioned anywhere else, including a biographical summary handwritten by Moya himself, there was some question about its accuracy. However, it is corroborated in the memoirs of María de los Desposorios Moya del Pino, the artist's sister.

[12] GREER THIEL, Y. Op. Cit.

[13] Greer Thiel's above-mentioned biography states that the painter's name was Mouton and he was a Frenchman. It has proven impossible to verify this information so we have chosen to use the Spanish name Mantón as shown in other biographies.

Fig. 1.3.1. Alcalá la Real in the present day

Moorish, Renaissance and, above all, Baroque architecture can be found in the buildings, castles, fortresses and monasteries throughout the area. Even in the most remote villages one can find a first-rate altarpiece, a masterpiece of painting or an item of the most intricate precious metal work.[14] In those years, although no longer at the height of their splendor, there were several workshops like the one of Carlos Mantón, the painter who had caught the attention of the child José. No doubt other children looked amazedly through their windows, but none was as brave as our protagonist.

Also, to understand what that first adventure was like, let's consider the activities of an itinerant painter in rural Andalusia in the first decade of the twentieth century. Such a painter would earn a living by going to the fairs of villages and farms, which were quite frequent at the time. In each place he'd ask about the patron saint and would paint his image, occasionally inventing the saint's attributes if he didn't know them; he would paint votive offerings or legends, which would remain in the churches or the peasants' homes as objects of religious worship. He would also paint the saint bearing the name of any peasant who asked for it.

One of the best studies on this subject in Spain states: *"The works of popular painters, despite having a creative nature, do not stem from artistic inspiration. Most of the time they are born in the shadow of a popular devotion, like the peasant churches and the old hermitages scattered throughout the countryside or the Andalusian coast where the devout crowd congregates for commemorative events. This pictorial theme is implanted in the artist's mind from the moment he first participates in these events, as a child or as an occasional traveler. Days of pilgrimage can give the votive painter the opportunity to receive commissions to paint these religious offerings, and some painters even became "professionals" of the genre".*[15]

The quality of these artists was, in general, rather low; and therefore the learning opportunities for a disciple accompanying the teacher wouldn't be great. As for the identity of these itinerant painters, in most cases they remained anonymous: *"The deep awareness that these men had of their artistic value prevented them with all humility from signing their work".*[16] Thus, neither in the aforementioned study, nor in the already published stories of the fraternities and brotherhoods of Priego, nor in the exhaustive study by José Cobos Ruiz de Adana and Francisco Luque Romero Albornoz that concentrates on the area around Córdoba,[17] were we able to find the name of Carlos Mantón.

Moya del Pino, however, described in detail the work of his teacher and his own activities. Mantón prepared his own canvases; José ground the colors for him and the pigment was put into a casing, made from pig intestines, that looked like a sausage. The method was crude, but helped Moya develop a knowledge of the chemistry of color. As they traveled by donkey and wagon, young José would beat a drum to call the attention of the people to such personages as "the Miraculous Virgin of Carmelo" or "Santa Lucía, advocate of the blind." *"Each village had its patron saint, and my master-artist specialized in painting these patron saints for whatever villager he could bargain with. He would paint the saints with long white robes, to give them the appearance of being in their heavenly abode."*[18] When the locals were too poor to buy these paintings individually, the artist would raffle them. He made raffle tickets and *"he and José sold them to the peasants, but seldom for cash. One would give a sack of potatoes, another a whole cheese, still another a hock of ham or two pounds of home-made smoked sausage. When all the tickets were sold the numbers were put in a hat and José [was] allowed to draw the winner. [...] All the goods gathered in payment were put in storage in*

[14] *www.andalucia.org/en/discover-us/art-culture-and-traditions/*

[15] RODRÍGUEZ BECERRA, S. and VAZQUEZ SOTO, JM, *Exvotos de Andalucía: milagros y promesas en la religiosidad popular* (Ex-votos of Andalucía: Miracles and Promises in Popular Religiosity). Andalusian editions Argantonio. Seville, 1980, pg. 106.

[16] RODRÍGUEZ BECERRA, S. and VAZQUEZ SOTO, JM, Op. Cit. Pg. 131.

[17] COBOS RUIZ, J. and LUQUE ROMERO, F. *Ex-votos de Córdoba*. Provincial Council of Córdoba and Machado Foundation, Córdoba, 1990.

[18] HAILEY, Gene. *California Art Research, Vol. XIII*. Works Progress Administration, San Francisco, 1937. Pg. 101. A copy of this document is also kept in the Archives of American Art of the Smithsonian Institution, Washington. USES. SIRIS 3830-77 and 78.

the donkey-driven wagon. With these supplies, and very little cash, both Mouton and his young apprentice managed to live and eat."[19]

But if the child's artistic learning, as we mentioned, couldn't progress much with that painter (especially since he had to devote himself more to cleaning brushes and taking care of his teacher's materials than to actually painting), the learning of the things of life on the other hand was fruitful and unforgettable. This is what our protagonist recalled years later: *"The day's work being done, my master-artist would find lodging in the house of a villager who had purchased one of his works, and we would be feasted and entertained royally. The old artist had a habit of introducing me as the boy who could drink as much as a man. This flattered my vanity, and much against my best judgment, I overindulged in wine. So much so, that when my master and I returned home to my parents after ten month's traveling, my eyes were bloodshot, I was dirty and my clothes were filthy and tattered. Horrified at the result of my contact with the old artist, my father annulled the apprenticeship immediately."*[20]

Moya recounted this adventure several times throughout his life, sometimes introducing different details about the artistic or commercial procedures of his teacher. His sister's memories mention that the family had to enlist the aid of the police in order to find him. In any case, this episode likely marked the end of José Moya del Pino's childhood. His desire to be a painter, however, did not wane—and consequently, when he returned home, his parents were forced to find a way to provide him with higher quality learning, which in Andalusía at that time had only one solution: the city of Granada.

[19] GREER THIEL, Y. Op. Cit.
[20] HAILEY, Gene. Op. Cit. pg. 102.

CHAPTER 2

A Precocious Artist's Formative Years

2.1. A Student in Granada

The vast majority of young Andalusians who chose to go on to higher studies, at least until halfway through the twentieth century, did so in the city of Granada (Fig. 2.1.1). The most popular pursuit at that time was the study of law, but Granada also offered the best options for higher learning in the arts. Both the sculptor José Álvarez Cubero and the painter Adolfo Lozano Sidro, famous artists born in Priego like our protagonist, developed some of the fundamental stages of their learning in Granada. In addition the towns of Priego, Frailes and Alcalá la Réal, even though within the provinces of Córdoba and Jaén, are closer to Granada than to Córdoba, Málaga or Seville.

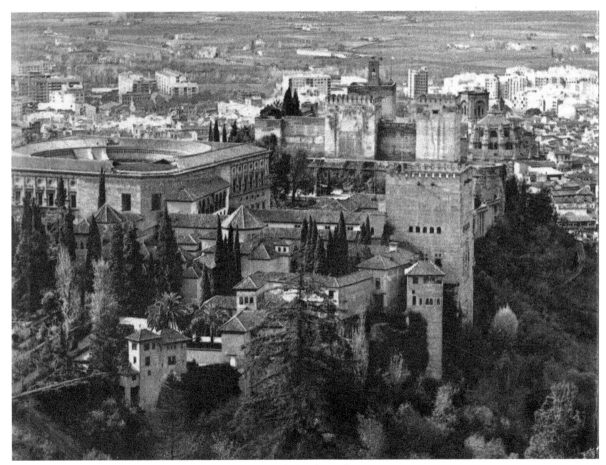

Fig. 2.1.1. Granada

The fashion designer Mariano Fortuny had spent some time in Granada between 1870 and 1872 and widely extolled the beauty of its urban landscapes, and as a consequence the "city of the Alhambra" had become a place of pilgrimage for many painters—even some of high prestige like Joaquin Sorolla, who visited it for the first time in 1902. Consequently, Granada was experiencing a certain fervor related to the visual arts; and this environment was stimulated by two very active institutions of the time: the Royal Academy of Fine Arts of Granada, founded in 1777; and the Artistic, Literary and Scientific Center that began its activity around 1885.

By 1904 José Moya del Pino had moved to Granada. One of his biographical accounts states that his father, convinced at last of his son's artistic vocation, sent him to study there and stay with his grandmother who lived that city.[21] The artist's sister instead claims that it was Tía Maria, Tío Pepe's widow who lived in Granada, who suggested the family move in with her so that young José could attend the Academy. *"She had a big and beautiful house with steps of marble and decorated rooms on the high [floor]. She invited us to go and stay with her until we would be able to find an adequate apartment, and promised through her influence to find a good job for Papa."*[22] In any case it appears that the whole family moved to Granada at some point, after closing the soap business, because the imprint of the Moya del Pinos is untraceable in Priego or in Alcalá la Real after 1904.

The young apprentice's stay in Granada was brief, but his first known works and the first opinions about his worth were formed in that city. To begin with, José Moya del Pino attended classes at the School of Industrial Arts, linked to the Royal Academy. He was also able to register at the Artistic Center, Granada's fashionable institution in which Adolfo Lozano Sidro had studied several years earlier.[23] However, his major influence was his apprenticeship with the painter Rafael Latorre Viedma who, though still young, was teaching out of his home in the Carrera del Darro. *"Latorre had studied in Italy and had the traditional technique. He could handle casein, tempera, fresco and water-gilding for the churches. He was proficient in sculpture but, though versatile, he was not a creative artist. His studio was a commercial one where he painted images of saints, did carvings and restored frescoes. He had four apprentices, including José, each boy receiving board with instruction but no stipend for long hours of work."*[24] Moya painted all day and attended school at night.

Almost immediately in 1904 the boy participated in the Exhibition of Fine Arts and Industrial Arts of Granada, with a work entitled *Escritorio de Señorita* (Desk of a Young Lady) for which he received a Diploma of Third Class in the Painting division. Moya's work, though he was only 14 years old, competed in this exhibition with works by established artists of the time such as Rafael Latorre (who won the contest) and José Ruiz de Almodóvar. The jury was composed, among others, by Isidoro Marín, Manuel Gómez Moreno and José López Mezquita, painters of recognized prestige.[25] It must have been in this competition that the following anecdote occurred, recounted by Yvonne Greer-Thiel in the aforementioned biography: Moya was handed an envelope with the prize; he opened it and found 25 pesetas in coins. He excitedly tore up the envelope and went to show a friend his winnings; when his friend suggested that there surely must have been more, they looked at the paper scraps and found that there was also a 100 pesetas bill, torn to pieces! Luckily José's grandmother managed to recompose the bill and convince the bank to accept it.

[21] GREER-THIEL, Y. *Artists and People*. Philosophical Library, New York, 1959.

[22] Unpublished memoir by Maria de los Desposorios Moya del Pino.

[23] See: FORCADA, M et al. *A Adolfo Lozano Sidro: Vida, Obra y Catálogo General* (Life, Work and General Catalog). City Council of Priego and Cajasur. Córdoba, 2000. Also: SANTOS MORENO, Mª. D. *Un pintor de Priego en la Cofradía del Avellano de Granada* (A painter from Priego in the Brotherhood of the Avellano in Granada). Ed. Granada Artística. City Council of Priego and CajaGranada. Granada, 2004. Pgs. 23-32.

[24] GREER-THIEL, Y. Op. Cit.

[25] CAPARRÓS MASEGOSA, L. *Las Exposiciones de Bellas Artes en Granada. 1900-1904*. Art Notebook no. 33 (2002) Pgs. 191-210. University of Granada.

Without a doubt, Moya del Pino made friends in Granada—friends who later remembered him from this city, but also others with whom he had intense relationships when they met again years later in Madrid. Among them for example was the writer Isaac Muñoz, born in Granada and residing there when Moya del Pino arrived. Later, in his first steps as a portraitist and illustrator, Moya painted a portrait of Isaac Muñoz and created covers for two of his novels.[26]

There are no records on any other work that Moya del Pino would have done in Granada, which would have been without doubt of a learning stage. However, many years later, while already focused on copying the works of Velázquez in Madrid, the painter would remember that in Granada he had done a painting titled *Pequeño Monstruo* (Little Monster), which represented a kind of dwarf or buffoon with an antique pot on his knees. He pointed to this work as the first influence of Velázquez in his painting and in his life.

2.2. His Footprint in Granada

Although these must have been years of very intensive learning, the young Moya del Pino stayed in Granada for only three or at most four years, since in 1907 his name began to appear in the copyists register of the Museo del Prado, which means that he was already in Madrid. However, contacts with Granada continued in the following years and the imprint left on him by the cultural environments of Granada must have been profound. On October 15, 1910, the art critic Francisco de Paula Valladar, who was the main writer and the soul of the magazine *La Alhambra*, dedicated an article to our protagonist in a series about young artists in which, after referring to him as *"a young fighter enthusiastic about art"*, he says: *"Moya del Pino, whom I esteem very much and whom I consider to have the foundation and very special aptitude to evolve from the modernism that captivated him like other progress-loving young artists, fights in Madrid with beautiful modesty and unwavering faith for the healthy and robust art that has as apostles Velázquez and Goya. Moya is not only a draftsman and painter; he has collaborated with this magazine on works of historical critique, revealing a firm and extensive culture and a calm and fair judgment for critique and its demonstrations. It seems strange that someone who has studied and still studies so much, who so likes to penetrate the arcana of history and of the development of the arts, would fall in love with insane modernisms that vanish little by little, like a dissipating cloud that hides from us the brilliance of the sun. But his taking this direction has an explanation: the multitude of young people who looked and still look at the different phases of modernism, fell nobly in love with an ideal that they believed could wreck rancid and systematic theories; now they are finding there is an error in that ideal, that it pursues something that is very difficult to embody in art. How to sustain the theory of futurism, for example, proclaimed in the following lines of the famous manifesto of March 10 in Turin? We read: 'Our growing need for truth cannot be content with form and color as they have been understood until now ... And so the futurists demolish everything ...'"* [27]

There are several considerations in the previous paragraph and more than a few suggestions that are worth a deeper look. A few months before the publication of this issue of *La Alhambra*, the alluded-to text of the *Futurist Manifesto* written by the Italian poet Marinetti and published in 1909 in Paris through *Le Figaro* had arrived in Granada. The manifesto contained a violent appeal against the artistic traditions and political systems prevailing at the time, to the point that one of its paragraphs said: *"We want to destroy and burn museums, libraries, academies, and to combat moralism, feminism and all other opportunistic and utilitarian cowardice"*.[28] Granada was then a small city, full of history, in which modernism was slow to be understood.

[26] CORREA RAMÓN, A. *Isaac Muñoz (1881-1925). Recuperación de un escritor finisecular* (Isaac Muñoz, 1881-1925. Rediscovery of a late-century writer.) Ed. University of Granada.

[27] VALLADAR, FP. *Artistas Jóvenes: Moya del Pino*. Magazine *The Alhambra* nº 302 of October 15, 1910. Pg. 452.

[28] Overall, the manifesto makes explicit an ultra ideology that was considered to be at the base of the emergence and growth of fascism that culminated in World War II.

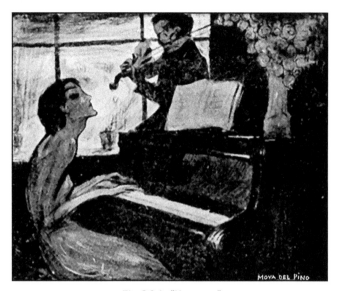

Fig. 2.2.1. "Nocturno"

Still referring to the *Futurist Manifesto*, Francisco de Paula Valladar continues about Moya del Pino: *"I would much like to know this young and enlightened artist's opinion about that manifesto, which hasn't yet been well publicized or discussed in this corner of the world. If he were here, among the members of the Artistic Center who always remember him with affection, we would talk about these theories I don't understand, and maybe they could help bring by the evolution that I hope for and that I look forward to. Moya, as I said, is in a great position to see with full judgment that very modern art that wants to 'demolish the works of Rembrandt, Goya and Rodin' ... to break the bonds that tie to modernist ideals, and like others, fulfill the mission to paint his time as nature gives it, far from any artistic restrictions ..."*. This same issue of *La Alhambra* reproduces an interesting work by Moya del Pino entitled *Nocturno*, which may be one of the first representations of his work that have come down to us: it shows a violinist accompanied by a woman at the piano. It is a very modern, almost avant-garde image, with visible emotion, unusual for that time. (Fig. 2.2.1)

What is clear from all the references to Moya del Pino that appear in the press of Granada, is that he was held in very high regard for both his human qualities and his great intellectual preparation. However, from 1910 on his contacts with Granada are increasingly scarce, and similarly scarce and confusing are the bibliographical references on his career. As an example we will cite the work of Antonio Aróstegui and José López, *60 Years of Granada Art:* even though it states that *"although he was born in Priego de Córdoba, he was considered a Granadan in the local artistic media at the beginning of our century"*,[29] the authors of this work include a brief biographical note that contains little concrete data and ignores Moya's trajectory after 1915.

But we cannot close his Granada stage without mentioning the first writing we know by José Moya del Pino. In 1910 an article was published, again in the magazine *La Alhambra,* that must have been sent from Madrid and that is entitled *Decorative Arts: Book Illustration*. In the first paragraph, Moya del Pino raises his thesis on what should be the contents and form of graphic illustration: *"Above all illustration holds, for me, an ornamental value superior to the false representative value it has been given, because the representative graphic part must always be subject to the ornamental idea."* Subsequently he goes on a journey through the history of illustration, comparing two painters who worked on Dante's *Divine Comedy* and considering much higher the work of Botticelli who *"developed the decorative technique with portentous aptitude throughout the course of his work"* to the work of Gustavo Doré who tried to reproduce the scenes of Dante's work graphically. Moya asks: *"If the poet already gives us the sensation of his vision, can the artist give it any more strength by graphically representing it within the limits of the small page of a book?"* In the last part of the article, Moya demonstrates a wide knowledge of the "decorativist" currents that had made their way in Europe, cites Wagner as an example of this same current in music, and ends with asking for a necessary modernization in the country's educational system for the Industrial Arts, in which illustration or the "book arts" would be included: *"In Spain, where until now the Industrial Arts Schools that have been so beneficial*

[29] ARÓSTEGUI MEGÍA, A. and LÓPEZ RUIZ, J. *60 años de arte granadino*. Granada. Anel, 1974. Pg. 185.

abroad have been missing, we still regret the routinely Mannerist, prudish and academic criteria like in the time of Mengs[30] *that put obstacles in front of the studious youth; and one wishes that the educational system could remake itself and take on study material similar to what can be counted upon abroad".*[31]

With this work Moya del Pino continues to impress us with his knowledge and for his ideas, since we have to remember that when he wrote it, he was no more than 20 years old and had just started his higher studies.

It is precisely his activity as an illustrator that provides us with the last news about Moya del Pino's stay in Granada. In its issue of April 30, 1910, *La Alhambra* announced the publication of the book *Andantes* by the poet Alberto Álvarez Cienfuegos, with a prologue by Villaespesa and a cover by José Moya del Pino. It may be the first book cover that he illustrated. (Fig. 2.2.2) Once in Madrid, book illustration would be his most frequent artistic activity.

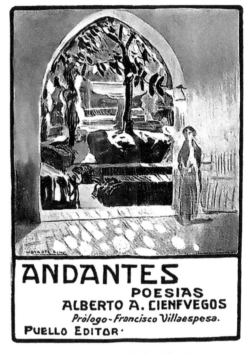

2.3. Training in Madrid and Paris

José Moya del Pino was 17 years old when he moved from Granada to Madrid in order to continue his artistic studies. In the Fall of 1907 he enrolled in the San Fernando Royal Academy of Fine Arts (at that time called Special School of Painting, Sculpture and Engraving); entry into this Academy was highly competitive, with rigorous testing and few students accepted. On October 8, endorsed by Luis Larrocha, he registered as a copyist in the Museo del Prado in Madrid, stating that he lived in Calle Leones no. 8, 2ⁿᵈ floor.

According to the records kept by the current Faculty of Fine Arts, in the academic year 1907-1908 Moya del Pino enrolled in only two subjects: Drawing of the Antique and

Fig. 2.2.2. Cover for the book "Andantes"

Clothing, and Landscape. In the 1908-1909 academic year he attended classes in seven subjects: Theory and History of Fine Arts, Perspective, Artistic Anatomy, Drawing from Nature, Landscape, Color and Composition, and Color Art Theory. And in the 1909-1910 academic year, his last year at this school, he was enrolled in Artistic Anatomy, Drawing from Nature, Landscape, Color and Composition, and Color Art Theory. His professors were, among others, José Garnelo y Alda from Córdoba for Drawing of the Antique and Clothing, and Antonio Muñoz Degrain for Landscape.

Moya del Pino has also stated that he was a student of Joaquín Sorolla, and that this artist was very influential on his artistic training.[32] There is no formal documentation about this, but Sorolla was known to select the most promising students from the academy and tutor them on an individual basis. There are also other indications of this prominent artist's influence on Moya del Pino: Sorolla had a deep appreciation for the masters and had previously copied a number of Velazquez paintings from the Prado museum, and in the first year that Moya was at the Academy Sorolla painted a portrait of the then-21-year-old King Alfonso XIII; both of these endeavors would be repeated by Moya himself about fifteen years later.

[30] Anton Raphael Mengs was a German painter of the mid-18ᵗʰ century, active in Dresden, Rome and Madrid, who became one of the precursors to Neoclassical painting, which replaced Rococo as the dominant painting style.

[31] *De arte decorativo. La ilustración del Libro.* In *La Alhambra*, 1910.

[32] HAILEY, G. *California Art Research*, Vol. 13. Works Progress Administration, San Francisco, 1937; also emphasized by the artist to his friends and family.

Moya del Pino finished his studies brilliantly, winning medals in Art History and in Anatomy. Upon graduation he won the highly competitive *Prix de Rome*, a scholarship to continue studying in Italy for the following year; this could point to Sorolla's influence as well, since the teacher had won a similar prize in 1885 and may have encouraged his pupil to apply. To compete for this scholarship Moya presented a certainly ambitious work: a nude, a lady with fair skin and red hair reclining on a divan covered in rich drapes. It appears that Moya may have later brought this painting with him to the United States, or perhaps made a copy of it (he sometimes made multiple versions of his favorite paintings), because his daughters remember the painted image, although the work is not now located.[33]

Madrid's *Prix de Rome* was awarded by the *Junta de Ampliacion de Estudios y Investigaciones Cientificas* and was modeled on the more famous scholarship of the same name that the École des Beaux Arts in Paris awarded each year to its top students for a period of study in the "eternal city." The young painters who went to Rome on scholarships were sent there to draw from the classical sculptures in the museums, to work among the ruins, to soak up the power and grace of the classical era. But Moya del Pino's stay in Rome seems not to have been very fruitful for his learning, according to the artist himself: *"I was given a scholarship called the Prix de Rome and went to study in Italy. I didn't stay long after visiting Italy because I went to the academy in Rome and it was so much like the official school of Madrid and it seemed to me of no use to go to Italy just to go into something with some professor who felt so very much of the classical education of the artist at that time. I asked permission from the foreign office that was in charge of this scholarship in Rome to switch to Paris. I went to Paris to study with the grant. And that is when I met Picasso and Juan Gris and the famous artists of that time."*[34]

Indeed, Moya del Pino's time in Paris appears to have been very enriching, as he himself emphasized throughout his life, asserting that it was here that he obtained his true formation as an artist. In addition to Picasso and Juan Gris, Moya also met Matisse and Diego Rivera, both of whom he would later see again in California. He formed a good friendship with Modigliani. He attended the famous Colarossi Academy, which had positioned itself as a progressive alternative to the Academy of Fine Arts of Paris which was still anchored in the conservative tradition. He also took classes at the Académie de la Grande Chaumière, where students could purchase tickets to attend specific classes and lectures *"like buying a ticket to the movies;"* there he met André Derain. The vibrant artistic environment of Paris was incubating all the future "vanguards"—that is, all the influential European artists of the first half of the 20th century.

Moya recalls: *"While in Paris the painters Juan Gris and Diego Rivera took me to the apartment in Rue de Fleurus of Leo and Gertrude Stein and I saw for the first time the paintings of Picasso and Matisse. Under the spell of these modern painters I became a cubist and exhibited at the Indépéndent and the Salon d'Automne."*[35] Interested in art and culture of all kinds, the artist also recounted later to his family that he had attended the opening of Stravinsky's controversial *Rites of Spring*, which took place at the brand-new Théâtre des Champs-Élysées in Paris in 1913; and although he did not take part in the riot that ensued, he remembers some individuals paying people to throw tomatoes at the performers to stir up turmoil.

Moya's stay in Paris, sharing a studio with other artists in Montparnasse, lasted several years; when his scholarship money ran out, he painted and sold portraits to earn a living. As he recalled years later, *"in those days of Paris an artist didn't starve, you know. They had art dealers who were so adventurous that they would buy even drawings (...) and not give much, but it was enough. In Paris I could make a living, enough to live, very modestly."*[36] He was even able to reach a certain popularity, especially after a group of South Americans

[33] The description of this painting is by Beatrice Diana Moya, daughter of the painter, who remembers it being stored in the attic of the house where they grew up house in San Francisco.

[34] Oral history interview with Moya del Pino, 10 September 1964, by Mary Fuller McChesney. Archives of American Art, Smithsonian Institution, Washington DC.

[35] Personal biography dictated to his wife Helen, handwritten, preserved in the family's archives.

[36] Oral history interview with Moya del Pino, ibid.

commissioned from him, with an extremely tight delivery time, a painting of a young Spanish woman with a fan; Moya painted it overnight and charged for his work the impressive sum of 2000 francs of the time, money he generously shared with his studio colleagues.[37] While in Paris he also did illustrations for the magazine *Mondial*, and illustrated the works of the South American poet José Ingenieros, including the first publishing of his *El Hombre Mediocre*.

Moya might have stayed longer in Paris, if the First World War hadn't broken out. In *Artists and People*, Yvonne Greer Thiel recounts a story he was fond of telling: *"By 1915 war was well on its way and Paris was preparing for siege. Art galleries closed and the Spanish government canceled all scholarships. All Spaniards were urged by their government to return home. José (...) wanted to remain in Paris, even though all the male population was assigned duties. He appealed to the French military authorities and got permission to remain."* Moya tried to join the French army but was not accepted because he was not a French national, though they did assign him to guard the sheep that were kept as emergency supplies in the Bois de Boulogne in case of siege—this, the artist quipped, was *"because the French supposed that all Spaniards were sheep herders."* [38]

Around the end of 1916 Moya del Pino returned to Madrid. Before this though, and not to be forgotten, is another important part of the artist's training in these years: the "study trip" he made from Paris to Brussels and The Hague to visit their museums, and his passage in 1912 through the Royal College of Art at the University of Kensington in London, a center where book graphic arts had become an innovative artistic specialty. Although the young artist's stay in London is not well documented, it seems that, while there, he had two experiences that would mark the rest of his life. The first was his exposure to new book and magazine editing, illustrating and printing techniques, an industry to which he dedicated almost a decade after returning to Paris and Madrid.[39] The second was his discovery that the work of the great Spanish painters, and in particular that of Velázquez, was almost unknown in London and in almost all of Europe, since anyone who didn't travel to Madrid could only know a few of the works of the Sevillian artist (almost all of which are in the Prado Museum) and only through black and white photographs generally of poor quality. According to later statements by Moya del Pino himself, he was surprised by the success in London of an exhibition of low quality carbon photographs of Velázquez's creations: *"The success of that exhibition made me think how much greater that effect would be if one could offer good reproductions for contemplation by the people, faithful copies at actual size of the forty-two indubitable paintings that are conserved in our gallery. My spirit filled with joy to think that in this way our art could be spread throughout the world and proclaim its greatness."* This implies that it was in London where the painter had for the first time the idea of copying Velázquez's work and showing it abroad.[40]

[37] GREER THIEL, Y. *Artist and People*. Philosophical Library. New York, 1959. Pg. 78.

[38] GREER THIEL, Y. *Ibid*.

[39] ALCOLEA ALBERO, F. *Pintores españoles en Londres (1775-1950). El siglo XX*. CreateSpace Independent Publishers, 2016, Pgs. 28-29.

[40] GHIRALDO, A. *El peregrino curioso*. In the magazine *La Esfera*, nº. 516 of 24 November 1923. Pg. 21.

CHAPTER 3

José Moya del Pino, Illustrator and Portrait Painter

3.1. Entry into the Cultural Circles of Madrid

Despite his intense dedication to studying between 1907 and 1911, it is evident that the young Moya del Pino did not miss out on the opportunities for social relations that the town and court of Madrid offered him. In fact, various publications of that period indicate that he spent time visiting cafés, theaters and museums where he could meet the writers, actors, sculptors and painters who played a leading role in the city's cultural life.

Already in 1910, while still a student at the San Fernando Royal Academy of Fine Arts, he had taken part in a response to the public scandal caused by a work entitled *El retablo del amor* (The altar of love, Fig. 3.1.1) presented by the Cordovan painter Julio Romero de Torres to that year's National Exhibition of Fine Arts. The work, in which several scenes with female nudes appear in a structure similar to that of the altarpieces of the Catholic churches, failed to gain a prize in the contest despite its obvious quality. In the following days, several press commentaries suggested that an injustice had been committed, and the matter came to be discussed even in the Congress of Deputies. On October 25, a group of intellectuals published a manifesto in which they asked the Ministry of Public Instruction to acquire a work by Romero de Torres as compensation for the injustice committed. Among those signing the manifesto, along with such prominent figures as Francisco Villaespesa, Pio Baroja, Benito Pérez Galdós, Jacinto Benavente and Dario de Regollos, there are the names of three from Priego: Niceto Alcalá-Zamora, who would later become President of the Second Republic; the journalist and bohemian Francisco Ruiz Santaella,[41] and the still unknown artist José Moya del Pino.[42]

Later, even while living most of the year in Paris, the young artist maintained his relationships in Madrid; he visited often and, upon his return, continued to work on breaking into Madrid's cultural circles. Evidence of the

Fig. 3.1.1. *El retablo del amor, by Julio Romero de Torres*

[41] Francisco Ruiz Santaella (Priego de Córdoba 1875-1950), architect, painter and photographer, led a bohemian life and worked for some years as editor of the newspaper *El Nacional* in Madrid.

[42] *https://bajolamiradadecordoba.blogspot.com/2011/04/retablo-del-amor-el-cuadro-de-la.html*

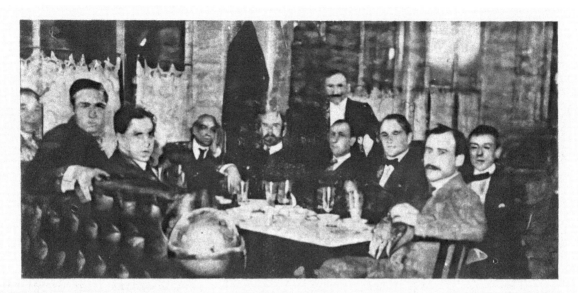

Grupo de escritores españoles en la Closerie des Liles, de París, y entre los que se encuentran Pío Baroja, Javier Bueno *(Antonio Azpeitua)*, el medio vasco Larcumbe, Moya del Pino y el pintor gitano Fabián.

Fig. 3.1.2. Gathering of Spanish writers and artists at the Closerie des Liles in Paris. Moya del Pino is seated, fourth from right.

success of this activity is the young painter's participation in the construction of a monument to Cervantes in the Plaza de España in Madrid, which was realized in 1915 based on drawings by the Royal Academy of Fine Arts of San Fernando in Madrid. Moya was part of a team called "The Block", composed of the architects Antonio Flórez Urdapilleta and Gustavo Fernández; the sculptors Julio Antonio, José Capuz, Moisés Huerta and Enrique Lautas; the painters Julio Romero de Torres, José R. Zaragoza, Anselmo M. Nieto and Aurelio Arteta; and the illustrators José Moya del Pino and Rafael Penagos.[43] In particular Moya's relationship with the Cordovan Romero de Torres will be evident in numerous episodes until his departure for the United States.

In *La sagrada cripta de Pombo* (The Sacred Crypt of Pombo), Ramón Gómez de la Serna mentions repeatedly the presence of Moya del Pino in the artists gatherings that took place in the Café de Pombo, and even in the banquets organized by "Don Ramón" (Ramón María del Valle Inclán), a genius of protocol and self-promotion. In the many photographs that Gómez de la Serna himself published, the image of Moya appears with the likes of Santiago Rusiñol, Jorge Luis Borges or Julio Romero de Torres. His name also appears (next to those of Américo Castro, Mariano Benlliure, José Ortega y Gasset and Juan Ramón Jiménez) in the list of those attending the banquet offered for *"the intellectual ambassador of Spain in Argentina"* Francisco Grandmontagne, in which the poet Antonio Machado and the writer Ramón Pérez de Ayala (later Spanish ambassador to London and nominated for the Nobel Prize in Literature) gave toasts. Moya also appears in the photo of a gathering of Spanish writers at *La Closerie des Liles* in Paris[44] (Fig. 3.1.2). And in his last years in Madrid, Moya del Pino attended a famous double banquet organized in honor of Gómez de la Serna himself on March 14, 1923, in the restaurant venues *Lhardy* and in *El Oro del Rin*; in the photo from

[43] TELLERÍA BARTOLOMÉ, A. *Solicitud de declaración como bien de interés patrimonial para el monumento a Cervantes de la Plaza de España*. Madrid, 2018. Madrid city heritage.
[44] GÓMEZ DE LA SERNA, R. *La sagrada cripta de Pombo*. Madrid, 1923. Facsimile reproduction in *Trieste*, Library of Spanish Authors, with prologue by Andrés Trapiello. Madrid, 1986. Pgs. 413, 423, 493.

this banquet, along with famous people such as Azorín, Prospere Merimée, Ramiro de Maeztu, Miguel de Unamuno and Gutiérrez Solana, Federico García Lorca also appears unmistakably, second on the left among those sitting on the floor (Fig. 3.1.3).[45]

But Moya's favorite café was undoubtedly the *Nuevo Café Levante*. Already upon graduation from the art academy he had become the youngest member of a group of Spanish artists and writers known as *La Tertulia de Levante*, which met here regularly and included many noteworthy artists of the time. Baroja, Ortega y Gasset, the poet Ruben Dario, the painters Solana and Regoyos were the main leaders of the group, and the writer Ramón María del Valle Inclán officiated as the supreme pontiff and master of ceremonies. The latter and our protagonist apparently understood each other from the start. Moya del Pino wrote of his impression of the Galician writer: *"I still remember with some emotion the first time I saw Valle Inclán. It was in the old Café de Levante, now gone. Don Ramón's thin silhouette towered among his friends; and in his noble head of warrior or stone saint, his eyes, behind the tortoiseshell glasses, had a copper glow. He spoke of Santiago de Compostela, a marvelous city where he had lived his turbulent youth, describing with passionate words the Portal of Glory by master Mateo, theological guide of illiterates and pilgrims, and evoking the naive works of the Picard stonemasons. Around him gathered Ricardo Baroja, Romero de Torres, Julio-Antonio, Anselmo Miguel, the Villalba brothers, Corpus-Barga, Penagos, Mariano Miguel, Vighi, Vivanco, Arteta, Solana, Montenegro and some emerging artists who listened attentively to the artistic evocations of his words."[46]*

After that first impression there was an extraordinary rapport between Valle Inclán and Moya del Pino and for a decade they collaborated in all the editorial projects promoted by the writer.

[45] GÓMEZ DE LA SERNA, R. Op. Cit. Pg. 632.
[46] MOYA DEL PINO, J. *"Valle Inclán y los artistas"*. In *La Pluma*, volume IV, № 32. January 1923. Pp 63-65.

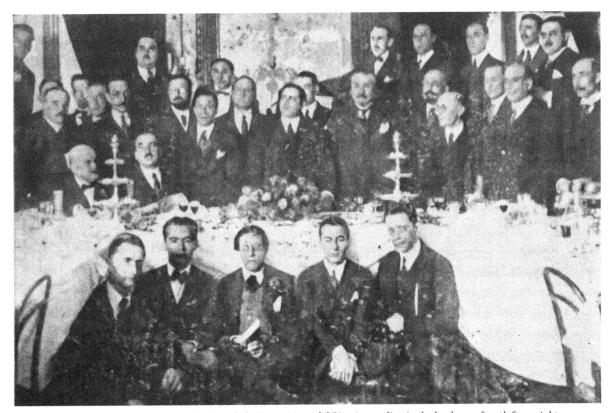

Fig. 3.1.3. Banquet in honor of Gómez de la Serna. Moya del Pino is standing in the back row, fourth from right.

3.2. Moya del Pino and the Book Arts

The first two decades of the twentieth century were a time of great expansion for the publishing industry in Spain. New companies in this sector presented to the public a wide range of magazines that brought novelties never seen before then: photography, engraving, color... The book industry also progressed by quickly adopting what we know today as graphic design. The book *"is then conceived as a decorated object, a combined product of visual art and discourse".*[47]

To put into context the meeting with Valle Inclán, which turned out to be an important moment for Moya del Pino, one must understand that in Spain the Galician writer was a true pioneer in introducing the book and graphic arts in the publication of his works, which were quite numerous in the second decade of the century;[48] and Moya collaborated on almost all of them, by direct invitation of the writer.

In 1911 Valle Inclán had embarked on the first edition of his work *Voces de Gesta* (Tales of heroic deeds), a tragedy in verse that takes place in a community of Basque-Navarre shepherds during the Middle Ages. (Fig. 3.2.1) Wanting to give higher quality to the publishing of his works, Valle had searched the guild of illustrators of the time and selected a group of artists, some already known and others almost new, each

[47] VILLARMEA ÁLVAREZ, C. and CASTRO DELGADO, L. *Valle Inclán frente a la industria del libro.* Annals of Contemporary Spanish Literature. Vol. 29, nº. 3. 2004.

[48] GIACCIO, L. M. *La Opera Omnia de Valle Inclán y su relación con el mundo de las artes gráficas* (The *Opera Omnia* of Valle Inclán and its relationship to the world of graphic arts). X National Conference of Comparative Literature, August 17 to 20, 2011, La Plata, Argentina. Available at: *http://www.memoria.fahce.unlp.edu.ar/trab_eventos/ev.2424/ev.2424.pdf*

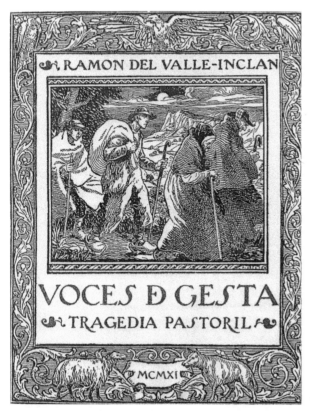

Fig. 3.2.1. "Voces de Gesta" by Ramon del Valle-Inclán (interior frames and possibly cover border by Moya del Pino)

Fig. 3.2.2. Full page illustration for Ramon del Valle-Inclán's "Aromas de Leyenda"

of whom could contribute their style and knowledge in the field of illustration. The edition was presented to the public with a total of 30 illustrations—8 of them full-page, plus other smaller ones. Aurelio Arteta signed two of these drawings, Julio Romero de Torres signed one and A. Miguel Nieto another; the other artists did not sign their drawings but their name appears on the closing page of the book, in uppercase letters and in Latin: "RICHARDUS BAROJA – ANGELUS VIVANCO – RAPHAEL PENAGOS – JOSEPH MOYA – ANSELMUS MICHAELIS – AURELIUS ARTETA – JULIUS ROMERO, ORNAVERUNT." This must have been the first collaboration between the writer and our artist; Moya was still a student and hadn't yet embarked on his *Prix de Rome*-financed trip to Rome, London and Paris.

From his future works as an illustrator we can deduce that Moya worked on the intricate frames that integrate the cover illustration with the interior covers that introduce each of the three "days" in which the work is divided. The purely decorative concept, based on plant motifs interspersed with very stylized forms with images of chalices, torches, jellyfish heads, skulls, drums, spears, arrows, rampant lions, eagles and other animals, corresponds to Moya del Pino's style, revealed repeatedly in his writings and works. In fact, in his already cited article *Decorative Art: The Illustration of the Book*, published in the magazine *La Alhambra* of Granada, he made it clear that the graphic image cannot exceed or attempt to replace the writer's material or psychological descriptions and that, therefore, the illustration must be above all "ornamentation," although in it may also appear symbolic elements that give content and depth.

That edition of *Voces de Gesta* immediately became a kind of manifesto for those involved in the book arts throughout Spain: editors, illustrators, writers, printers and even photographers. And from then on, the collaboration between Valle Inclán and Moya del Pino continued for more than a decade. Moya's constant activity in Spain's capital city seems almost incompatible with the accounts of his stay in Paris until the beginning of the Great War: it is hard to think that the work was commissioned by mail to Paris because the mail of that time did not work as quickly as we are used to today, nor could the work of an illustrator be carried out without direct contact with the writer and his work. Most likely Moya spent some seasons in Paris and others in Madrid during these years.

In 1912, Moya was hired by Valle Inclán, along with Rafael de Penagos and Ángel Vivanco, to illustrate his *Ópera Omnia*. In this collection appeared the following publications by the Galician writer:

In 1913: *Flor de Santidad* (Flower of holiness), *El Embrujado* (The enchanted), *Sonata de Primavera* (Sonata for spring), *Sonata de Estío* (Sonata for summer), *La Marquesa Rosalinda* (The Marquise Rosalinda), *Aromas de Leyenda* (Whiffs of Legend, Fig. 3.2.2), *Sonata de Otoño* (Sonata for autumn) and *Sonata de Invierno* (Sonata for winter). In 1914: *La cabeza del dragón* (The head of the dragon), *Romance de Lobos* (A wolf romance), *Jardín Umbrío* (Shady garden) and *El yermo de las almas* (The wilderness of souls). Almost all these books had new editions or reissues in the following years, but *Sonata de Primavera* was the most successful, with constant reissues by Imprenta Helénica in 1913, 1914 and 1917; its decorations are all by Moya. (Fig. 3.2.3)

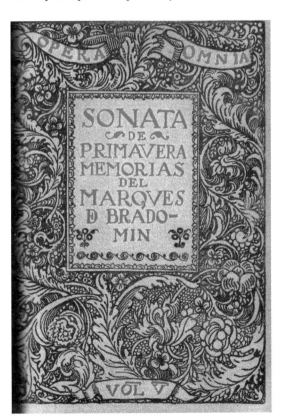

Fig. 3.2.3. Ramon del Valle-Inclán's "Sonata de Primavera," cover by Moya del Pino

In 1916 another collaboration of exceptional quality between the two artists takes place. In this year was released a second edition of *La lámpara maravillosa. Ejercicios Espirituales* (The Wonderful Lamp. Spiritual Exercises), which had been previously published without illustrations in 1913. This new edition instead presents a total of 35 illustrations by Moya del Pino, plus as many intricately ornamented capital letters, and ends with an inscription on the last page: "JOSEPH MOJA ORNAVIT."[49] These illustrations are described as *"precious, suggestive and initiatory"* in a reissue made recently by the publishing house *La Felguera*, in whose introduction appears this paragraph: *"It can be said that the illustrations that enrich this edition, and that were incomprehensibly deleted from later editions, are a book inside a book, a key that serves to decode an intense and rapturously luminous book, whose mysticism makes it insuperable in Castilian language. The author and the illustrator shared the same vision, a vision that, heir to the theosophy and occultism of the end of the century, defended the existence of an esoteric sense of life and the world."*[50] Editora Alvarellos also released a facsimile edition of this work in 2018, which includes an excellent prior study by Olivia Rodríguez Tudela that analyzes the intellectual relationship between the painter and the illustrator.[51] (Fig. 3.2.4, 3.2.5, 3.2.6 A–M)

In addition to these cited works, Valle-Inclán, a highly prolific writer, published short stories in several other periodicals and collections and continued to count on our artist's collaboration. Thus, in 1913 *Mi hermana Antonia* (My sister Antonia) appeared in issue no. 2 of the magazine *El cuento galante*, with cover and four interior illustrations by Moya del Pino. In 1919 the magazine *Voluntad* published Valle's poem *Karma*, decorated with two images by Moya del Pino—this poem is fundamental in its aesthetic, according to the scholars who study del Valle, and was integrated into his book *Claves Liricas* as its closing.

The artist's illustrations are still valued to such an extent that professor Jesús Rubio Jiménez has dedicated several studies to the collaboration between Valle Inclán and Moya, suggesting, even in the title of one of them, that in this case it cannot be accepted that the illustrations are secondary in a literary work, as is often the case in general. This author says that Moya undoubtedly benefited from Valle's ideas on book publishing, especially since he attended the writer's course on aesthetics at the Academy of Fine Arts in 1916, but that *"we must not forget his powerful personality and the solid formation on which he operated."*[52] When he arrived in Madrid in 1907, Moya *"came with his own ideas and was willing to build his art and aesthetics with great rigor and self-discipline,"* says Rubio Jiménez, adding that the relationship was enriching for both: *"And I say for both because the two influenced each other by establishing a fluid dialogue of artists who combined their voices to give rise to some of the most exalted works of Spanish modernism, both for the texts and for the images with which they were published."*[53]

The intense body of work he developed with Don Ramón María del Valle-Inclán did not prevent Moya del Pino from doing many other works as an illustrator during that period; in fact this activity was his most important source of income at that time. Outlined below are a series of illustrations for other authors.

The poet Francisco Villaespesa was probably, after Valle Inclán, the writer who most valued Moya, who illustrated and created covers for his books *Jardines de Plata. Poesías* (Silver Gardens. Poems), Hellenic

[49] *Estética y poética de la contemplación en Valle Inclán: La lámpara maravillosa* (Aesthetics and poetics of contemplation in Valle Inclán: The wonderful lamp). Doctoral thesis of Mª Isabel González Gil at the Universidad Complutense de Madrid. 607 pgs. Madrid 2015. Appendix pgs. 603-607 reproduce 35 engravings by Moya del Pino that accompanied the 1922 edition. *https://eprints.ucm.es/29969/1/T36016.pdf*

[50] *https://laslecturasdeguillermo.wordpress.com/2018/04/02/la-lampara-maravillosa-ejercicios-espirituales-de-ramon-del-valle-inclan/*

[51] *La Lámpara Maravillosa. Ejercicios Espirituales de Don Ramón del Valle Inclán".* Facsimile Edition. 2018. Consortium of Santiago and Editora Alvarellos. Presentation by Joaquín del Valle-Inclán Alsina. Also see previous study, *La elección del artista. El camino estético de Valle-Inclán* (The artist's choice. The aesthetic path of Valle-Inclán), by Olivia Rodríguez Tudela.

[52] RUBIO JIMÉNEZ, J. *Valle Inclán retratado por José Moya del Pino: la melancolía moderna* (Valle Inclán portrayed by José Moya del Pino: modern melancholy). In *Moralia*, magazine of Modernist Studies. Gran Canaria, November 2009. Pg. 26.

[53] RUBIO JIMÉNEZ, J. *Valle Inclán y Moya del Pino: buscando el fiel de la balanza* (Valle Inclán and Moya del Pino: seeking the perfect balance). In *Anales de la Literatura Española Contemporanea*, vol. 37, n. 3, 2012. Pg. 58.

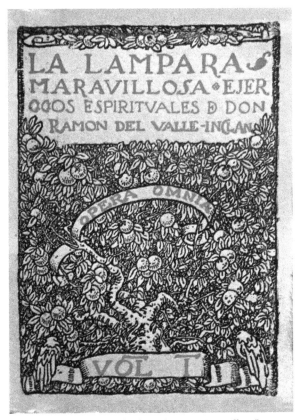

Fig. 3.2.4. Cover for "La Lámpara Maravillosa"

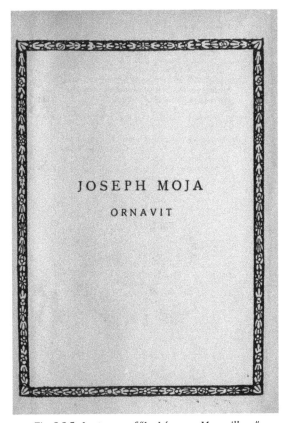

Fig. 3.2.5. Last page of "La Lámpara Maravillosa"

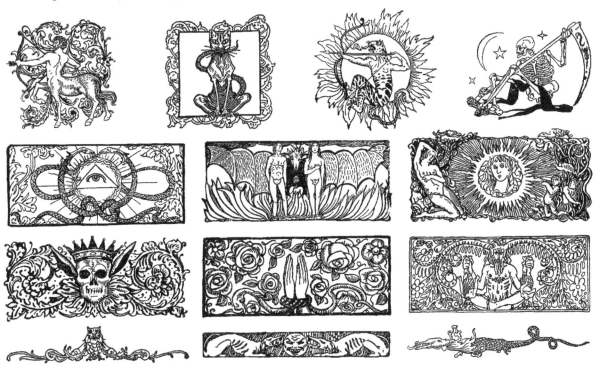

Fig. 3.2.6 A–M. Some of Moya del Pino's illustrations for "La Lámpara Maravillosa" by Don Ramon del Valle Inclán

Fig. 3.2.7. Cover for Villaespesa's "Lámparas Votivas"

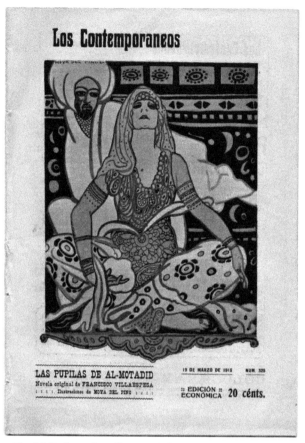

Fig. 3.2.8. Cover for Villaespesa's "La Pupilas de Al-Motadid"

Fig. 3.2.9, 3.2.10, 3.2.11, 3.2.12. Illustrations for books by Francisco Villaespesa

Printing, Madrid, 1912; *Las lámparas votivas* (Votive Lamps), Biblioteca Hispana, Madrid, 1913; and in 1915 *Panales de Oro* (Honeycombs of Gold), Sucesores de Hernando Editors, Madrid, and *Las Pupilas de Al-Montadid* (Al-Montadid's pupils), in *Los Contemporaneos* nº 325. (Figs. 3.2.7 – 3.2.12)

Other illustrations by José Moya del Pino in this period include:

In *El cuento semanal* of 12-29-1911: cover and 5 illustrations for *Inés de Magdala* by Antonio Zozaya, reissued on 8/15/1912 in the collection *El libro popular*.

In 1912 and 1913: the covers of two novels by the Granada-born Isaac Muñoz, entitled *Ambigua y cruel* (Ambiguous and cruel) and *Lejana y perdida* (Far away and lost) (Fig. 3.2.13).

Also in 1912, *La IX Sinfonía de Beethoven*, for Mateo H. Barroso, Decorated by Moya del Pino, Penagos and Vivanco. German Printing, Madrid, 1912 (Fig. 3.2.14). This work was reissued in Mexico in 1959. And in the same year, the cover for *El libro de mis quimeras* (The Book of My Chimeras) by Joaquín Dicenta; Hellenic Printing, Madrid. (Fig. 3.2.15)

Fig. 3.2.13. Cover for "Lejana y Perdida" by Isaac Muñoz

Fig. 3.2.14. Cover for "La IX Sinfonía de Beethoven" by Mateo Barroso

Fig. 3.2.15. Cover for "El libro de mis quimeras"

Fig. 3.2.16. Cover for "La onza de oro"

Fig. 3.2.17. Alegoria de Carnaval for Mundo Gráfico

Fig. 3.2.18 La muerte de Salomé

In 1914: *Los siete durmientes* (The seven sleepers), by Eugenio de Castro. Imprenta Art, Sáez Hermanos, Madrid. And in that same year, cover for *La onza de oro* (An ounce of gold) by Federico Navas. (Fig. 3.2.16)

In 1915: *Alegoria de Carnaval* for the cover of Mundo Gráfico (Fig. 3.2.17). In the same year, *La muerte de Salomé*, illustration for a poem by Emilio Carrere (Fig. 3.2.18) and *La zarpa de la esfinge* (The claw of the sphinx) by Antonio de Hoyos y Vinent, in *Los Contemporáneos* nº 320.

In 1916, *La Paz del sendero* (The peacefulness of the path) for Ramón Pérez de Ayala, with prologue by Rubén Darío and illustrations by Moya del Pino. (Fig. 3.2.19 A and B)

In 1917, *La muerte ilustrada* (Death illustrated), drawings published in the magazine *La Esfera* on January 3 and March 17 (Fig. 3.2.20 A & B). And the same year, *Romances y Letrillas* and *Los libros de Horas* (The books of hours) by Luis de Góngora y Argote, Biblioteca Corona, printed by Blas y Cía. Madrid, 1917. Cover and interior decorations. (Fig. 3.2.21)

Fig. 3.2.19 A & B. Cover and first page illustration for "La paz del sendero" by Ramon Perez de Ayala

Fig. 3.2.20 A & B. Illustrations for "La muerte ilustrada"

And in 1920, Moya did the cover for the publication of the poem *El Cristo de Velázquez* by Miguel de Unamuno in the collection *Los Poetas* by publishing house Calpe. (Fig. 3.2.22)

He also drew for the magazine *La Esfera* in the following publications: *Amor y Burlas* (Love and jest), 2/13/1915 (Fig. 3.2.23); *La novia blanca* (The white bride) by Ramón Díaz Mirete, 12/18/1915; *El caballero*

negro (The black knight) by Fernando López Martín, 9/25/1915; *El peregrino ciego* (The blind pilgrim) by Ramón Díaz Mirete, 2/19/1916; *Madrigal escrito junto a la Ría* (Madrigal Written Near the Estuary) by Rafael Sánchez Mazas, 12/8/1916; *Dietario sentimental* (Sentimental Diary) by Carrere, 10/16/1915. (Figures 3.2.24 to 3.2.31)

Many other illustrations lie semi-lost or at least forgotten in publications of the time, either because those publications were never reissued, or because when they were, the illustrations were eliminated.

Fig. 3.2.21. Cover for "Los Libros de Horas" by Luis de Góngora y Argote

Fig. 3.2.22. Cover for "El Cristo de Velázquez" by Miguel de Unamuno

Fig. 3.2.23. "Amor y burlas"

Fig. 3.2.24 & 3.2.25. Illustrations for the magazine "La Esfera"

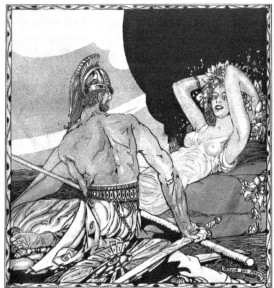

MARTE Y LA PRIMAVERA

CUENTO DE ABRIL

Fig. 3.2.26 – 3.2.31. Illustrations for the magazine "La Esfera"

BLANCO Y NEGRO

Fig. 3.2.32 & 3.2.33. "Una fiesta de Carnaval en Florencia" for the magazine "Blanco y negro," and "Circe," cover for issue 1429

As Jesús Rubio Jiménez stated, José Moya del Pino "... *came to be consecrated as one of the great designers of Spanish modernism*".[54] At the same time, it is interesting to note his almost total absence from the magazine *Blanco y Negro*, perhaps the best known and longest running of that time. Adolfo Lozano Sidro, Moya's compatriot, worked there, although we have no record of any relationship between them. In the archives of Madrid's ABC Museum of Drawing and Illustration, which preserves the illustrations published in the magazine *Blanco y Negro*, there are only two works by Moya; the first, entitled *Palazzo, o Una fiesta de Carnaval en Florencia* (A Carnival Party in Florence) appeared on page 18 of issue 1406 of the magazine, published on April 28, 1918 (Fig. 3.2.32); the second, entitled *Circe, o Bajo el ala del Sombrero* (Circe, under the brim of the hat) was the cover of number 1429, on October 6 of the same year.[55] (Fig. 3.2.33)

3.3. Portraits

Moya del Pino had an immense capacity for social relations, and that quality earned him abundant friendships, directly or indirectly, in the Madrid of town and court. He must have done many portraits, but if ever there was an intimate and elusive genre in the art of painting, that is undoubtedly the portrait. First the subject has to pose, and the one who poses is not always happy with his or her own self-image; then the result, i.e. the painter's work, must be accepted; finally, the painting must find a frame and be hung in some place that can be the most striking in the house (or the hallway to the bathroom)... There tend to be few portraits that end up in museums or in exhibition catalogs, not even in the inventories made by each painter's biographers.

Nevertheless, we are going to present here a selection of Moya del Pino's portraits from this period prior to his departure for America. The models are so diverse that they range from a boy or girl whose name we do not know, to the Duke of Alba and the King of Spain.

Moya del Pino's dedication to the portrait was a constant throughout his career, and when studying the whole of his production in this genre, one reaches the same conclusions as when talking about his work as an illustrator: the quality is extraordinary, there is symbolism in the surrounding elements, and in the portraits, in addition, there is a real depth in the interpretation of the characters— similar to Velázquez in the attempt to reflect in each portrait not the appearance or the external reality of the person portrayed, but the spirit, the intimacy: what is not seen with the eyes but with the heart. Not in vain had Moya studied in the "school" of Velázquez in the Prado, long before he began his exhaustive copying of the works of the Sevillian genius.

Fig. 3.3.1. Portrait of Rafael Caro Raggio

Although we haven't been able to locate this painting, it appears that already in the 1910 National Exhibition of Fine Arts Moya had presented the portrait of Don Isidoro de las Cagigas, a character he probably knew in Granada. Another of his first portraits, of the Granada writer Isaac Muñoz, appeared in *El Heraldo de Madrid* on September 20 of 1912. And in the National Exhibition of Fine Arts of 1917 he presented *The sculptor Madariaga and his model*,[56] a work that received favorable criticism but we could not locate either.

[54] RUBIO JIMÉNEZ, J. *Valle Inclán retratado por José Moya del Pino*. In *Moralia*, Gran Canaria, November 2009. Pg. 26.
[55] Our thanks to Inmaculada Corcho, director of the ABC Museum, who discovered these works and gave us the publication data.
[56] The sculptor Emilio Madariaga, who was born in La Coruña in 1887 and prematurely died in Madrid in 1920, was the brother of the writer and diplomat Salvador de Madariaga.

Fig. 3.3.2. *Portrait of Ana Teresa Suárez*

Fig. 3.3.3. *Portrait of José de León Contreras*

Among Moya's friends for many years were the novelist Pio Baroja and his brother-in-law Rafael Caro Raggio. The latter was from Malaga, but spent his life in Madrid and there he married Carmen Baroja, sister of the novelist. Rafael had a bookstore in the Plaza de Canalejas in Madrid, from which he worked as editor and printer; in addition, he attended the café *Nuevo Levante*, where he probably met Moya del Pino. His portrait, showing the protagonist wearing a Spanish cape, is currently in the Baroja house museum in Itzea, in Bera de Bidasoa (Navarra). (Fig. 3.3.1)

More forceful, in the visual and psychological sense, is the portrait that our painter did for Doña Ana Teresa Suárez, a lady from the bourgeoisie of Madrid (Fig. 3.3.2). The portrait was described in *Moralia: Revista de Estudios Modernistas*, as follows: *"In the Portrait of Ana Teresa Suárez, all the tendencies that marked the practice of this genre in the early twentieth century arise in counterpoint (...). The lady is portrayed in a three quarters pose and sitting, with a slight turn towards the viewer. The background of the portrait, an intense crimson red, is a color with abstract connotations, more typical of graphic illustration than of naturalistic portraiture. Moya del Pino creates a glamorous image of great lady, similarly to many artists in his line of work at that time, such as Manuel Benedito, de la Gándara, Álvarez Sotomayor and Néstor; an image that perpetuates the traditional symbols of the ruling and wealthy classes. The lady wears a splendid marabou shawl, which allows Moya del Pino to entertain himself pictorially by reproducing rhythmic and luminous effects that he handles with mastery and modern technique. The jewels that adorn the lady's hands, ears and neck are painted with a quick stroke, which dissolves when scrutinized. In this painter's case this characteristic no doubt comes from his admiration for Velázquez, whom he copied and studied intensely in these years. Thus, Moya del Pino incorporates these references to the classicism of Spanish painting into the modernity of his portrait style. The quality of the skin and the modeling of the face, neck and shoulders are magnificent, as well as the descriptive work on the hair. The color strategy is surprising and unusual, and reminds us distantly of symbolism: the aforementioned background in red, the white of the shawl, and the green, a novel combination.*

This portrait allows us to get a more fair and realistic idea of the artistic capabilities of Moya del Pino, whose name had been restricted until recently only to the field of graphic illustration". In addition to extolling the depth of his work as a painter, the author of this article also affirms that Moya del Pino is *"among the most cosmopolitan and versatile illustrators of the golden age of modernist graphic illustration in Spain."*[57]

In 1923 Moya did a portrait of José de León Contreras, count of Cimera; the military attire of the personage contrasts with the rather non-authoritarian character of his gaze, which demonstrates the painter's ability not to be trapped by the external appearance of the portrayed. (Fig. 3.3.3)

An instrumental work in Moya del Pino's life, however, was the portrait he painted of Jacobo Fitz-James Stuart y Falcó, 17th Duke of Berwick and Alba de Tormes, who posed with the uniform of Master of the Real Maestranza de Sevilla—ostentatious to the point that, under his cloak, could be concealed the most cultivated personality. (Fig. 3.3.4) One of the most influential aristocrats of his time, the Duke of Berwick and Alba was a Spanish noble, diplomat, politician and enthusiastic art collector, and became one of Moya's early supporters and patrons. The artist had already shared with him his dream to copy all the Velásquez paintings; the Duke had thought it a splendid idea and offered not only to become a financial sponsor, but also to introduce the concept to the king of Spain for eventual support.

And so in 1924, as a collateral to his *"Exhibiciones Velázquez"* project (of which we will talk more later), the artist painted King Alfonso XIII. But something unexpected happened with this portrait of the

[57] http://moralia.tomasmorales.com/index.php/moralia/article/view/1069

Fig. 3.3.4. Portrait of the Duke of Alba

Fig. 3.3.5. Portrait of King Alfonso XIII

king, and partly thanks to that unforeseen situation, it turned into an excellent portrait. Moya del Pino, putting himself in the mindset of Velásquez's portraits and thinking that it would be the most convenient, suggested to the king that he pose in military uniform. *"I want to portray the king,"* the painter said in a newspaper interview, *"as a soldier; I have that ideal and that conception of Alfonso XIII. Velázquez presented his characters in his own way, not just the most human or sympathetic view but the most characteristic and most habitual in them. I will portray his majesty in the uniform of a general on a campaign: King and soldier ..."*

But Alfonso XIII did not accept the suggestion and presented himself for posing dressed in a jacket and tie. By 1924 the king had already been portrayed at least fifty times. Painters as prestigious as Julio Romero de Torres, Daniel Vázquez Díaz, Gonzalo Bilbao, José Garnelo, Joaquín Sorolla, Ramón Casas, Ángel Díaz Huertas, José Mongrell and Federico Beltrán had portrayed the king. Ramón Casas portrayed him three times, one of them on horseback. Alfonso XIII had been always painted in military or nobiliary uniform: as general of the cavalry or infantry, with the uniform of Hussars or the Order of Calatrava, with the Collar of Justice ... uniforms and symbols that crush without mercy the most esteemed personality. That is why the portrait by Moya del Pino, which presents the king dressed as any mortal, is probably the most human and understanding of all those that were made of him. (Fig. 3.3.5)

From Moya's inexhaustible anecdotes, recounted in journalistic interviews and family stories, stands out this pearl: *"When the portrait was finished, I presented it to the King for his approval. After contemplating his likeness for a while in silence, he smiled and said to me, joking: 'Thank God, for once I do not feel like the picture on a deck of cards'."* [58]

3.4. Caricatures

Moya's portraiture work resumed strongly, as we shall see later, in San Francisco, California, in the thirties and forties, after the end of the *Exhibiciones Velázquez*; but, while still in Madrid, our painter also practiced another aspect of portraiture: the caricature. A caricature drawn on a piece of paper can be a portrait as great as that which has been painted in oil on a luxurious canvas and in large format, because genius is not, as we've said, to reflect the appearance of the character but his interior life. This is the case with the caricature-portraits that Moya del Pino did of Valle Inclán, for example. Professor Jesús Rubio Jiménez has published an unsurpassed study of these portraits, whose steps we will follow here.

To begin with, let's remember that when Moya did these portraits, Valle was already a well-known figure in Madrid with an unmistakable image that he had created himself: the exaggeratedly long beard (*"this great don Ramón with the beard of a goat,"*

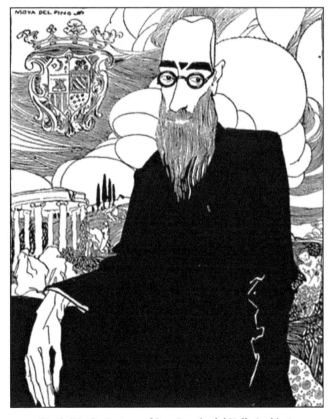

Fig. 3.4.1. Caricature of Don Ramón del Valle Inclán in "El Gran Bufón"

[58] HAILEY, G. *California Art Research*, Volume 13, pg. 105. Works Progress Administration, San Francisco, 1937.

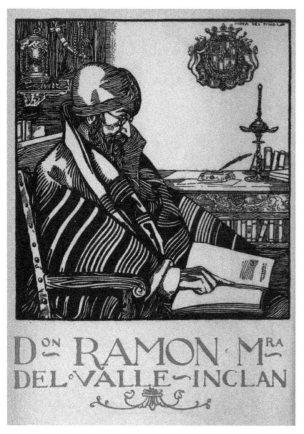

Fig. 3.4.2. Caricature of Don Ramón del Valle Inclán in "La Lámpara Maravillosa"

Fig. 3.4.3. Caricature of Don Ramón del Valle Inclán in the magazine "La Pluma"

according to Rubén Darío), the round glasses, his black clothes and his hat, the empty sleeve of his left arm which he had lost due to an infected wound...

In the first portrait, published in the magazine *El Gran Bufón*, Moya del Pino interprets the image of the writer, as Rubio Jiménez tells us, *"emphasizing Don Ramón's noble features, his seriousness and haughtiness, his singular elegance. The landscape on which the figure is placed also has its importance: it is a rural landscape full of classical resonances, adapting to the mood evoked by the 'Sonatas', with its Latin and Tuscan ambiance; the rolling hills are dotted with cypresses and splashed with evocative ancient ruins: a temple, the statue or figure of a faun, etc. And in the upper left is a blazon that recalls the one that Valle used in his Opera Omnia, ennobling his writings with the reference to his belonging to a family with noble ancestors."* (Fig. 3.4.1)

The second portrait appeared in the presentation of *La lámpara maravillosa*, on page 8 of the 1916 edition that was illustrated by Moya del Pino. In this case, the painter presents the writer *"with the appearance of a rabbi initiated in kabbalistic and theosophical knowledge (...) who studies with concentration the kabbalah wrapped in his turban and shawl."* In the background of the image are *"... a sword (in the shape of a crescent moon), a rosary and an hourglass, perhaps as signs of religious concern ... On the table with writing notes and various books is a lamp with its three wicks unlit. The true light that he seeks seems to come rather from the book he holds in his hands and that he reads self-absorbed: 'The wonderful lamp'."*[59] (Fig. 3.4.2)

In 1919 a variant of the previous portrait is published as an illustration for the poem *Karma*. Then another portrait of Valle Inclán by Moya del Pino appears in the magazine *La Pluma* in 1923.[60] Rubio Jiménez describes it this way: *"In this woodcut the external elements that can distract the attention have disappeared.*

[59] RUBIO JIMÉNEZ, J. *Valle Inclán retratado por José Moya del Pino*, Pgs. 29-31.
[60] *La Pluma*, January 1923. Madrid, IV, 32, pg. 64.

The background is just a landscape suggested and resolved by the contrast between lights and shadows. All the attention is focused on the bust of the portrayed, whose head is very slightly leaning forward and who meditates—or perhaps reads—self-absorbed. It is his inner world that seems to matter to him and nothing outside distracts his attention." (Fig 3.4.3)

The aforementioned professor compares Moya's portraits with those of Albrecht Dürer, considered one of the great portraitists in the history of painting, and ends his study by explaining that Valle Inclán's goal was to turn his life into a work of art—an objective that Moya executed perfectly: *"The portraits by Moya del Pino are the result of thoughtful analysis of what the portrayed meant to him, they are successive challenges to show plastically, rather than in physical features, the profile of a great personality, the inner power and how it expanded outward. (...) In the end one must conclude that seldom did an artist capture and express with such well-roundedness the singular personality of Valle Inclán, perhaps never."* [61]

We can't end this outline of Moya del Pino's professional relationship with Valle Inclán without noting the opinion that the painter had about the writer, as expressed in an article published by the magazine *La Pluma* in a tribute issue dedicated to the writer, when the collaboration between the two was close to its end. Moya del Pino says in his writing that, in contrast to more realistic artistic positions, Valle represented the spirit, and spoke with great knowledge of the painting of Rafael and El Greco, of the writings of Paracelsus and of the poetic work of Saint John of the Cross. He was, says Moya, an *"essentially visual"* writer because in his work more weight is given to *"a pictorial vision than a meticulous psychological analysis."* He loved painting and was endowed with a *"very fine perception and sensitivity for color."* Moya affirms that Valle strongly influenced the renaissance of the decorative arts in Spain, and especially in the book arts: *"But where Valle Inclán's influence has been most clear and defined is in the book arts. All the current editions that present any artistic interest are derived from those first books: especially 'Voces de Gesta,' in which Don Ramón put the best of his great knowledge of this art. (...) The influence of the aesthetic norms of Valle Inclán on contemporary Spanish art has been very great. All the aforementioned artists—many of whom have achieved solid and deserved prestige—were influenced, to a greater or lesser extent, by his doctrines and disseminated them through their works."* [62]

In fact, as is easy to deduce from all the above, the relationship between the Galician writer and the Andalusian artist far exceeded the merely professional, and became a deep personal friendship. We also know that Moya spent some summer vacations as a guest in the house that Valle owned in A Pobra do Caramiñal, in the province of La Coruña.

3.5. Advertising and Other Endeavors

In the early years of the twentieth century advertising hadn't been a very developed economic or artistic sector. It was modernism that introduced the image in commercial ads, which up to then had been purely textual. In 1916 the Galician company *Jabones La Toja* commissioned an advertising campaign for its salt soaps, involving artists such as Rafael Penagos and Bartolozzi, and as part of this campaign several plates by Moya del Pino were released. (Fig. 3.5.1 and 3.5.2)

Moya also submitted an illustration to an advertising poster competition sponsored by the "Heno de Pravia" brand in Barcelona. It was published in *El Mundo Gráfico. Revista Popular Ilustrada* and is probably his most accomplished work in this sector, for its attractive design and for the colors of the image and the surrounding ornamentation.[63] (Fig. 3.5.3)

[61] RUBIO JIMÉNEZ, J. *Op. Cit.,* Pgs. 34-36.
[62] MOYA DEL PINO, J. *Valle Inclán y los artistas.* In *La Pluma,* IV. No. 32. January 1923. Pgs . 63-65.
[63] GARCIA FELGUERA, M. *Aspectos iconográficos del cuerpo en la publicidad en Galicia a principio del siglo XX* (Iconographic aspects of the body in advertising in Galicia at the beginning of the 20th century). SEMATA, Social Sciences and Humanities, 14. University of Santiago de Compostela, 2003.

Although mainly dedicated to illustration in these years, Moya did not abandon other fronts. We don't have information for every year, but in 1918 he painted a homage to celebrated Spanish composer Enrique Granados, who had died on the passenger ferry Sussex which was crossing the English Channel when it was torpedoed by a German U-boat (this attack reverberated through the world and led to a heated diplomatic exchange between the US and Germany, culminating in the so-called Sussex Pledge where Germany agreed not to target passenger ships during the war). The 2 x 2 m. painting (Fig. 3.5.4) mimics a mosaic and shows three muses on a pedestal inscribed with "Laus Musicae," with mourners at their feet, surrounded by Grecian-styled figures playing various musical instruments. The central inscription says "A GRANADOS VICTIMA DEL TORPEDAMIENTO DEL XVXES POR VN SVBMARINO ALEMAN." This work is currently property of the Museo Nacional Centro de Arte Reina Sofía in Madrid.

It is also known that in 1922 Moya presented to the National Exhibitions of Fine Arts an oil on canvas of 152x180 cm. titled *Cintia y Arabela*, and its review appears on page 41 of the catalog of the contest of that year. And that same year, he won the Purchase Prize of the Fine Arts Circle in Barcelona, though we have no record of the painting submitted.[64]

Fig. 3.5.1 and 3.5.2.
Advertising illustrations for Jabones La Toja

Fig. 3.5.3. *Advertising poster for the soap company Heno de Pravia*

Fig. 3.5.4. *"Homage to Granados"*

[64] HAILEY, G. *California Art Research, Vol. XIII*. Works Project Administration, San Francisco, 1937.

CHAPTER 4

Exhibiciones Velázquez: An Idea that Will Change His Life

4.1. Realization of the Copies and Formation of the Company

On March 3, 1921, José Moya del Pino turned 31, and although his social activities suggests that he was not experiencing too much financial hardship, his subsequent memories of those years hint at a dissatisfaction with the need to have to earn a living every day. In a long interview granted in San Francisco many years later, he said: *"I got tired of that precarious life and was always trying to find some scheme for living ..."*[65] That is to say that in the Madrid of the Roaring Twenties, neither his work as an illustrator, nor the portraits, brought him great riches—nor did all the favorable reviews manage to launch his name to a first level as an artist.

After the summer of that year he decided to put into practice an idea that had been maturing for years: to make a complete copy of Velázquez's work in the Prado Museum and to organize an itinerant expedition to show the collection in foreign countries. The idea ended up being so successful that it turned Moya del Pino into a celebrity in Madrid during the final stages of Alfonso XIII's reign.

Moya del Pino's idea first received support by the artist Edward Archibald Brown, whom he had met in London, then by the Duke of Berwick and Alba, a well-known patron of the arts. It was the Duke who introduced the concept to King Alfonso XIII, and the King eagerly embraced it. In recent years travel to Spain had plummeted due to the 1918 influenza pandemic that many foreigners thought had started in that country;[66] the King, hoping to revive the economy, had become a great promoter of tourism, and a "cultural mission" to introduce other nations to Spain's artistic masterpieces seemed like a worthwhile effort to help foster travel to the country.

And so on November 2, 1921, according to the register of copyists of the Museo del Prado, José Moya del Pino began to copy the painting titled *Aesop* by Velázquez, on a canvas measuring 178x96 centimeters— that is, practically identical to the original which is cataloged in the museum with dimensions of 179x94 cm. He either completed it in record time, or worked on more than one painting at a time, since on November 9 he began to copy *Menipo*, and on the 12th of the same month he also started on *El Niño de Vallecas*. By the end of the year he had also worked on *Felipe IV joven* (King Philip IV young), *Don Sebastián de Mora*, *Bobo de Coria* and *Felipe IV viejo* (Philip IV old). He had worked on seven paintings in two months and, strategically, he had chosen paintings of lesser complexity while perfecting his technique.

The logistics were daunting. Most of the paintings were enormous, even by classical standards. Perhaps the most famous of Velasquez's works, Las Meninas, was nearly 10 feet by 10 feet. Moya was committed to duplicating the originals to their exact measurements, and to grind the pigments and hand-mix the colors according to 17th century specifications. This, as the artist stated later in an article in the Philadelphia Forum

[65] Oral history interview with José Moya del Pino by Mary Fuller McChesney, Sept. 10, 1964. Archives of American Art, Smithsonian Institution, Washington, DC.

[66] The 1918 influenza was in fact called by many "the Spanish flu," though its origins are unclear. Many countries during World War I censured their communications, while Spain, who remained neutral, shared information more freely and therefore appeared more hardly hit than other countries. King Alfonso XIII himself fell gravely ill, and his illness was widely reported, contributing to the impression that Spain was the most affected area.

of April 1925, *"required an extensive preparation and a slow and careful study of the processes followed by Velasquez, in respect to both color and manner of composing. For two years I did nothing else but imbue my mind with the work of the most glorious of our painters. Afterwards, I began the scrupulous reproduction of the paintings, and to this task I devoted myself for four years."*[67]

In fact, whenever dimensions are noted in the Prado's register of copyists, they are almost always the same or very close to those of Velázquez's originals, with only one exception: for *El Niño de Vallecas* the book indicates that the copy's size was 49x39 cm. However, since this is one of the copies that has survived to the present, we know that it measures 106x83 cm which is practically the same as the original; so either Moya made a smaller copy first, or this is a mistake by the official in charge of the register.

The artistic endeavor picked up again on January 10, 1922, just after the Christmas holidays. And the bureaucratic endeavor, which must have taken several months, began a few days later. Undoubtedly the painter demanded the signing of some kind of contract, because he had been working without remuneration for more than two months based only on verbal support.

On January 19, 1922, the *Exhibiciones Velázquez* project was registered as a "public limited company" through a document that also describes its objective as to *"diffuse abroad"* the artistic beauties of Spain *"exhibiting, in successive expositions, copies of the riches that are treasured in our museums, forming true scientific missions that, through conferences and special editions of books and brochures written expressly for these purposes, will popularize outside of Spain the greatness of our art."*[68]

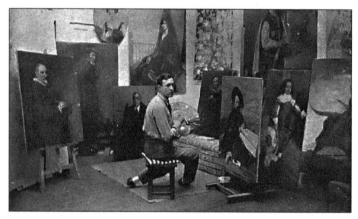

Fig. 4.1.1. Moya del Pino working on the copies of Velázquez

Since this is one of the highlights of Moya del Pino's distinctive life, it is worth a look at the business-like conditions in which the project was to be carried out. Gathered before a notary were, on one side, Don Archibald Edward Brown and Don Víctor E. Cazeaux as acting Board of Directors of the *Exhibiciones Velázquez* Company, and on the other Mr. José Moya del Pino, painter, acting in his own name. They declare that both parties have agreed that the painter shall make copies of the Velázquez paintings that are in the Prado Museum, under the following stipulations. Moya must reproduce the paintings and present, at the end of his work, a certificate from the Museum's directors that proves that the copies conform to the originals *"in their making, size and detail."* While performing this

Fig. 4.1.2. Moya del Pino copying "Las Meninas"

[67] *José Moya del Pino*, editorial in the *Philadelphia Forum*, April 1925.
[68] General Archive of the State Administration in Alcalá de Henares. (10) 3.10 54/05261

work he is to receive 2,500 pesetas per month, which is inclusive of any materials expenses, although he can request a supplement of money for the larger paintings. He will also receive 35 percent of the profits obtained by the company for the exploitation of the copies in any form, or of the sale price if they are sold. Moya will be the company's administrator and also its Artistic Director, receiving fees to be determined by the company. In case of breach or dissolution of the Company, Moya will receive as compensation half of the paintings made at the time of dissolution or 50% of their sale price; if the breach is on the part of the painter, the Society may seize ownership of half of the paintings made. The document is signed by the three persons mentioned and submitted to the courts of Madrid.

Motivated now by the official creation of the company, Moya worked tirelessly until June, by which time he had at least started 14 paintings, some as ambitious as *Los Borrachos* (The Drunkards), *Las Hilanderas* (The Spinners) and *El principe Baltasar Carlos a caballo* (Fig. 4.1.1). On June 9 he began to paint *Las Meninas* (the largest painting, measuring 310x276 cm), then interrupted his work, possibly to complete some of the works previously started or to focus on other paintings. He resumed copying *Las Meninas* on February 27, 1923 (Fig. 4.1.2), and worked on it from February to June of 1923; he completed only four Velazquez copies that year, plus a portrait of the Duke of Alba intended to accompany the exhibition (Fig 4.1.3).

In 1924 the museum's book of copyists recorded nine paintings copied by Moya del Pino, among which were some quite important ones due to their size and complexity, such as *The Surrender of Breda*, *The Coronation of the Virgin*, *The Forge of Vulcano* and *Adoration of the Kings*. He also traveled to Valencia this year in order to copy Velazquez's self-portrait, an image that would open the printed guide to the exhibition.

Fig. 4.1.3. Finishing the portrait of the Duke of Berwick and Alba

On February 21, 1924, the King received the painter in audience; in this meeting the details of the project were probably finalized, and the sessions scheduled for Alfonso XIII to pose for the portrait that would accompany the Velázquez collection (Fig. 4.1.4, 4.1.5). The patronage of the King was officially confirmed, and the structure of the company was formalized: the Duke of Alba would be its Honorary President; the Minister of Public Instruction and Fine Arts, Joaquín Salvatella, and the ambassador of Spain in London, Mr. Alfonso Merry del Val, would hold the positions of vice president; and the executive director would be José Moya del Pino, with his friend the sculptor Francisco Moré de la Torre and with Antonio González de la Peña, a relative of the Duke of Alba, as direct collaborators.

Fig. 4.1.4. Working on a portrait of King Alfonso XIII

As the work of copying the paintings of Velázquez neared its completion, Moya started the second phase, publicizing the project in the cultural world of Madrid and in all of Spain and preparing the company to face the tour of foreign countries. And as the project was made public, the support of the cultural elites of Madrid was almost total, eliciting in some even an overflowing enthusiasm. Encouragement, and in some cases financial help, came from the counts of Cimera, Zubiría and Ribero, the Marquises de Amboage, the Duke of Parcent, Dr. Marañón and other personalities.

By contrast however it is worth noting that, despite the fact that the project had the support of the King and of a great part of the country's nobility, express backing was not obtained from the de facto head of the government: the dictator Miguel Primo de Rivera. King Alfonso XIII, having been blamed for the Spanish defeat in the Moroccan War of 1921, was in constant conflict with Spanish politicians. His anti-democratic views had encouraged the military, headed by Captain General Miguel Primo de Rivera, to overthrow the parliamentary government, upon which Primo de Rivera established himself as dictator in 1923. Resentful of the parliamentarians' attacks against him, King Alfonso tried to give Primo de Rivera legitimacy by naming him prime minister. With the blessing of the king, the general suspended the constitution, established martial law and imposed a strict system of censorship.

Moya del Pino had originally been thinking of starting with a tour of European countries, since the idea for his project had started forming while he was in London; but it seems that the shifting political climate and the foreign policy of Primo de Rivera caused a change in those plans.

The general-turned-dictator's foreign policy was directed in part towards countries with similar governments to his, such as Italy, but mainly towards other Spanish-speaking countries, with the intention of creating a diplomatic infrastructure that had been forgotten for decades. This line of action also led to sending Cardinal Juan Bautista Benlloch as an extraordinary ambassador to Latin America, a trip promoted jointly by King Alfonso XIII and Pope Pius XI. Benlloch toured eight countries in four months of 1923, with the mission of restoring the Latin countries' spiritual and cultural ties with Spain and the Church.

Within the framework of this foreign policy, Moya del Pino's idea pivoted towards the Americas; and by 1924 he was defining very clearly the cultural and even "commercial" purpose of the company. The itinerary was laid out, at least in Moya del Pino's mind, and a generous end in Buenos Aires was even planned: *"The purpose is to disseminate in other countries the knowledge of the great figures of Hispanic art and the furtherance that this can bring to tourism and our relations with America. ... [After the exhibition in Madrid]... we will leave for Paris, London, North America, Central America and South America, finishing the tour in Buenos Aires where it is our desire that the works remain, to form a Museum of artistic reproductions in that Republic"*.[69]

However, the contacts established so far did not entirely come through with concrete support for that ambitious program. The newspapers *La Nación* in Buenos Aires and *El Universal* in Mexico offered support for the dissemination of the project; the director of Mexico's *Biblioteca Popular del Libro Español*, Fernando Mota, provided support in the abstract; Spanish and Latin American intellectuals and personalities declared themselves interested in the project; The Marquis of Comillas offered the Transatlantic Company's ships for the trip; the Marquis of Urquijo, the Marquis of Valdecilla, the Count of Cimera and the Count of Lemus showed their good disposition; Peru's government issued a statement suggesting that the exhibition pass through the cities of the Pacific as well; the Spanish embassy in Ecuador, as early as January 1925, wrote they would be willing to bear the expenses that arise ... But there didn't seem to be any signed agreements or firm commitments.

Instead, the ambassador of the United States of America in Madrid, Mr. Alexander P. Moore, appeared on the scene. He had taken office as "Ambassador Extraordinary and Plenipotentiary" on May 16, 1923 and in a few months had become a popular character in Madrid; his direct and frank style in dealing with the

[69] Statements by José Moya del Pino in an article entitled *El peregrino curioso* (The curious pilgrim) by A. Ghiraldo, in *La Esfera*, no. 516 of November 24, 1923. Pg. 21.

Fig. 4.1.5. José Moya del Pino shows King Alfonso XIII his portrait

Fig. 4.1.6. US Ambassador Alexander Moore, painted by José Moya del Pino

King and with the government, his cordiality and his admiration for Spanish culture (he even attended the bullfights in Madrid), earned him the appreciation of senior officials, politicians and people of culture (Fig. 4.1.6). Upon learning about the *Exhibiciones Velázquez* project, the ambassador promised his support explicitly and publicly; in this way, the United States became at least one of the possible stops of the traveling exhibition.

4.2. Dissemination of the Project

The promotion of the project began with an article signed by Alberto Ghiraldo in the magazine *La Esfera* that was essentially a literal transcript of a long statement by Moya del Pino. The painter began with a close praise of Velázquez, demonstrating the deep knowledge he already had of the work of the Sevillian genius: *"Velázquez is the most universal of painters; what contributes essentially to the universality of his work is the perfect equanimity with which the man and the painter stood before nature. El Greco, Zurbarán, Valdés-Leal saw, in large part, with their exalted spirit; Velázquez saw, first of all, with his eyes. He possessed that rare gift, that logic and that habitual rectitude of eyes that prize lucid ideas, clear forms and boldness formulated with precision".*[70] The article continued with Moya's explanation of the project's details.

In the first days of March 1924, Moya del Pino himself gave a lecture in the salon of *Los Caballeros del Pilar* (Knights of the Pillar), presented by the Jesuit Father Torres, to announce the formation of the company. In the following days, in the pages of *ABC*, the prestigious journalist José Ortega Munilla reported on the subject in an extremely complimentary manner; and the information reached the international press. And finally, on March 16 the news spread wide with an interview that took up no less than three pages with four photographs in the newspaper *ABC*.[71]

The tone of the first paragraph already shows the political, even historical, importance that is being given to the subject: *"The Press, all the foreign Press, especially the English and North American, and the Latin American—which for Spaniards is like a continuation or a supplement to the national—is dedicating thoughts of honor and preferential spaces to Spain and to Spain's name. It is all about the 'Velázquez Exhibitions'. (...) On October 12, on the Fiesta de la Raza—the credit goes to America—the Exhibition will be inaugurated in Madrid as a festival of the people and royalty united, and then, immediately and continuously, it will go traveling around the world, around both worlds."* The interviewing journalist Federico Navas[72] later reiterates the same concept, comparing this project with the deeds of Cardinal Benlloch and with a possible tour of America by the King, which actually never came to be: *"The Velázquez Exhibitions will be Spain's greatest trip and the most beautiful reason for our desired spiritual reconquest of America. And after the trip of Cardinal Benlloch and the long-awaited one of Don Alfonso XIII, now this trip by you, or by Velázquez, will be the consecration of the intercontinental race in this new era of exaltation of Iberianism in America."*

In his answers, Moya enumerates the support received from cultural entities in Mexico, Argentina and Peru, as well as from national personalities and institutions that support the project; he particularly mentions the support of the US ambassador, Mr. Moore, *"who will manage before his government everything related*

[70] GHIRALDO, A. *The curious pilgrim.* In *La Esfera*, no. 516, November 24, 1923. Pg. 21.
[71] *Diario ABC* of March 16, 1924. Pgs . 11 – 13
[72] Federico Navas, born in Guadix in 1885, was another "Granada connection": In 1914 Moya had illustrated his book *La onza de oro* (The Ounce of Gold).

to the formalities and installation of the Exhibition in New York." He also announces that a program of cultural events is being developed to accompany the exhibition in each city, with conferences commissioned from Azorín, Ramón Pérez de Ayala and José María Salaverría, as well as the organization of Spanish music concerts by well-know composers Tomás Luis de Victoria, Manuel de Falla, Isaac Albéniz, Enrique Granados, Conrado Del Campo and Joaquín Turina.[73]

In the last part of the interview the journalist poses two difficult questions to the painter. The first is whether Moya could risk losing his

Fig. 4.2.1. Exhibition of the copies at the Salón de Otoño in Madrid

personality as a painter, going down in history only as a copyist or imitator. The creator of *Exhibiciones Velázquez* responds *"we'll see..."*—that right now he's only thinking about the paintings that remain to be copied, and that later *"perhaps Velázquez or his technique will not make me useless, or maybe yes, as a punishment for touching his divinity, just as Tut-Ank-Amon punishes his alleged defilers."* Demonstrating that he had thought about that possible loss of personality as an artist, Moya del Pino mentions that Rubens too copied the previous great masters, and says that he has already thought about *"picking myself up and composing my own work"* and about what he is going to paint when the Velázquez Exhibitions tour ends.[74]

The second question was a doubt that apparently circulated in Madrid by voice and also in writing: we hear of benefactors and even promoters of "this idea," but whose idea was it, really, to make the complete copy of Velázquez works and to take them abroad? The Duke of Alba? Perhaps the King himself? To this question José Moya del Pino, clearly upset, responds bluntly: *"Benefactors yes, but the idea is mine, absolutely mine. The promoter is me, I have already said so more than once. I came up with this idea when I saw an exhibition of charcoal photographic reproductions of Velázquez's paintings in London. Then I presented the idea to my colleague the sculptor Moré de la Torre and to the honorable Mr. Archibald E. Brown. And in Spain it was I who went directly to the Duke of Alba. Since then other personalities have intervened and intervene as benefactors of 'my idea'."*[75]

Demonstrating an enviable capacity for work, during these months Moya also wrote an essay in which he analyzed Velázquez's work as he perceived it within the framework of European painting of the previous centuries. The work, entitled *The Universality of Velázquez*, was published on August 19 in the newspaper *El Sol* and had a great impact due to the profound reflections it contained and the knowledge of classical painters it demonstrated.[76] This essay, with some new paragraphs added later by Moya, was also published in America in 1925 in the *Philadelphia Forum Magazine*.

[73] In other statements Moya affirms that taking part in these conferences will also be Unamuno, Valle Inclán, José María de Cossío and Francisco Rodríguez Marín. Neither these authors' appearances nor the concerts actually took place.

[74] One of his intentions apparently was to work on *Los Santos de Ávila* (his vision of Saint Teresa), and on *"The Knights of Santiago, with an old and new Galicia, of yesteryear and of today."* The theme of the Spanish mystics and the Galicia theme both go to show the enormous influence that his friend Valle Inclán was still exerting on the painter.

[75] *Diario ABC* of March 16, 1924, pgs. 11-13

[76] The article entitled *The universality of Velázquez* is also referenced in the *Critical and Anthological Bibliography of Velázquez* by Juan Antonio Gaya Nuño (Ed. Fundación Lázaro Galdiano, Madrid, 1963. Pg. 472), with a brief comment according to which Moya's work is *"an excellent and concentrated semblance of the artist [Velázquez]."*

In January and February of 1925, already feeling the urgency of the imminent trip, Moya del Pino copied *Philip IV on horseback*, reducing its width by 89 cm.; and finished another imposing painting, the *Equestrian portrait of the Count-Duke of Olivares*. In total he completed 41 paintings by Velázquez plus the portraits of the King and the Duke.

As requested by Alfonso XIII while he was having his portrait done, an exhibition of the collection was organized at the Palacio del Retiro as part of the Autumn Salon of Madrid (without the two paintings that Moya did in 1925) (Fig. 4.2.1). In attendance at the inauguration on Hispanic Day ("día de la raza"), October 12, 1924, was the King himself, as well as, according to a report by *The Impartial*, "... the Minister of Portugal and representatives of the Latin American nations; the patriarch of the Indies, the Marquis de la Torrecilla; the director of the Geographic Institute, Mr. Cubillo, acting as deputy secretary of Public Instruction; the general director of Fine Arts, Mr. Pérez Nieva; the Mayor Mr. Conde de Vallellano; artists, literati, etc. etc."[77] The chronicler ends with these words: "*The work of Mr. Moya del Pino was justly appreciated. It well deserves it, for the magnitude of the effort and for the quality of the results. Foreigners will receive, to a large extent, the closest sensation to that experienced before the canvases of the immortal Don Diego. (...) We hope that all of Madrid will parade through the premises where the 'Velázquez Exhibitions' are installed, a great event in the artistic life of the town and court.*"

Velázquez Copies Carried Out by José Moya del Pino in the Prado Museum

The data in this table are taken from the copyist registration books of the Prado Museum, except for the third column. The measurements in the column "Dimensions of Original Work" have been added to the table by taking them from the Official Catalog of Paintings of the Prado Museum published in 1996 by the Ministry of Education and Culture. In the first column we have added translations of the paintings' titles where they seemed needed.

Title of the Painting	Application Date	Start Date	Dimensions of Original Work	Dimensions of the Copy (cm)
1921				
Esopo (Aesop)	October 22	November 2	179x94 cm.	178x96
Menipo	November 9	November 9	?	
El Niño de Vallecas (The child of Vallecas)	November 12	November 12	107x83	49x39 (106x83) [1]
Felipe IV joven (Bust of Felipe IV young)	November 30		57x44	
D. Sebastián de Morra (The jester Don Sebastián de Morra)	November 30		106x81	
El Bobo de Coria (The jester Calabacillas of Coria)	December 2		106x83	
Felipe IV viejo (Bust of Felipe IV old)	December 24	December 24	64x54	
1922				
El primo, D. Luis de Acedo (The jester Don Luis de Acedo)	January 10	January 10	107x82	
Retrato de Montañés (Martinez Montañés)	January 10	January 13	109x88	
Mercurio y Argos	January 25	January 25	127x248	
Francisco Pacheco	January 31	January 31	40x36	40x35
Don Antonio el Inglés (Don Antonio the Englishman)	February 14	February 14	?	

[77] Journal *"El Imparcial"* of October 14, 1924, pg. 7. Editorial unsigned.

Los Borrachos (The drunkards)	?		165x225	
Las Hilanderas (The Spinners)	February 14		220x289	
El príncipe Baltasar ecuestre (Prince Baltasar on horseback)	March 1	March 1	209x173	
Bufón apodado D. Juan de Austria (The jester Don Juan of Austria)	March 18	March 18	210x123	
El príncipe Baltasar, cazador (Prince Baltasar hunting)	April 1	April 1	191x103	
Doña Mariana de Austria	April 1	April 19	231x131	
Felipe IV cazador (Philip IV hunting)	May 23	May 23	191x126	
Felipe IV cazador [2]	May 27		191x126	
Pablo de Valladolid	June 9	June 9	209x123	
Las Meninas (The Young Ladies at Court) [3]	June 9		318x276	
Don Fernando de Austria	November 29	November 29	191x107	190x105
El Infante Don Carlos (Prince Balthasar Carlos)	?		209x125	210x112
1923				
Felipe IV joven (Philip IV young)	February		201x102	190x110
Las Meninas	February 27	February 27	318x276	Same as original
Villa Medici [4]	June 2	June 2	48x42	Same as original
Juana de Pacheco	November 7	November 7	62x50	63x50
1924				
La rendición de Breda (Las Lanzas) (The Surrender of Breda, also called "The Spears")	January 9	January 9	307x367	Same as original
El dios Marte (The god Mars)	February 8		179x95	Same as original
Dª. Antonia of Ipeñarrieta	March 26	March 26	205x116	202x110
D. Diego del Corral	June 14		205x116	205x110
Coronación de la Virgen (Coronation of the Virgin)	July 8		176x124	Same as original
La adoración de los Magos (Adoration of the Three Kings)	August		203x125	
San Antonio y San Pablo	August		257x188	Same as original
Cristo en la Cruz (Christ on the cross)	September 3		248x169	
La fragua de Vulcano (Vulcan's forge)	October 27	October 27	223x290	Same as original
1925				
Conde Duque de Olivares (Count Duke of Olivares)	January		313x239	
Felipe IV equestre (Philip IV on horseback)	February 7	February 7	301x314	310x225

NOTES:
1. According to the book of copyists of the Prado Museum, Moya del Pino reduced the size by just over 50%. However, this copy is currently held by the heirs of the painter and has dimensions of 106x83.
2. It must be a double request or a repetition of the same painting.
3. In February 1923 this picture appears again. It could be a continuation of the copy started in June 1922 or a new copy after discarding the first.
4. There is only one entry but the painter did copy both of the views of Villa Medici by Velázquez, and they were both included in the *Exhibiciones Velázquez* show catalog.

4.3. The Farewell

Given the celebrity that Moya del Pino had achieved with all this, and given the caliber of the project and its sponsors, it was practically obligatory to organize a banquet in his honor, as was common at that time even for much smaller reasons. The date was set for October 31, and the place: not the dark "crypt" Café de Pombo of previous gatherings of artists, but the luxurious dining room of the Ritz Hotel. The invitation letter[78] is a true literary piece, so we include a translation in its entirety:

> "Very dear sir: To you, lover of Spanish art, we turn. To you, to whom surely the news will have arrived of a lofty and singular effort made by a young man, deserving of all encouragement, applause and endorsement. We refer, first, to the work that, under the name of 'Exhibiciones Velázquez,' currently occupies the halls of the Palacio del Retiro, and second, to the author of that work, José Moya del Pino, faithful and firm interpreter of one of the most remarkable and prolific treasures of our race.
>
> It is a question of doing justice to an initiative that is already underway and that honors us all: that of taking across the seas, to the fraternal lands of America, a transcript of the gigantic Velázquez creation: that creation that, by itself, in the art world, places us in the highest of the heights. José Moya del Pino is the happy and hard-working author of the first and only copy of Velázquez's total work, of the forty-two paintings, of the forty-two pictorial jewels that, due to Velázquez's magic brush, fill one of the halls of the Prado Museum in Madrid; and those forty-two copies are what constitute the treasure, the artistic envoy that prepares to bring to our American brothers one of the most finished and glorious manifestations of the Spanish genius.
>
> To demonstrate to the noble artist, who thus honors his race, our recognition for the enormous and transcendent effort of the work that has just come out of his hands, a group of friends has decided to offer him a farewell banquet—since he will be the head of this artistic expedition about to sail for America—to which we invite you, and which will take place on October 31, 1924 at the Ritz Hotel in this capital, at nine o'clock at night."

Leading the signers of that invitation is the Cordoban Julio Romero de Torres, good friend of the honoree. And following are 51 other names that represented the cream of Spanish culture of the time. Among the writers are Ramón Pérez de Ayala, Gregorio Marañón, Serafín and Joaquín Álvarez Quintero and Manuel Machado. Among the painters and sculptors, Luis Bagaría, Rafael de Penagos, Salvador Bartolozzi, Francisco Sancha, Manuel Benedito, José López Mezquita, Mariano Benlliure, José Gutiérrez Solana, Victorio Macho, Moré de la Torre and José Pinazo. Among politicians or professionals from other sectors, Alberto Ghiraldo, Juan de Echevarría, Cipriano Rivas Cherif, Luis Araquistain, Indalecio Prieto, José Francés, Luis Bello, Ángel Vegué y Goldoni, Melchor Fernández Almagro, Antonio Palacios, Mariano Benlliure, Francisco de Icaza, José Francos Rodríguez, Enrique de Mesa, Adolfo Salazar and several others. All of these were well-known names in Madrid at the time.

The tickets to attend the event could be picked up, at the price of 25 pesetas, in places as distinguished as the Circle of Fine Arts and the Athenaeum of Madrid.

The day after the event, *El Imparcial* published a chronicle of the dinner, according to which the following speeches were delivered beginning during the dessert course. The ambassador of the United States Alexander Moore, to whom we have alluded earlier, *"described with flattering phrases the Spanish influence on the culture of North America, also expressing his confidence that the expedition entrusted to Moya del Pino would be another link in the Spanish-American fellowship"*. The Argentine writer Alberto Ghiraldo, the General Director of Fine Arts, Mr. Pérez Nieva and the former Minister of Public Instruction, Joaquín

[78] José Moya del Pino Papers, Archives of American Art, Smithsonian Institution, Washington D.C. Roll 103-3830.

Salvatella, spoke afterwards. Moya del Pino then took the floor to thank the attendees for the tribute and, according to the report in *El Imparcial*, modestly shied away from praise for his person, directing all the applause to the organizations and personalities that stimulated this initiative.

Presumably, almost all the signers of the invitation and many other people attended the banquet. In the documentation that Moya del Pino's descendants delivered to the Smithsonian Institution of Washington, there are also letters and telegrams sent by those who could not attend: excusing their attendance for different reasons were, among others, the writers Alberto Insúa and Eduardo Zamacois, the illustrators Sancha and K-Hito, the Count of Cimera, the sculptor Mariano Benlliure, the theater director Gómez Hidalgo and the American Consular Corps.

After so much praise and applause, the bitter pill was given to Moya del Pino only three days later by the Royal Academy of Fine Arts of San Fernando. The minutes of the session held on November 3 state that Mr. Santamaría, representing the painting department, asks if the matter of *"the copies of Velázquez existing in the Museo del Prado, currently exposed to the public"* could be addressed; the censor answers yes, as long as the matter *"is of an official nature"*. Given that the matter is backed by a Royal Order and that the president of the company is the Duke of Alba who is President of the Board of Trustees of the Prado Museum and is also an academic, it is concluded that indeed, the matter has an official nature and should be addressed in academia. Then the banquet that has been organized in honor of Mr. Moya del Pino is brought up, and *"it is made known that at the foot of the invitation are the signatures of three numerary academics (...) who declare not to have signed it"*.[79]

The academic Don Elías Tormo Monzó[80] then takes the floor and says that *"the copies do not have the value that could be desired [...] well understanding that it is not an easy task to actually make faithful copies of Velázquez,"* adding that *"they can only be considered as a means of propagating in America what is the Velázquez collection that the Prado Museum owns."* After comments by other attendees, the President summarizes the debate and proposes that the Academy declare itself *"totally unaffiliated with the organization of the exhibition of copies of Velázquez's paintings..."*, and that this be communicated to the newspapers for dissemination. To which Moya del Pino, author of the copies and director of *Exhibiciones Velázquez*, who had been very clear from the beginning that his goal was none other than *"... propagating in America ...,"* responds by stating that *"at no time had [he] requested the official support of the Royal Academy of San Fernando,"* but that he was *"sincerely grateful to those who had helped him and supported him in his artistic intent"*.[81]

From the date of the tribute banquet, it still took the expedition three and a half months to leave for America. Among other things it couldn't have been easy to obtain the right conditions for the transport of the collection (43 paintings, most of them of enormous size) to a port of embarkation. But the obstacles were surpassed, and the preparations for the trip to New York continued. Moya del Pino and his immediate collaborators at this point still had the illusion that the Hispanic countries would respond to the call and that, therefore, the tour would be long and fruitful.

A letter on *Exhibiciones Velázquez* letterhead, dated February 5, 1925 and signed by José Moya del Pino as Director and by Francisco Moré de la Torre as secretary, communicated to the Ministry of State the planned itinerary: *"After starting the tour of the exhibition in Cuba and the United States of America, Mexico will follow, and the Central Republics and Pacific Republics, completing the mission in Buenos Aires, Montevideo and Rio de Janeiro."* The signatories indicated they would accept the offer of the governments of Ecuador and other countries that have shown interest in the project and that *"the expedition will leave Cadiz*

[79] Judging from one of the letters preserved in the Smithsonian Institution archives, the sculptor Mariano Bennliure was unaware of the banquet until he received the invitation, so he is unlikely to have been one of the signatories; another of the "academics" referred to here was probably the painter Ignacio Pinazo, but there is no mention of specific names.

[80] Elías Tormo Monzó (1869-1957) was elected Academician in 1913. He became Minister of Public Instruction and Fine Arts during the "dictablanda" of General Dámaso Berenguer and was a solicitor in Cortes during the dictatorship of General Franco.

[81] Archive of the Royal Academy of San Fernando in Madrid. Book 11/3, pgs. 400-403.

on the 18th and in due time and in accordance with the process of the exhibitions, we will be communicating the date of arrival in the respective countries to the Ministry and to our diplomatic representatives in America." [82]

Accordingly, the Minister of State granted José Moya del Pino, on February 11, 1925, a passport *"for the States of North, Central and South America,"* valid for one year, asking the authorities of the countries through which he passed to facilitate the success of the expedition. A few days later, the Transatlantic Company issued round-trip tickets in first class from Cádiz to New York, valid for twelve months, on the steamer *Reina María Cristina;* the tickets were paid for by the Ministry of Public Instruction and Fine Arts. (Fig. 4.3.1)

However, the efforts to continue the tour to Buenos Aires or Cuba and then take it to other Hispanic countries were failing, due to lack of response and in some cases direct refusal. In fact, the countries that responded did so when the expedition was already in the United States.

The ambassador of Spain in Brazil replied on May 13, 1925 saying that *"The idea is magnificent ... the difficulty lies in the economic part"* since in that country there was a severe economic crisis. On May 16, Ecuador regretted that, although a few months before it had been willing to bear all the expenses, now it had no funds to do so. On the 29th of the same month it was Colombia that turned down the tour, affirming that *"at this time it is impossible to provide a subsidy"* to the project. Twelve days later, the embassy of Spain in Cuba communicated that all the Spanish entities in Cuba express their support, but none can offer either funds or premises to accept the expedition. Along the same lines, on June 12 the Embassy of Spain in Montevideo, Uruguay, sent a letter with moral support but lack of effective backing.[83]

The final answer from Argentina did not come until August 17, 1925, when the exhibition had already been in the United States for a couple of months; the letter, signed by the Ambassador of Spain in Buenos Aires and addressed to Moya del Pino, says that *"... with all my interest I have worked with different entities to achieve our wishes, but have not obtained the favorable result to which we aspired. Indeed, it is not possible for the Argentine Government to provide material support or subsidize a company of this nature, since the exception this would make would constitute a precedent that they wish to avoid. At the same time, there is no individual entity here willing to provide economic facilities, as the current circumstances are far from allowing."*

Still unaware of these rejections, however, on the 18th of February 1925, the Reina María Cristina left the port of Cádiz on its way to New York—loaded with the first, and only, copy of the "treasure of Spain."

Fig. 4.3.1. First class round-trip ticket to New York on the steamer Reína Maria Cristina

82 General Administration Archives, file PE of 1925, Cultural Assets section.

83 REYERO, Carlos. *Los "Velázquez" del Prado en América. Crónica de una exposición de copias en 1925* (The Prado's "Velázquez" in America. Chronicle of an exhibition of copies in 1925). Bulletin of the Prado Museum. Vol. 26, nº 44 of 2008. Pgs . 73-86. Many of the consular letters referenced are digitized in the Archives of American Art, Smithsonian Institution.

CHAPTER 5

With Velázquez, in America

New York was already the capital of the "new world." For over a century it had been the biggest point of attraction for immigrants on the planet, and at the beginning of the twentieth century it was becoming the globe's largest center of industry, commerce and communications. In 1925 it was crowned as the most populated city in the world. It is at this port that Moya arrived on March 8 of that same year.

5.1. Philadelphia, Washington, New York

The team responsible for the Velázquez expedition, Moya del Pino and his assistants Francisco Moré de la Torre and Antonio González de la Peña, stayed in one of the most luxurious hotels of New York, the Pennsylvania Hotel at 401 7th Avenue in Manhattan, which gives an idea of the level to which the expedition aspired.[84] The arrival of the Spanish cultural expedition was noted by the media of the city, and Moya del Pino, as director of *Exhibiciones Velázquez*, was the center of attention. In an interview that appeared in the *New York Times* on March 10 he explained that the exhibition would be headlined by a portrait of Alfonso XIII, of whom he spoke very highly as sponsor of the expedition: *"The King is most desirous that the American people should see him in simple attire, and not in military dress or in royal pompousness. (...) He posed for me for one hour at each sitting, in the tapestry room at the palace, sitting on an onyx-top table in true democratic fashion, and usually smoking a cigarette. He is the soul of simplicity, very democratic and the nicest man in our country."*

The interview also includes a paragraph unrelated to the Spanish cultural expedition, surprising for its focus on a particular part of the face: *"(Moya del Pino) ... was in raptures yesterday over the beauty of the New York women he had seen on Fifth Avenue: 'I never saw so much luxury in dress,' he said. 'their wonderful clothes and wraps, together with their beauty, actually bewilder me. I never saw anything to surpass it in Europe. So far I have divided them into two classes—women with curved noses and women with retroussé noses. It is quite fascinating.'"*[85]

Alexander Moore, the United States Ambassador to Madrid who had helped organize the US tour of the exhibition, arrived in New York on March 11. Moya had painted a fan that he entrusted to the ambassador to send to the White House as a gift for the wife of the US President at that time, Calvin Coolidge. They had also produced several copies of a commemorative medal for the event, with a representation of King Alfonso XIII, designed by Moré de la Torre, to deliver to the most outstanding sponsors (Fig. 5.1.1).

[84] The Pennsylvania Hotel opened its doors on January 25, 1919. Designed by the architect William Symmes, at the time that Moya del Pino stayed there it was considered the "non plus ultra" of luxury and modernity; it is located right in front of the world famous Madison Square Garden. Over the past 100 years it has changed ownership several times and even its name ("Statler Hilton," "New York Penta"), until adopting its original name again in 1992. It has been repeatedly threatened with demolition (1997, 2007), but until now the citizen movements created to save it have prevailed. Today is still open and you can stay there for a price commensurate with its history and its old age.

[85] *New York Times*, March 10, 1925, p.8. Also quoted in HAILEY, G. *California Art Research, Vol. XIII*. Works Progress Administration, San Francisco, 1937.

Fig. 5.1.1. Commemorative medal for Exhibiciones Velázquez, designed by Francisco Moré de la Torre

The first stop for the exhibition was Philadelphia. The exhibition, consisting of the 41 copies of Velásquez "reigned over" by the portraits of Alfonso XIII and the Duke of Alba, was inaugurated at the Philadelphia Art Alliance on March 26 and ran through April 12; it was backed and organized by the Philadelphia Forum, a prestigious institution in the city. The Philadelphia Forum published an article entitled *José Moya del Pino*; the article's author provided reasons to attend the exhibition and placed Spain's famous copyist among the best painters in Europe: *"The purpose of the exhibition is to bind closer the ties between Spain and the United States by making us better acquainted with the glorious masterpieces of Spain's greatest painter. It was impossible, of course, to remove the Prado Museum to America, and quite as impossible to bring the Velásquez originals. The alternative was to make exact and perfect reproductions, and this is what Moya del Pino, working steadily for four years, has done. In spite of his youth he is one of the foremost painters in Europe, and the greatest living authority on Velásquez. The reproductions are so very like the originals that only a Velásquez expert can tell the difference. (...) Next to a visit to Madrid, a visit to Moya del Pino's reproductions is the best method of studying Velásquez."*

At the same time an article by F. Arline de Haas[86] states: *"To Philadelphia this week came an unprecedented event. (...) The group is called the 'Spanish Artistic Mission for the Exhibition of Velásquez Paintings' (...) To see each painting of a master so well represented is indeed remarkable. Moya del Pino has not only faithfully transcribed the color, line, light and mass, but he has caught the essence of the spirit of the Spanish painter whose work was and is a constant source of developments that have created epochs in art. Copies of paintings are indeed difficult—and usually as dry as the work of a painter who copies his teacher without the spirit that comes through creation. Of this Moya del Pino says: 'I have studied the art of Velásquez, but to copy any painter is like making a translation. There is never exactly the same spirit in a copy as in the original. But some pictures, some painters, we have more sympathy for, and those are the painters we can best copy.' (...) Besides the Velásquez in the exhibition are two splendid portraits by Moya del Pino—one of the King of Spain, the other of the Duke of Alba. This painter, too, follows the Velásquez tradition and in his own work catches the solidity, the luminosity of color and light and design."*

A similar pattern was repeated in the Brooklyn Museum in New York, where the show opened on May 17 and remained open to the public until June 15 (Fig. 5.1.2).[87] On this occasion Moya also donated a painting titled *Avila, Castile* to the Brooklyn Institute of Painting; and, as planned, at least one explanatory lecture entitled *El Prado, Spain's Treasure Chest* was held by the writer José María Salaverría.

We haven't found the exhibition dates in Washington, a city where, as Moya later recalled in his interview for the Archives of American Art, the exhibition was held at the Corcoran Gallery.

It must be said that the *Exhibiciones Velázquez* team had prepared the tour conscientiously; in addition to José María Salaverría's lecture, a detailed guide about the work of Velázquez was published in English and in Spanish and distributed to the visitors (Fig. 5.1.3 A & B); and a text written by Moya entitled *The universality of Velásquez* was published in the *Philadelphia Forum Magazine* in April 1925. This text

[86] Article found among the José Moya del Pino papers kept by the painter's heirs; masthead missing.

[87] The Brooklyn Museum's press release indicates that the Spanish Ambassador, Juan Riano, would be attending the opening reception; however in a letter in the Moya del Pino papers the ambassador regrets that he has to decline, May 17 being King Alfonso's birthday and his presence being therefore required at other celebrations. Interestingly, the newspaper on the opposite page shows a picture of the inauguration that includes the Spanish Ambassador standing in front of the painter.

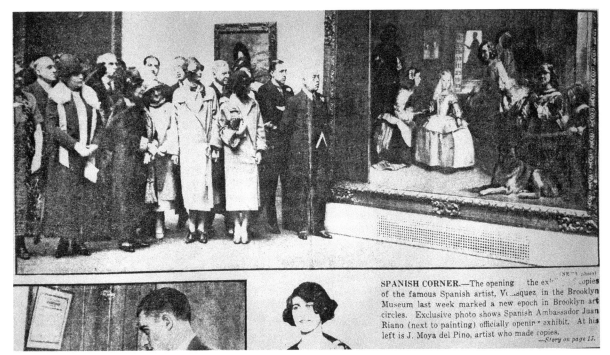

SPANISH CORNER.—The opening the ex··· ··· ·opies of the famous Spanish artist, V··· quez in the Brooklyn Museum last week marked a new epoch in Brooklyn art circles. Exclusive photo shows Spanish Ambassador Juan Riano (next to painting) officially openi·· exhibit. At his left is J. Moya del Pino, artist who made copies.
—*Story on page 15.*

Fig. 5.1.2. Photograph accompanying article about exhibition in New York. Masthead missing.

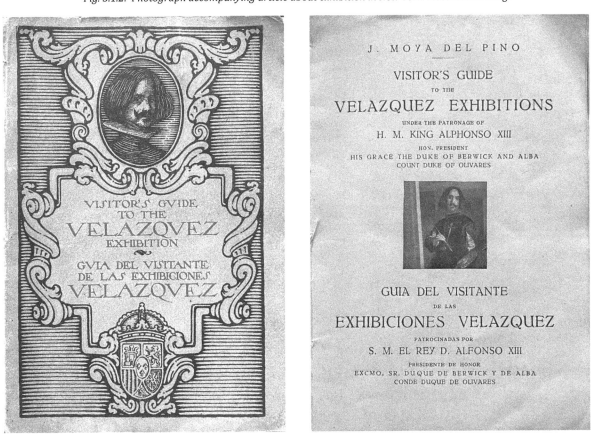

Fig. 5.1.3 A & B. Cover and first page of the guide to the exhibition

had already appeared in Spain in the newspaper *El Sol* on August 19, 1924; it is a true in-depth treatise on Velásquez's work, a valuable study that shows that Moya del Pino was not only a good painter, but also a great theorist of art history. The article was translated into English and the author wrote some additional paragraphs for the United States edition.

Despite this excellent preparation and the great success of the first steps of the tour, an unforeseen issue hindered its progress from the beginning: in the United States, at that time, museums were free and therefore *Exhibiciones Velázquez* wasn't able to charge admission; the organizers had been unaware of this and had expected that a good part of the cost of the tour could be financed with the collection of tickets, which they had hoped would be substantial.

Without this expected income, the troubles soon began.

5.2. Arrival in San Francisco and End of the Tour

The close of the exhibition in Washington created a period of uncertainty. The logical thing at that time would have been to package up the collection and set course by ship again for the countries of Latin America but, as we've seen, no country had given guarantees that the exhibition could be mounted and displayed appropriately. Instead, an opportunity arose to bring the artwork to San Francisco, California, where the "California Diamond Jubilee" was to be held in commemoration of the 75th anniversary of the proclamation of the State of California, which had occurred in 1850. Moya del Pino, having been assured that a museum in San Francisco would pay for the collection's transport, didn't hesitate to risk such a long journey, which required carefully crating the many large paintings for the long train trip across the United States. In support for this new stage of the tour, the Spanish ambassador to Washington sent a letter to the director of *Exhibiciones Velázquez*, signed on June 10, in which the he congratulated Moya del Pino on the successes achieved and wished him *"to continue the same triumphal step for the West and for California;"* included with it was a letter of recommendation addressed to Mr. Juan C. Cebrián, who was the president of the National Honorary Hispanic Society of San Francisco and maintained strong ties with the University of California at Berkeley.

And so, in late July 1925, the exhibition opened in the newly inaugurated west wing of the M.H. De Young Memorial Museum in Golden Gate Park, becoming one of the first shows ever installed there (Fig. 5.2.1). And although this time it wasn't possible to hold lectures or other complementary

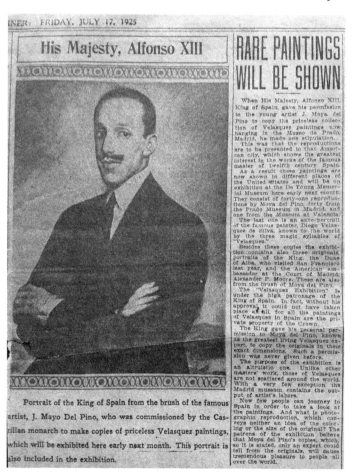

Fig. 5.2.1. Article in San Francisco Examiner, July 17, 1925

activities, the exhibition was a success if we consider the information provided by the *San Francisco Chronicle* that counted the number of viewers over the first 6 weeks of the show at over half a million.[88] For its part, *The Monitor* commented that it was *"one of the finest art exhibitions ever shown in San Francisco"* and that its author is *"one of the most noted European artists of the present day."* In a separate article in the same newspaper, the Archbishop of San Francisco, Edward J. Hanna, urged *"all Catholics to view these replicas of the great Spanish masterpieces."*[89]

But with this trip to the West, a series of negative events began, which would cause the final failure of the expedition and a dramatic period for Moya del Pino that would initiate the second part of his life. The first event was the disappearance during the trip of one of the members of the team, the treasurer that carried the money on which the entire group had to subsist; it was therefore an authentic robbery that neither Moya del Pino nor the American police knew how to solve.

And the problems did not stop there.

No new money was coming in with the expected sale of museum tickets, since museum admission was free. Spain was having its own financial troubles and facing increasing civil unrest, and nobody responded to the appeals for help. The Spanish Embassy in San Francisco had no authorization to extend any financing. To make matters worse Alexander Moore, the United States ambassador to Madrid who had previously been such a great supporter of the exhibition, was no longer in any position to help, having been reassigned to the US embassy in Lima, Peru.

Moya del Pino never spoke clearly about what happened in these months. He never said anything publicly about the disappearance of the treasurer; and about the situation at the end of the exhibition, he only said in the oral history interview for the Archives of American Art: *"After the exhibition, there was a problem of what to do with the paintings. I couldn't put them in a warehouse because storage would have cost a fortune."* Moya didn't even have the resources to pay for his stay and sustenance in a humble hotel. Antonio González de la Peña, who had helped finance the expedition and traveled with it to San Francisco, returned to New York, though he and the artist remained very good friends for years to come; so it was probably Francisco Moré de la Torre who helped Moya stay afloat for a few months after the end of the exhibition, since he was a person with enough economic resources of his own. Moré de la Torre also went to Los Ángeles to explore the continuation of the tour, according to a newspaper from that city, but that event never happened so he must not have received the necessary support.

Everything indicated that there was no possibility of continuing. Moya had, of course, a return ticket to Spain—but he would have needed to find a way to get back to New York to board a ship, and there was still the problem of how to either store or transport the paintings.

It must have been Juan Cebrián that resolved the situation. He had ties with the University of California at Berkeley, so it was probably his idea to raise funds from donors and members of the local Hispanic community to acquire the collection and donate it to the University. A committee was organized to ensure the future of the collection.[90] Edward J. Hanna, the Archbishop of San Francisco who had so appreciated the exhibition to exhort all readers of the newspaper *The Monitor* to view it, was Honorary President; John Drum, President of the Trust Company, was treasurer; the secretary was Clay M. Greene and members were Juan C. Cebrian himself, the President of the California Women's Club, Mrs. John S. Phillips, and other artists or art connoisseurs such as J.B. Havre, E.J. Molera, Herminia Peralta, Haig Patigian, C.A. Vogelsang and the Consul General of Spain in San Francisco, José Gimeno.

[88] *San Francisco Chronicle*, September 14, 1925.
[89] *The Monitor*, August 1, 1925.
[90] The committee printed letterhead and called itself "Committee sponsoring the subscription for the purchase of the forty-one canvases for presentation to the University of California."

As director of Exhibiciones Velázquez, Moya del Pino addressed a letter to the Regents of the University, proposing that *"the collection remain in the University of California, being the proper place, and that rather than allow the paintings to be sold at a sacrifice your Honorable Board make through the co-operation of friends and admirers of the University an offer that will in some measure reimburse the owners of the collection for the expenses incurred as aforesaid, and make the paintings the permanent property of the University of California."*[91]

We don't know the exact date in which the delivery was made, but it is likely to have been in January or early February 1926: the Velázquez paintings seem to have still been on display at the De Young Museum in December 1925, according to the *Oakland Tribune* (which also reported that at the end of the exhibit they would be donated to the university and would be temporarily installed in the library until the completion of the University's planned art museum) (Fig. 5.2.2),[92] and they already appear in the March 1926 registry of donations made to the University of Berkeley. At that time the value of the paintings was estimated at $500,000.[93]

A reception and private viewing of the collection was held for *"a group of art lovers, artists and university officials"* on February 27, 1926; among those attending were the president of the university, W.W. Campbell, and the chairman of its art department, Eugen Neuhaus. In their statements to the press after the visit, everyone praised the historical figure of Velázquez and the quality of the copies made by Moya del Pino that had been *"presented to the university by a committee of prominent citizens of the bay region."* The article continues: *" 'The most valuable possessions of any country are the creation of its artists,' Dr. Campbell told the assemblage. (...) 'We appreciate the generosity of Señor del Pino, director of the exhibition committee, and Señor De La Torre, sub director, in deciding to leave this cherished collection in the possession of the University of California."*[94]

Unfortunately the donation to the University may have been premature—the expected funds were never raised, and *Exhibiciones Velázquez* never received payment for the paintings.

5.3. Velázquez at U.C. Berkeley

The subsequent story of the only complete copy of Velázquez's work is long and eventful as it continues to this day. We will tell in this chapter what happened while the collection remained at the University of California at Berkeley, leaving for the last chapter of this book the situation of these paintings today.

According to a detailed study by Fran Cappelletti,[95] the paintings were hung on the walls of the East Reading Room of the university's Doe Library, a location confirmed by two valuable photographs: in the first oe we can see the complete room with all its furniture, with the painting of *Christ on the Cross* standing out towards the center of the wall on the right; the other paintings are more difficult to make out. In the second photograph, on the wall at the back of the room are the two large paintings *The surrender of Breda* and *Vulcan's Forge*.[96] (Fig. 5.3.1 and 5.3.2)

But a few years later there were further problems. In 1932 it was made public that the paintings had been inscribed as collateral for a mortgage, for which one Edmond T. Osborne had obtained a judicial ruling ordering the auction of the paintings to pay the debt, which was little more than a thousand dollars. A newspaper headlined the news *"41 paintings on public sale"*.[97] After the ensuing scandal and possibly the

[91] A copy of this letter is among the papers kept by the descendants of Moya del Pino.
[92] *Oakland Tribune*, December 28, 1925.
[93] *San Francisco Examiner*, March 24, 1926.
[94] *Oakland Tribune*, March 1, 1926.
[95] CAPPELLETTI, F. *Rediscovering Moya's Velázquez*. Available at *http://www.moya-rhs.org/uploads/2/9/5/3/2953392/ rediscovering_moya_velazquez_paintings.pdf*
[96] Photographs courtesy of the Bancroft Library, University of California, Berkeley. University Archives, UARC PlC 09:31(c).
[97] Oakland Tribune, November 6, 1932, 57.

U. C. GETS COPIES OF VELASQUEZ BY MODERN ARTIST

Collection Authorized by King Alfonso Will Be Housed in Library.

The collection of reproductions of the paintings of Velasquez now on exhibit in the De Young Memorial Museum in Golden Gate Park, San Francisco, has been presented to the University of California and will be housed temporarily in the University Library on the Berkeley campus until such time as the contemplated art museum of the university is built.

This announcement has been made by the committee of public-spirited citizens in charge of the collection, headed by Archbishop Edward J. Hanna, following the acceptance of the gift last Wednesday by the board of regents of the university.

The gift is considered one of vast interest to art lovers, as the collection is the only one of its kind, consisting of copies of the great Spanish artist's works hanging in the Del Prado Museum in Madrid.

The reproduction are the work of Moya del Pino, noted Spanish painter of today, who labored constantly upon the collection for more than six years.

"It can be stated that this fine achievement of Moya del Pino," one noted art critic has said, "will definitely set the Velasquez creations in a manner second only to the originals themselves."

The reproductions were made with the consent and co-operation of the governors and patrons of the Del Prado Museum and at the instance and with the financial support of the Spanish government. King Alfonso XIII felt that the Del Prado collection, being the only concrete exhibition of Velasquez in the world, never to be studied except after making the long journey to Madrid, decided to cause it to be reproduced by Moya del Pino, with More de la Torre as financial secretary, to be sent to America with the distinct understanding that a similar collection never can be made again.

DONORS ARE MANY.

Along with the announcement of the gift, the committee reports that the drive for subscriptions is showing marked progress, especially among citizens of Spanish blood. Juan Cebrian, who is a member of the committee, heads the list with a generous subscription.

The Velasquez donation committee has offices at 519 California street, San Francisco, where subscriptions are received for deposit with the Mercantile Trust company, treasurer for the committee and custodian of all its funds.

The personnel of the committee is as follows:

Archbishop Edward J. Hanna, honorary chairman; John Drum, president; Clay M. Greene, secretary; Juan Cebrian, Mrs. Herminia Peralta Dargie, J. B. Havre, Mrs. John S. Phillips, Haig Patigian, E. I. Molera and Jose Gimeno, Spanish consul in San Francisco.

Rancher, Thrown By

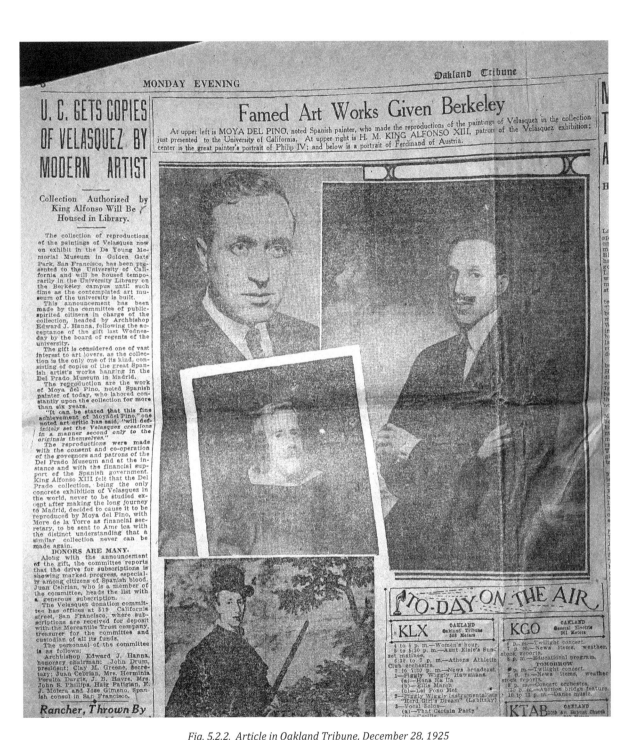

Famed Art Works Given Berkeley

At upper left is MOYA DEL PINO, noted Spanish painter, who made the reproductions of the paintings of Velasquez in the collection just presented to the University of California. At upper right is H. M. KING ALFONSO XIII, patron of the Velasquez exhibition; center is the great painter's portrait of Philip IV; and below is a portrait of Ferdinand of Austria.

TO-DAY ON THE AIR

KLX OAKLAND Oakland Tribune 508 Meters

4 to 5 p. m.—Women's hour.
5 to 5:30 p. m.—Aunt Elsie's Sunset matinee.
6:30 to 7 p. m.—Athens Athletic Club orchestra.
7 to 7:30 p. m.—News broadcast.
1—Piggly Wiggly Hawaiians.
 (a)—Hona Ka Ua
 (b)—Ellis March
 (c)—Lei Pono Moi
2—Piggly Wiggly Instrumentalists "Hard Girl's Dream" (Labitzky)
3—Vocal Solos—
 (a)—"That Certain Party"

KGO OAKLAND General Electric 361 Meters

6 p. m.—Twilight concert.
7 p. m.—News items, weather, stock reports.
8 p. m.—Educational program.
TOMORROW
6 p. m.—Twilight concert.
7 p. m.—News items, weather stock reports.
8 p. m.—Concert orchestra.
9:30 p. m.—Auction bridge feature.
10 to 11 p. m.—Dance music.

KTAB OAKLAND 10th Av. Baptist Church

Fig. 5.2.2. Article in Oakland Tribune, December 28, 1925

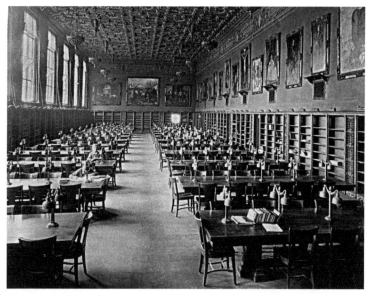

Fig. 5.3.1. Doe library at U.C. Berkeley with the paintings on the upper walls

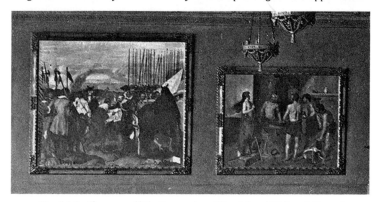

*Fig. 5.3.2. Close-up of 'The Surrender of Breda' and 'Vulcan's Forge'
on the back wall of the library*

intervention of the committee chaired by the Archbishop, the auction did not take place and the collection remained installed in the library.

On a few other occasions San Francisco area newspapers published articles about the work done by Moya del Pino. When the Civil War broke out in Spain, the *Daily Californian* asserted that *"the copies were part of a plan to preserve them in the United States in case the Spanish originals were destroyed."*[98]

Then in 1959, more than 20 years after the installation of the paintings at UC Berkeley, following numerous complaints about the inadequacy of the rather outdated lighting in the library, the University decided to undertake a profound renovation. A drop ceiling was installed at a lower height than the original one, so that the paintings no longer fit on the upper walls; the only available alternative was to deliver them to the University Museum, which for lack of exhibit space locked the collection in a warehouse.

When the drop ceiling was removed again in 1969 and the original coffered ceiling uncovered, it was agreed that the paintings could be re-installed. In preparation, they were moved to the former Rare Book room (west side, Floor 1) for surface cleaning and minor repairs; however subsequently the library administration decided against the re-installation because they were not originals.[99]

The saga continued after the death of José Moya del Pino, as we shall see later, when his heirs requested to have the paintings returned to them, seeing as they were not being displayed to the public.

5.4. In Spain, in the Meantime ...

There is no information on any formal communications by the company *Exhibiciones Velázquez* with Spain after it left for the United States. Considering Moya del Pino's close ties with the Spanish embassies in Washington and in New York, it seems fair to assume that efforts must have been made to keep the tour going, especially after the treasurer's flight; but it appears that nobody responded to these requests, and there is no sign of the Spanish government or its emissaries intervening. Such important people as King

[98] CAPPELLETTI, F. Op. Cit., Pg. 3.
[99] *Velasquez Paintings at Berkeley*, personal notes by Larry Dinnean, former librarian.

Alfonso XIII and the Duke of Alba were involved in the creation of this cultural mission; why would they abandon the project?

We must remember that the expedition had obtained the patronage of the king, but not the express support of prime minister Miguel Primo de Rivera, who had been effectively running the country as a military dictatorship since 1923 (when the Velásquez project was already under way). And the general had other things to worry about at this point. The country was still in the middle of the Moroccan (Rif) war, the economic growth that the country had experienced in the first couple of years of his reforms was beginning to slow down, and his regime was under criticism. The king, who had initially sided with him, was losing favor; and social revolution fermented in Catalonia. The fate of the copies of Velásquez in America had to be low on the list of priorities.

Facing bankruptcy and massive unpopularity, in part because of the war in Morocco but also as a result of the Great Depression, Primo de Rivera was forced to resign in 1930. The urban population, disgusted with the king's involvement in the general's dictatorship, voted for republican and socialist parties in the election of 1931. Street riots ensued, calling for the removal of the monarchy, and the Spanish Army declared that they would not defend the king. The Second Spanish Republic was proclaimed on 14 April 1931, and the king fled the country; he remained in exile until his death in 1941.

Regarding this moment in history we have an interest document that reflects how the arrival of the new regime was seen by the Spaniards who were outside Spain. In New York, before his departure for San Francisco, Moya del Pino had struck a friendship with Antonio Martín, a high official of the Spanish embassy in the United States. They had remained in regular contact; and a letter from Antonio Martín, dated April 20, 1931—only six days after the proclamation of the Republic—in reply to one he had received from Moya del Pino, has some surprising comments. We reproduce it in its entirety below (translated from the original Spanish) and comment on it.[100]

> *67 East 53 Street*
> *New York City, April 20*
>
> *Dear Pepe:*
> *I just received your last letter from the 15th, at the same time that I had written one to you because Camba[101] told me that you had gone to Spain, according to what García Sánchez had told him.*
> *I too believe (as you say) that Moré did indeed put the evil eye on Don Alfonso ... as well as on Don José and Don Antonio and the Divine Word. What is funny is that in Italy they believe that Don Alfonso has "jettatura,"[102] because whenever he's been there, there have been storms, earthquakes, etc... I didn't know this, Papini[103] told me in Florence.*
> *It is funny that you say "viva la republica" from abroad ... Next May 2, I go to Spain to see the 22 million republics that are coming to us 22 million Spaniards—one per skull—because each one feels and thinks differently than their neighbor. I think it was a real carnival in Madrid, the chusmocracia[104] got fed up with fighting ... just to return to the bakery the day after like all the others. I believe that it has been a trick of Romanones, who seeing the King's cause as lost, made a*

[100] The original letter is kept in the files of the Smithsonian Institution. Roll 3830-28.

[101] Julio Camba, a well-known journalist and writer of his time, was the New York correspondent for Spain's *ABC* newspaper.

[102] An Italian word meaning jinx, something or somebody who brings bad luck to others.

[103] Giovanni Papini (Florence, 1881-1956) was a philosopher and author of numerous books of great impact in his time, such as *Il tragico quotidiano* ("Everyday Tragic"), *Gog* and *Un Uomo Finito* ("A failed man").

[104] Government by "chusma" meaning rabble, riff-raff, mob. Mobocracy.

deal under pressure with your countryman from Priego, Alcalá Zamora, for the establishment of a Republic, copying the French.

You might know that Salvador de Madariaga has been named ambassador in Washington, how strange he must feel within a few days of this wreck, I am happy because he is very worthy and is nice. Pérez de Ayala goes to London, and Álvarez del Bayo to Berlin.

I am very sorry to leave here without seeing you, but I don't lose the hope that one day you will de-mollusk[105] yourself and come to Europe.

My wife is already thinking next year about going to San Francisco and Seattle through the Panama Canal and she asks me to say hello to your wife. I don't remember who in Philadelphia was Don Pedro the Cruel, Damock 1838?

Viva Priego! And a hug from
Antonio

The letter shows that within Spain's diplomatic service in the United States the fall of the monarchy was received with relative normalcy, and that just a few days after the proclamation of the Republic ambassadors were already being appointed to different countries (Madariaga and Ramón Pérez de Ayala were indeed ambassadors in Washington and London, while Julio Ávarez del Vayo was sent not to Berlin but to Mexico). Antonio Martín and José Moya talk about journalists or artists they know: Julio Camba, Moré de la Torre. They attribute to the latter the "evil eye" that fell upon, among others, King Alfonso XIII who was considered "jinxed" in Italy.

The resignation of the King after a pact ("a trick", says Martín) between Romanones and Alcalá-Zamora is in the history books of course, but it is surprising that so much was known so early, or at least intuited, by the officials of the embassies that were so far from Spain.

The appearance in the letter, twice, of the name of Priego is also striking. When talking about Alcalá-Zamora, the sender identifies him as "your countryman from Priego," and not satisfied with this reference to Moya's hometown, reaffirms it in the farewell with a surprising "Long live Priego!" All this indicates that Moya del Pino, who by this point had been away from his homeland for 6 years and even longer from his hometown, continued to feel his origins deeply, and must have mentioned Priego to his friends as "his town."

In the last paragraph, the author of the letter alludes to his wife's desire to travel to San Francisco, which actually did happen, since in the following years Antonio Martín was named Consul General of Spain in San Francisco, where he picked up again his friendship with Moya del Pino and even became the godfather of one of his daughters. The allusion to "Don Pedro the Cruel, Damock 1838" we find for now undecipherable.

The reality is that in the end, despite the enthusiasm for Moya's work and the patronage of many elite figures in Spain, King Alfonso XIII left Spain for an exile from which he would not return; and the Duke of Alba was dismissed shortly afterwards from his post as President of the Board of the Prado Museum and lost all the consideration and privileges that he had previously enjoyed. Thus the top sponsors and promoters of *Exhibiciones Velázquez*, with whom Moya had had an excellent relationship in Madrid, had left the public scene—leaving permanently unresolved the situation of the cultural expedition led by José Moya del Pino.

[105] In the first decades of the twentieth century, farming of abalone, developed on the coast of California; it was a frequent delicacy in San Francisco. Mollusks stick firmly to their rock; perhaps this is an allusion to how Moya had by now settled in California and showed no sign of leaving.

CHAPTER 6

Starting Anew

6.1. The Darkest Years

The day that José Moya del Pino handed over his collection of copies of Velázquez to the University of Berkeley, his future had a bleak horizon. He had completely lost the support of the Spanish government; had been abandoned by the Spanish embassy in Washington and even by his friend Alexander Moore, who was no longer in Madrid but was now stationed at the US Embassy in Lima; and he had little money to live on while waiting for the funds promised with the donation to UC Berkeley, which never materialized. His situation was practically desperate. The artist who just a few months earlier had been acclaimed in Madrid as *"deserving of all encouragement, applause and support"* had to admit now that the project that had given him fame had suddenly become a resounding failure.

The years 1926 and 1927 are probably the darkest of his biography. But the San Francisco Bay was in those years an ideal place for an enterprising man. Since the opening of the Panama Canal in 1914 that facilitated commerce by sea, the swarm of cities that had developed around the Bay (Richmond, Albany, Berkeley, Oakland, San Leandro, San Bruno, Daly City, Redwood City ...) was growing at a dizzying pace, turning the area into America's second largest economic center, thanks to a powerful and diversified industry and to the trade of agricultural products from the interior of the country that found exit to the Pacific via the ports of the bay. The influx of immigrants from all over the world was incessant, and for a painter, the beauty of the bay, that small inland sea, must also have been an incomparable attraction.

Our artist did what he knew how to do: paint pictures and try to sell them—especially portraits to order, as he had done successfully in Madrid and Paris years before. But even with proven skills, it is hard to get commissions when you can't publicize your work through exhibits. Most subjects of portraits don't like their image on show for public view, which makes it difficult to spread the word and find new patrons. The first information we are able to find about Moya del Pino participating in an exhibit is from May 1930, at the San Francisco Art Association—not with a portrait but with a still life. His reputation for excellence therefore had to expand slowly and only by word of mouth.

Moya's only advantage was that during the Velázquez exhibit at the De Young Memorial Museum and during the process that led to the donation of the paintings, he had been able to move among San Francisco's society elites who supported him and appreciated him. In banquets and receptions organized to publicize the exposition, he had been introduced to many patrons of the arts as an emissary of the king of Spain, and met other prominent figures through Mr. Cebrián, president of the National Honorary Hispanic Society, and José Gimeno, consul of Spain in San Francisco. He told his children years later that he looked forward to such receptions and, on those occasions, he would eat as much as he could because he didn't know where his next meal would come from.

The artist had connections, but it was not easy to get commissions or to charge well for them. And it became even more difficult to earn a living by painting starting in October 1929: on the 29th of that month, a financial cataclysm took place in the United States that led to the worldwide crisis known as The Great Depression. The economic situation worsened not just for a painter in the San Francisco Bay, but for all

Fig. 6.1.1. Portrait of Dr. Thomas Addis

Fig. 6.1.2. Portrait of Aliki Diplarakou

the inhabitants of North America and for those of almost the entire world. The Great Depression came suddenly; within a few months, unemployment in the United States rose to 25 percent; with the decrease in demand, the price of crops fell by more than 50 percent, and construction and some industrial sectors were semi-paralyzed. The effects spread quickly to all the countries that were united by trade; poverty appeared everywhere in a way nobody could remember ever happening before.

In every economic crisis, the first sector that falters is the arts & culture: while human beings can't live without eating or having shelter, they can do without going to the theater, reading poetry or sitting for a portrait. As a result, all the professional artists that were in the United States (writers, painters, actors, musicians, filmmakers...) started to feel as much hunger as the masons, farmers and industry workers who were now unemployed. The art market shrank to almost nothing. Even large museums froze purchasing and cut staffs.

Moya remembered this dark time in an interview he gave years later:[106] *"And then I got so broke here in San Francisco that I had to live here. (...) In San Francisco I had a terrible time trying to paint to make a living, but thanks to my academic training I was proficient in portraiture. (...) I painted Mrs. Alfred Sutro; her daughter, Miss Adelaide Sutro; and then Miss Peggy Pillsbury. I painted Dr. Olmsted of the University of California. (...) And then Dr. Emile Holman; and Dr. Ramón y Cajal, and Dr. Thomas Addis. And then a woman who was Miss Europe at the time (...) called Aliki de Diplorakos."*[107] (Fig. 6.1.1, 6.1.2)

[106] Oral history interview by Mary Fuller McChesney, 10 September 1964. Archives of American Art, Smithsonian Institution.
[107] Alfred Sutro (1869-1945) was a prominent San Francisco lawyer who later became director of the Pacific Telephone and Telegraph Company; Sutro Tower and Mount Sutro in San Francisco are named after his family. Dr. Emile Holman (1890-1972) was a physician and surgeon at Stanford University, who made important discoveries in the field of surgery and is considered a legend in the field of hospital medicine in California. Dr. Ramon y Cajal (1852-1934) was a Spanish neuroscientist and Nobel Prize winner; his portrait is included in the Appendix. Thomas Addis (1881-1949) was a Doctor of Medicine who became

There are no definite records of where José Moya del Pino lived or set up his studio, but judging from some of the early friendships he established, it is likely to have been a four-story building located at the southeast corner of Montgomery and Washington Streets known affectionately as the Monkey Block. Reminiscent of Montmartre's Bateau-Lavoir, the Monkey Block was home and workplace to literally hundreds of artists, writers and actors who shared the rooms for living, working and socializing. Some of its better-known earlier residents included Jack London, Ambrose Bierce, Bret Harte and Mark Twain. Situated adjacent to the Barbary Coast red-light district and the old San Francisco produce market, life at the Monkey Block was colorful, rowdy and exuberant.

Moya soon became acquainted with other San Francisco artists, some of whom had been in Paris studying at the same time as Moya. Ralph Stackpole, considered by many to be San Francisco's leading artist and sculptor during the 1920s, had his studio in the Montgomery Street building and helped Moya get established. Otis Oldfield lived and worked there and became a life-long friend (interestingly, Oldfield had spent several years in Paris at the same time that Moya del Pino was there, but they lived in different areas of the city and didn't meet until they were both in San Francisco). Muralist Maynard Dixon and his photographer wife Dorothea Lange were residents of the famed building. They all embraced Moya and introduced him to San Francisco's bohemian artistic world, which was at the same time part of a fashionable community of Bay Area artists, well-to-do art patrons and socialites. Moya overcome the language barrier by the sheer force of his effervescent, engaging personality and warm, outgoing nature. Photographers Ansel Adams and Edward Weston soon joined Moya's ever-widening circle of friends. Not only was Moya del Pino establishing friendships with fellow artists and art patrons, but a number of them also were important members of the San Francisco business community.[108]

If one were asked to name the three most influential architects in Northern California from 1920 to 1960, surely the names Gardner Dailey, John Bolles and Timothy Pflueger would appear on almost everyone's lists. Many credit Dailey with introducing modern architecture to the Bay Area; Bolles listed IBM, Macys, and Paul Masson Winery among his clients, and designed Candlestick Park, the stadium built in 1960 for the former New York Giants (then converted into a football field for the San Francisco 49ers); Pflueger designed some of the leading skyscrapers and movie theaters in San Francisco. Within a few years, all became good and lasting friends.

6.2. His Wedding with Helen Horst

In a way, Moya put an end to his "penniless immigrant" situation by marrying Helen Pauline Horst in December 1928. Born in San Francisco on July 25, 1898, Helen was the daughter of Emil Clemens (Clem) Horst and Daisy Brown, and grand-daughter of Martha Cassandra Wilburn and William Bailey Clark Brown, who was the state comptroller and a prominent person at the time. The Browns were a family with deep roots in California.

Clem Horst was a German who had emigrated to the United States in the late 19th century and, with his brothers Paul and Louis, started selling hops (the main ingredient for brewing beer) for a New York company. By the beginning of the 20th century, each of the brothers had formed his own company.

Horst continued in the hop trade which soon became an international business; the central valley of California's interior offered exceptional conditions for cultivating this crop and the ports of the San Francisco Bay facilitated its export. In addition, Horst invented several automation machines, including a mechanical hop separator that significantly increased production and reduced labor in the collection of hops. By 1912,

President of the San Francisco Medical Forum and, after the Spanish Civil War, led an Association supporting Spanish exiles. Aliki Diplarakou [correct spelling] (1912-2002) was the first Greek woman to win the title of Miss Europe; she was runner-up in the title of Miss Universe and did a tour of the United States in 1930.

[108] SCALES, Garrett. *José Moya del Pino: His Life and His Works.* Lecture at Marin Arts and Garden Center, September 20, 2013.

Fig. 6.2.1, 6.2.2. Helen Horst

the E. Clemens Horst Company owned the largest number of acres of hops under cultivation in the world,[109] and supplied most breweries throughout the United States and many in Europe (including Guinness in Ireland). In fact, these global exports also allowed the company to weather prohibition: from 1920 to 1932 brewing beer was illegal in the United states, but it was not illegal to grow hops for export abroad. Therefore, when Helen and José met in 1929, although her father's company was not at its height, the economic situation of the Horst family was quite comfortable.

Helen had a bright, engaging, fascinating personality with an active and reflective mind, and reportedly had many suitors. She was an accomplished artist in her own right: she painted and sculpted, was a talented woodcarver and also worked with silver and copper. According to her close friend Helen Oldfield (the wife of Moya's good friend Otis Oldfield), she was known to be somewhat of a free spirit—for example driving a Packard roadster with an open top and an egg beater mounted onto its hood, that would twirl in the wind when she drove. (Fig. 6.2.1, 6.2.2)

The young couple were introduced at a party by their mutual friend, the architect Gardner Dailey. It did not take long for romance to bloom, and Moya del Pino soon approached her father, Clem

Fig. 6.2.3. José Moya del Pino and Helen Horst, passport photo

Horst, to ask for her hand in marriage. The family recounts that halfway through Moya's long winding speech in broken English, Horst interjected: "Moya, I can't understand a word you're saying. If you want to marry my daughter, that's fine by me; but if you think you're marrying a cook you have another guess coming."[110] (Fig. 6.2.3)

The press reported widely on the engagement, as customary with members of high society families. Helen, wrote a newspaper, had studied at a Catholic school and at Miss Burke's private school in San Francisco and completed her studies in Paris; Moya was presented as a member of *"an old Spanish family"* and belonging to the *"Royal Spanish Society of Fine Arts."*

[109] *https://en.wikipedia.org/wiki/Emil_Clemens_Horst*
[110] According to Moya's daughters, Helen and her sisters were very proficient in cakes and candies but the mainstays of a meal were always left to the Chinese cook. Once married, however, Helen did become an excellent cook.

Fig. 6.2.4. The San Francisco Examiner reports on the wedding, January 13, 1929

The wedding was held on December 26, 1928, and it was a double wedding: Beatrice Horst, Helen's sister, had become engaged to Edward Thys at the same time, and the two sisters decided to marry on the same day. San Francisco's archbishop Edward J. Hanna presided over the ceremony, which was held at the brides' family home. An improvised altar was installed and the house was decorated with flowers in shades of pink and Della Robbia wreaths linked together by garlands of silver leaves. Miss Helen was given in marriage by her father, Emil Clemens Horst; and Miss Beatrice by Emil Clemens Horst junior, the brides' brother.

The San Francisco Examiner gave an account of the event with real pleasure, including photographs of the two brides and the flower girls: *"Sisters Are Brides in Charming Home Double Ceremony."* The article occupied almost three quarters of the cover page of the society section of the newspaper, and described it as one of the *"brilliant events of the month,"* enumerating the most distinguished family members and attendees, and going into a detailed description of the brides' bouquets as well as their matching wedding gowns, which were trimmed with Duchess lace that had belonged to their grandmother Cassandra Brown.[111] (Fig. 6.2.4)

The couple lived on Washington Street in San Francisco for the first year of their life together; then during the Depression as finances became tighter they moved back into the Horst family home on Presidio Terrace, an affluent cul-de-sac neighborhood of San Francisco. In 1938 they moved into their permanent home (designed for them by their friend the architect Gardner Dailey) in Ross, a town in Marin County just north of San Francisco. During their courtship and in the first years of their marriage Helen and José communicated mostly in French—the one language they had in common, since both had previously spent time in Paris: Moya's English was still not very good, and Helen spoke no Spanish at all.

By marrying Helen, Moya del Pino freed himself from the anguish of surviving since he now had the support of the Horst family, but he did maintain his interest in breaking through as an artist in his new adopted country. Helen, on the other hand, abandoned her activities as a painter in order not to compete publicly with her husband. Her descendants retain several portraits Helen made of her twin sister Hazel, during the years that Hazel was ill before passing away at age 25. They also retain some still lifes and some landscapes; all these paintings show that Helen was an excellent painter (Figures 6.2.5 and 6.2.6). After marrying Moya, she refocused her art on another one of her passions, sculpture, and dedicated herself to her family and her love of gardening; in fact, as we will see later, she was instrumental in the development of the Marin Art and Garden Center in Ross. She shared with her husband a liberal-progressive ideology, unlike other family members who supported more conservative policies. (Fig. 6.2.7 & 6.2.8)

6.3. Exhibitions and Prizes

Although he must undoubtedly have tried earlier, Moya del Pino did not manage to present a solo exhibition of his work until March 1931; this was at the Gelber-Lilienthal Gallery of San Francisco, with a selection of landscapes and still-life compositions in different media. No portraits were on display; in spite of this, the first articles that appeared in the press about his exhibition of course made the allusions that Moya had hoped to avoid: his role as an exhaustive copyist of the works of Velázquez, and his logical dependence on the style of the great master. But an article published by the San Francisco Examiner on March 22, while reporting that Moya had arrived in San Francisco years earlier with his 41 reproductions of Velázquez, states that now, with this exhibition, the artist *"... is emancipating himself from such influence. For he paints now in the modern manner, and there are in his work echoes of the theories dear to the heart of contemporary artists."* The critic adds: *"The richness of the artist's oils and his modern use of color is seen in 'Hills.' (...) In his 'Still Life' the folds of a tablecloth suggest the heavy stiff silks of a by-gone era, even while the apples are reminiscent of those of Matisse."* Among the watercolors, those titled *"Gitanos (Spanish Gypsies)"* and *"Playland"* stand out.[112]

[111] *Society Clubs Fashions*, society supplement of the San Francisco Examiner, January 13, 1926.

[112] HAILEY, Gene, *California Art Research,* volume XIII. Works Progress Administration, San Francisco, 1937.

Fig. 6.2.5. *Still Life by Helen Horst*

Fig. 6.2.6. *Helen's portrait of Hazel Horst,
her twin sister*

Fig. 6.2.7 & 6.2.8. *José and Helen Moya del Pino a few years after their marriage; photographs by Edward Weston*

In February 1932 he exhibited 24 portraits at Gump's Gallery; some of them are the ones that Moya enumerated later when being interviewed for the previously-mentioned oral history for the Archives of American Art (see page 64).[113] But the reviews were not completely positive since, according to the critics, his work could not be placed either among the old (classical art) nor among the new (post-impressionism and modernism). On one hand, the *San Francisco Examiner* comments: *"His works at Gump's are handsome interpretations in the patrician manner, excellent in craftsmanship and of dignified style"* and points to the painting entitled *The Peasant's Cap* as *"especially striking"* (Fig. 6.3.1).[114] On the other hand, in *The Argonaut*, Junius Cravens is a harsher critic, asserting that in contemporary painting, portraits that pretend to classicism have *"no more relation to portraits by great masters than has the average tinted photograph. And, as a document, it seems to us to have less value than the photograph, in that, despite its pretenses to accuracy, the chances are that it is less accurate than an image produced by the lens. Of the twenty-four portraits by J. Moya del Pino which grace the walls of the central gallery at Gump's, only that of Mrs. Frances B. Gump and the head called 'The Peasant Cap,' both of which are decorative and quite nicely handled, appealed to us as possessing a degree of those aesthetic qualities which we have been taught to consider as being necessary to works of art."*[115]

Fig. 6.3.1. "The Peasant Cap" (portrait of Helen Moya del Pino)

The artist had somewhat better luck a year later, when he participated in an exhibit at the Oakland Art Gallery. The critic of the *Oakland Tribune* finds Moya del Pino's still life *"ultramodern"* and comments: *"Jose Moya del Pino's 'Still Life,' is of apples and oranges in a blue glass bowl, with vase and tulips in the background. The vase is twisted, so the painting must be modern, after Gaw, after Cezanne, etc.; the blue glass holding the fruit gives me the willies, but I am told that these little shocks in art are good for the soul and that the still life is fair enough or better, so we shall let it go at that."*[116]

It appears that Moya del Pino gradually started to make a name for himself, as implied in a letter of April 1933 by the Society of California Pioneers, which thanked the artist for delivering watercolor sketches representing the Spanish troops at the time of the conquest of New Spain:

Fig. 6.3.2. An initial pencil sketch for "Bach" (the final painting is not located)

[113] Among the portraits on exhibit were those of Alfred and Adelaide Sutro, Sebastian de Romero, Roger Reynolds, E. Clemens Horst (see appendix), Peggy and Lucy Harrison, Peter E. Dunne, Gardner Dailey, Francis B. Gump, and Margaret Pillsbury.

[114] *"Portraits by Spaniard are of Fine Type,"* San Francisco Chronicle, February 21, 1932.

[115] *The Argonaut*, February 19, 1932.

[116] *Oakland Tribune*, March 1933; as quoted in Gene Hailey, Op. Cit.

the Society especially appreciated the research Moya did to ensure that the gala uniforms of the soldiers depicted were true to the authentic uniforms of that time, and stated that they *"value these sketches highly not alone because they are authentic reproductions of their period, but also because they are a bit of your own work which many of us admire very greatly."* At around the same time Moya participated in a collective show at the Palace of the Legion of Honor of California in San Francisco, and this time he experimented with abstraction. His work, entitled *"Bach,"* is mentioned by the critics explaining that the artist is representing music through a violin and a piano keyboard.[117] (Fig. 6.3.2)

In September of the same year, Moya del Pino won the first prize in the art competition of the California State Fair in Sacramento, with his work *View from Telegraph Hill* (we have not been able to locate this painting). The *San Francisco Chronicle* comments: *"Moya del Pino's first prize painting in the marine division is a broad view of the bay from Telegraph Hill. It is a canvas of remarkably bright, neat and attractive pattern."* Shortly after, the work is exhibited at the San Francisco Art Center and is described in the *Oakland Tribune* with these words: *"Moya del Pino's 'Landscape' (View from Telegraph Hill) won a first prize at the last State Fair art exhibition. It is a view of the San Francisco water-front, looking down over factories, wharves and other buildings to shipping, the bay and the Berkeley hills. A well handled canvas."* [118]

Another work attracted the attention of the critics that same year (1933): *Like Seals*, which he exhibited among other paintings in a one-man show at the Kingsley Art Club at Crocker Gallery in Sacramento, California. In this exhibition Moya appeared *"free from the restrictions which portraiture imposes upon any artist,"* and the art critic appreciated *"the artist's pleasure in rhythm, especially in 'Like Seals' which was composed to convey the sense of the musical flow and sound of the ocean."* [119] The painting was exhibited again in October 1933 at the gallery of the San Francisco Art Association: *"Like Seals is the title of a dark atmospheric painting by Moya del Pino. It*

Fig. 6.3.3. *"Like Seals"*

pictures five nudes on a rocky shore. They are powerfully modeled and interwoven in form. Their metal-like sheen gives del Pino's conception a novel mood." [120] (Fig. 6.3.3)

Although our artist was making his way into other genres and liberating himself from the traces of the Velázquez style, it is evident that his specialty was still the portrait. And not always with California high

[117] *The Wasp*, April 29, 1933.

[118] *Oakland Tribune,* August 12, 1934; as quoted in Gene Hailey, Op. Cit.

[119] This article highlights several other paintings in this one-man show at the Crocker Gallery, including *Boys with Cat, Portrait in White* (his wife Helen, see appendix), *Little Orchard*, and *Woman at a Balcony*. Unfortunately the newspaper clipping in the files kept by the artist's heirs doesn't show the publication's name or date.

[120] *San Francisco Chronicle*, October 8, 1933

Fig. 6.3.4. "Chinese Mother and Child"

society models, but sometimes with true "prototypes" of the California society. One portrait that is worth highlighting has remained for history in anthological exhibitions on California art of the twentieth century.[121] It is entitled *"Chinese Mother and Child"* (1933. Oil on canvas, 100x76 cm. Fig. 6.3.4). In the composition, Moya's technical expertise as well as his ability to express the inner life of the characters are evident. Steven A. Nash, a specialist on the history of painting in the San Francisco Bay area, has written these words about it, in which we find a masterful interpretation of how a portrait can express the dramatic situation of a whole marginalized group in a modern society:

"... Spanish painter José Moya del Pino [...] today is best known as a muralist. Yet in the early '30s he produced one of his most arresting views of the city in a portrait: a penetrating study of a 'Chinese Mother and Child' (1933). Before the Depression, Moya del Pino had built his reputation locally by his society portraits and scenic decorative murals, and social realism never really characterized his art. But as an immigrant himself, he must have had a special affinity for this particular subject, the difficulty of transplanting one's native culture in a foreign land. The Chinese population in the city represented the most obvious example of the conflict of cultures. Ostracized by the very society that had exploited their rush to the 'Golden Mountain' in the nineteenth century, the Chinese were confined to those jobs that American laborers did not want and were sequestered in a separate community by discriminatory housing restrictions and by their own withdrawal from the hostile world outside the borders of Chinatown. Remarkably, avoiding the conventions of most painters of San Francisco's Chinese people, Moya del Pino has placed this mother and child not in the setting of Chinatown, but within the city at large, a firm reminder that by 1930 a large part of the Chinese living in San Francisco were California-born. He has presented his sitters with remarkable equanimity—as a study of the basic human identification with family, home, and community, and of the inner strength that enables the dispossessed everywhere to endure. The artist's uncommon command of Spanish baroque portraiture and history painting—he had painted celebrated copies of the Velázquez paintings in the Museo del Prado in Madrid—is revealed in his brilliant colors and bravura brushwork, in his well-modeled figures, and in the complex composition, incorporating still life and landscape as essential components." [122]

This comment defines Moya del Pino as a great painter, who has been able to combine the prodigious technique of the Spanish Baroque painters (Velázquez of course, but also Murillo, El Greco or Zurbarán) with the symbolic dimension of his characters and with the most modern currents of composition and color.

6.4. First (and Last) Trip Back to Spain

A few years after having to give up his collection of copies of Velázquez, in September 1934, Moya del Pino traveled to Madrid, accompanied by his wife and his first daughter, Beatrice Diana, who was barely 8 months old. The trip had several purposes: he was going to present his wife and young daughter to his

[121] The painting was part of, for example, the exhibition entitled *Made in California: Art, Image, and Identity, 1900-2000* organized by the Los Angeles County Museum of Art from October 2000 to February 2001.

[122] NASH, Steven A. *Facing Eden. 100 Years of Landscape Art in the Bay Area*. The Fine Arts Museums of San Francisco. University of California Press, 1995. Pg. 82.

mother, who so far had only received news from her son through his letters; he probably also hoped to find out what had happened with the loss of support from Spain after he had arrived in San Francisco; and, importantly, he needed to legalize his situation in the United States, a country he had entered with a diplomatic passport that was only valid for one year.

He must have made numerous efforts with official bodies or tried to visit the people who had supported him, but of these efforts we have found no written account. After the proclamation of the Second Republic on April 14, 1931, it was to be expected that communications would be complicated, since all the authorities that had supported Spain's "cultural mission" to America had lost power: Alfonso XIII and his family were in exile in Italy, the Duke of Alba and the other representatives of the nobility who had given their support were now threatened with the expropriation of their property, and the prevailing ideology in the country had completely changed direction. It is very likely that, knowing that the cultural company called *Exhibiciones Velázquez* had been sponsored by the monarchy and the nobility, the new republican authorities had no interest in supporting the painter's endeavors.

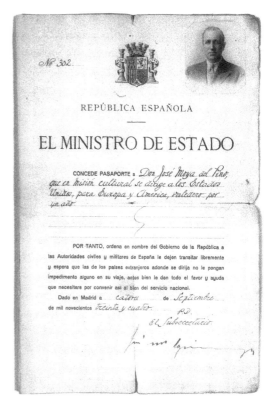

Fig. 6.4.1. Moya del Pino's new passport

Moya del Pino did, however, get a new passport, a document whose copy has reached us and whose content is extremely curious (Fig. 6.4.1). The document is headed by the shield of Spain in force during the Second Republic; on the right is the photograph of José Moya del Pino. The text (translated) reads: *"Spanish Republic. The Minister of State grants a passport to Don José Moya del Pino, who travels to the United States on a cultural mission via Europe and America, valid for one year. Therefore, the Government of the Republic orders the civil and military Authorities of Spain to let him travel freely and expects those of the foreign countries where he is traveling not to put any impediment on his trip, rather, that they give all the favor and help he may need in pursuing the good of the national service."*

The document is dated September 14, 1934. As we can see its content, most surprisingly, is identical to the diplomatic visa he had been granted when he left Spain to lead the Velásquez exhibition on its way to the United States; it appears that he is being sent again *"on a cultural mission,"* when such a mission was concluded 9 years before; and the authorities of Spain and foreign countries are asked to give him *"all the favor and help he may need."*

Unfortunately this new document still did not allow him to obtain United States citizenship, as he had hoped; in fact, Moya del Pino had to travel to Canada two years later, accompanied by his wife, to re-enter the country on the quota system established by the US, in order to claim citizenship.[123]

The other reason that brought the painter to Spain was his family. His father had recently died of a heart attack (Fig. 6.4.2). His only close relatives were his mother, Maria del Carmen del Pino Codes (Fig. 6.4.3) and his sister María de los Desposorios Moya del Pino (called by family members Esposita), who lived

[123] The Immigration Act of 1924 limited the number of immigrants allowed entry into the United States through a national origins quota. The quota provided immigration visas to two percent of the total number of people of each nationality in the United States as of the 1890 national census. *https://history.state.gov/milestones/1921-1936/immigration-act*

in Madrid. Moya del Pino recounted later to his children how much he had been shocked by the violence in the streets of that city during his visit: although Spain's civil war hadn't fully broken out yet, clashes between the then-fascist-nationalist Falange Española and the new government of the Radical Republican Party created uprisings and open violence in the streets of Spanish cities,[124] and José and Helen had opportunity to witness this first-hand from their hotel in Madrid. This must have raised concerns about his mother and sister's wellbeing, and must have started the efforts to bring them to the United States—which culminated in 1936 when the Spanish civil war was in full swing.

Moya was hesitant to move his mother and sister to America, worrying especially that his mother, elderly and knowing no English, would have a difficult time adapting to a new country; to make matters worse, Carmen was in ill health and the evacuation was not going to be comfortable. But his father-in-law Clemens Horst insisted for their safety, financed the move, and used his connections to facilitate the arrangements. And so Carmen del Pino and her daughter Maria Desposorios (Esposita) opted for exile, like many other Spaniards, including the former president of the Republic—and, like him, were forced to make a long trip to reach safety. Their ordeal, first in Madrid and then in a protracted evacuation via Valencia, Villajoyosa, Valencia again,[125] Barcelona and finally Paris, took 14 months and is recounted in wrenching detail in Esposita's memoirs.

The mother and daughter were eventually able to board the *Normandie* in the port of Le Havre (France), according to the ship's manifest of September 15, 1937; they disembarked in New York where they were greeted by business associates of Clemens Horst, then took the train to San Francisco to be reunited with Moya and his family. Both women lived in the San Francisco Bay area the rest of their days.

Fig. 6.4.2. Miguel Moya Garrido
(José Moya del Pino's father), undated photograph

Fig. 6.4.3. Carmen del Pino Codes
(José Moya del Pino's mother) in 1949

[124] *https://en.wikipedia.org/wiki/Spanish_Civil_War*
[125] At the end of 1936 the government of the Republic had settled in Valencia and many residents of Madrid also fled to that city to escape bombings, famine and the harassments by the rebel army. Carmen and Esposita had hoped Valencia would provide respite but fled again when it too was bombed; they had to return in order to obtain passports from the government and visas from the American Consulate.

CHAPTER 7
Moya del Pino, Muralist

7.1. The Merchants Exchange Club

While continuing to paint in oil on canvas, José Moya del Pino had also started experimenting with fresco techniques (his 1932 exhibit at Gump's Galleries had included a couple of fresco portraits), and was soon able to branch out in a new direction: murals and works of art on a grander scale. In 1932 he was hired to decorate the hall of the Merchants Exchange Club, in the heart of San Francisco's business district. This was an elegantly appointed private club frequented by the *"highest stratum of San Francisco's booming Financial District"*[126] and it is likely that this commission was facilitated by Moya's father in law, Clemens Horst, a prominent businessman and merchant himself.

These were the first large scale murals painted by our artist and therefore must have been an interesting and different challenge. Moya summed up the history of San Francisco in three images representing the 18th, 19th and 20th centuries—the "Age of the Dons," the "Golden Days," and the present—focusing on shipping and commerce, the main activities of the club (Fig. 7.1.1 – 7.1.4). In the first mural he depicted the Spanish colonial era, with a Spanish galleon and a Panama sailing vessel on the bay, and in the foreground the padres, Native Americans with baskets of fruit, and Spanish soldiers in colorful uniforms. In the second mural he illustrated the Bay Area's first settlement at the time of the pioneers: the so-called "49ers" that made their way across the country from the eastern states in search of gold in the second half of the 19th century, and the first immigrants from Asia; a large Boston clipper ship is being unloaded.

The third mural is a wide panorama of the cosmopolitan life of the bay in the 20th century and looking to the future: steamships ply the bay's waters, airplanes and even a dirigible float in the sky above the bay and hills, and in the foreground, steel workers engaged in the construction of a skyscraper hint at the continuing development of the city. Interestingly, the painting includes a remarkably accurate depiction of the San Francisco Bay Bridge—crossing the waters from San Francisco through Yerba Buena Island toward Oakland and Berkeley—for which construction didn't even begin until July 1933, three months after the Merchants Exchange murals were completed. Moya del Pino must have studied the plans quite carefully to be able to represent the bridge so accurately, even though it didn't exist yet. No doubt the architect Timothy Pflueger, whom Moya had met and become friends with a few years earlier and who was the chairman of a committee of consulting architects on the Bay Bridge project, facilitated access to the construction plans.

Upon completion of this work, the *San Francisco Chronicle* dedicated an entire page to large photographs of the murals,[127] and *The Wasp* of April 22, 1933 described each in detail and commented: *"The fine sweeping murals have a historical significance, based upon accurate research, yet effectively subordinated to the plastic elements of the composition. Necessarily romantic and pictorial on account of their theme, they reveal a grasp of structural essentials and unified design. In spite of their variety of detail, the three paintings are beautifully harmonized."* A report in the weekly magazine *Hispano-América*, published in Spanish, dedicated half of the

[126] https://mxclubsf.com/about/
[127] *San Francisco Chronicle*, April 16, 1933; page 4 of the Rotogravure Pictorial Section.

Fig. 7.1.1. Merchants Exchange mural — The 18ᵗʰ Century: The Age of the Dons

Fig. 7.1.2. Merchants Exchange mural — The 19ᵗʰ Century: The Golden Days

Fig. 7.1.3. Merchants Exchange mural — The 20ᵗʰ Century: The Present and Future

Fig. 7.1.1, 7.1.2, 7.1.3. Murals for the Merchants Exchange Club
as shown in the San Francisco Chronicle of April 16, 1933

Fig. 7.1.4. The "Moya del Pino Bar and Lounge" at the Merchants Exchange Club today.

cover page to Moya del Pino, with a good sized photo of the artist, which shows that he was already a respected and valued artist. The editor, MJ Urrea, comments on Moya's murals and puts him at the level of great artists such as Frank Dumond, Gottardo Piazzoni and Diego Rivera.[128]

After the success of these murals, Moya's relationship with the Merchants Exchange Club was long and fruitful. His work and contributions to the institution were appreciated to such an extent that the Merchants Exchange board of directors decided to modify their bylaws, which had prohibited anyone from being a member without paying an initiation fee and monthly dues, with the express objective of appointing the painter honorary member for life, *"by reason of unusual and extraordinary service to the club."* As late as 1959 Moya del Pino received another commission from the Merchants Exchange Club to create two paintings, one representing Coit Tower and the other a typical San Francisco Cable Car, for which he was paid $2,500.

7.2. Coit Tower

In November 1932, perhaps in the hardest period of the Great Depression, Democrat Franklin D. Roosevelt was elected President of the United States; his government urgently launched a gigantic public investment plan to boost the economy and give work to all those who still remained in poverty. The plan mainly focused on the construction of infrastructure: roads, electric power plants and public buildings for the federal administration or for local institutions; it also legalized trade unions and put some limits on unregulated capitalism. This was the "New Deal," and within a few years it helped to put the United States back on track.

The Works Progress Administration (WPA, renamed Work Projects Administration in 1939) was the largest and most ambitious of the New Deal agencies, employing millions of unskilled workers to carry out public works projects; it also operated large arts, drama, media, and literacy projects. The private market for art had evaporated: galleries were closing, and artists were trying to stay alive by selling directly to the public through outdoor art shows, setting up cooperative galleries and bartering for goods and services. So the WPA created specific programs to provide work for artists and artisans: the "Public Works of Art

[128] URREA, MJ. *The frescoes of Moya del Pino.* In *Hispano-América*, July 29, 1933. On the date of the report the three artists cited were in full maturity and were considered as the most prominent and influential in the United States.

Fig. 7.2.1. Coit Tower

Project" (PWAP), which ran from December 1933 to June 1934 under the United States Treasury Department and was paid for by the Civil Works Administration; and, in 1934, the "Federal Art Project" (FAP). Proposals to decorate public buildings were accepted without many conditions in exchange for a small weekly salary, and it has been calculated that in the first program more than three thousand artists were hired and in the second one more than five thousand throughout the country.

These years coincided with the rise of mural painting, which had important antecedents in Mexico. In successive stages of the Mexican revolution the departments of education and culture had imposed the need for monumental art painted on the exterior walls of public buildings in order to educate the people, belittling "easel" painting which they considered bourgeois and available only to the elites. Murals became nearly a social movement: young artists were painting their revolutionary ideals on hundreds of public walls and squares. But at the beginning of the 1930s, the best Mexican muralists (among them Orozco, Rivera and Siqueiros) emigrated to the United States to take part in the PWAP and the FAP.

Building on his experience with the Merchants Exchange Club, José Moya del Pino too was able to integrate into these New Deal programs for artists, demonstrating in a few years an extraordinary ability to adapt to the themes and styles in fashion in those times and in those lands. The mural he is best known for is in Coit Tower, a monumental building in the heart of San Francisco that is still open to the public today and is one of the city's prominent tourist attractions.

Coit Tower, officially known as the Lillian Coit Memorial Tower (Figure 7.2.1), had been built in 1931 with a bequest by Lillie Hitchcock Coit, a wealthy, eccentric woman who smoked cigars and dressed like a man to enter gambling houses where the presence of females was at that time inconceivable. Because of her unceasing public activity in support of San Francisco's fire service, she became a mascot or "muse" of the fire department and was later honored with the title of honorary firefighter. Upon her death, she left one-third of her estate to the City of San Francisco *"to be expended in an appropriate manner for the purpose of adding to the beauty of the city which I have always loved."*[129] Thus Coit Tower was built, by project of architect Arthur Brown Jr. (designer of San Francisco's City Hall), and was dedicated to the volunteer firemen who had died in San Francisco's five major fires; some reports indicate its design is intended to look like the nozzle of a fire hose, though there is no consensus about it.

The tower is 210 ft. high (64 m) and is located at the top of Telegraph Hill, a historic and touristic neighborhood of the city; it had no pictorial decorations until late 1933 when the decision was made to paint the interior with murals. The artists were paid around $40 a week and were to depict "aspects of life in California;" work on the murals started in December 1933 and was completed by June 1934. Inspired by the wonderful views of San Francisco Bay that can be contemplated from the top of Telegraph Hill, Moya del Pino designed an ambitious, technically complex painting titled *San Francisco Bay, North* in a space of 4.5 × 9 feet (about 3.7 sq.m), located in the elevator foyer of the tower. Matching the point of view of a spectator sitting exactly in that location atop Telegraph Hill and looking due north, in the upper area appear the cliffs on the opposite

[129] *www.guardiansofthecity.org/sffd/people/coit.html*

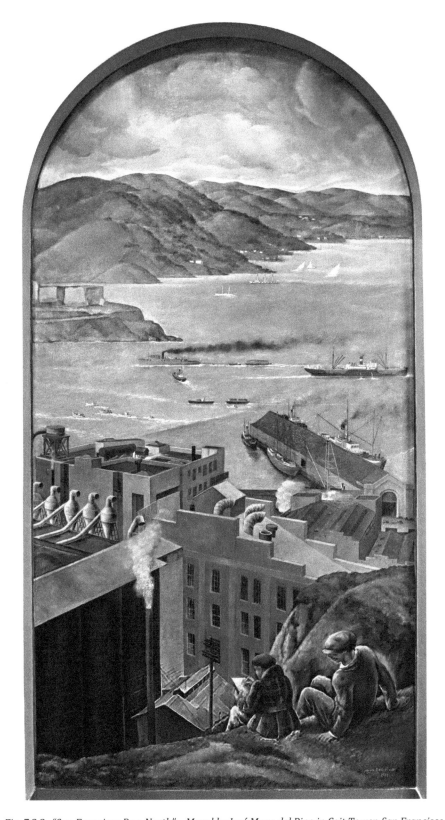

Fig. 7.2.2. "San Francisco Bay, North" – Mural by José Moya del Pino in Coit Tower, San Francisco

edge of the bay, the blue water dotted with sailboats and, as if it were a floating raft, the island of Alcatraz with its buildings that were just then in the process of being converted into a maximum security prison. A steam boat with its red hull and dense smoke placidly crosses the bay pulling a barge. In the lower half of the mural instead there is a bustle of industry: boats are docked around the pier, buildings of several stories are seen from above, a factory chimney billows out steam... and at the edge of the cliff, looking down on it all, two men are sitting with their backs to the viewer: one of them draws the scene below, as the other watches on (Fig. 7.2.2). Otis Oldfield, Moya's friend and also a Coit Tower muralist, served as the model for the first man; while the second is the artist himself. It is interesting to note how common it was for painters to use their friends and each other as models for their work: many of the Coit Tower murals include the likenesses of other artists or their families. In fact, among the people milling about a busy Powell Street in Lucien Labaudt's mural (along the interior stairs, viewable by guided tour) is a man with a baby in his arms: the model for this character was Moya del Pino himself, with his daughter Beatrice Diana who was 3 months old at the time. (Fig. 7.2.3)

In the same elevator foyer there are three other murals and small lunettes above the doorways painted by Otis Oldfield and Rinaldo Cuneo; all of them show expansive scenes of the San Francisco bay or the hills and fields beyond and, unlike most of the murals in the rest of the building, they are done in oil on canvas rather than true fresco. This is ironic, because José Moya del Pino not only knew well the fresco technique, but also had stressed the importance of not using oil for mural paintings, in an article he had written a few months prior: "...Nowadays, it seldom occurs that an artist is content with executing an easel-painting amplified to colossal proportion on a canvas, and afterward pasting it to the place destined by the architect to be decorated. This nefarious practice that, with few exceptions, during the last fifty years has infested the Capitols and public buildings the world over with absurd decorations, should fall into complete disuse. The mural painter of today (...) should possess complete knowledge of the various processes of mural painting—fresco, tempera and encaustica. Oil painting should not be employed, because it is neither adapted to the large surfaces to be covered, nor to the rejection of atmospheric effect practiced in every mural painting worthy of the name."[130] However, it was deemed important that all the murals in the elevator lobby look cohesive, and due to Oldfield's inexperience with fresco, oil on canvas provided the most flexibility. In fact the cartoons were brought to Cuneo's studio in the Montgomery Block, where the canvases were painted then cut to shape to be affixed to the walls when complete.[131]

It is also interesting to note that the three artists who painted the elevator lobby chose to stay above the political themes favored by some of their fellow muralists, and focused instead on the artistic depiction of the beauty and bustle of the San Francisco Bay area. Many of the other muralists were influenced by the Marxist sentiments of the prominent but highly controversial artist Diego Rivera, an avowed Communist. Just a few months earlier a great controversy had risen around his soaring *Man at the Crossroads* mural for New York City's Rockefeller Center, which was ordered destroyed because he refused to paint over a fairly prominent image of Vladimir Lenin; this event led to protests and boycotts by many other artists throughout the US, including in San Francisco, and is even alluded to in a newspaper headline on one of the Coit Tower murals (Fig. 7.2.4).

Fig. 7.2.3. José Moya del Pino and his three-month-old daughter Beatrice Diana are depicted in Lucien Labaudt's 'Powell Street' mural

[130] *Mural Painting* by J. Moya del Pino. *The Wasp*, May 6, 1933.

[131] This was the process, according to an interview with Otis Oldfield (Archives of American Art, Smithsonian Institution): the painted canvases were rolled up and brought to Coit Tower where decorators would *"marouflé the back with white lead and Venetian turpentine"* and affix them, then *"go over the surface with a roller to get all the bumps out and get it to stick."* Then they'd apply a wax varnish to preserve the paint and to tone down the gloss, to avoid the glare of the lights.

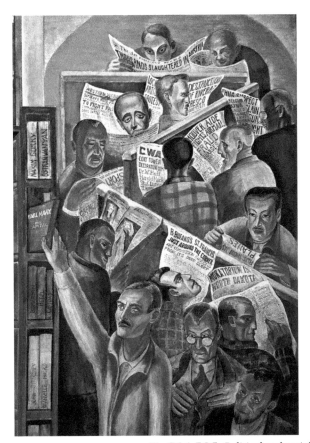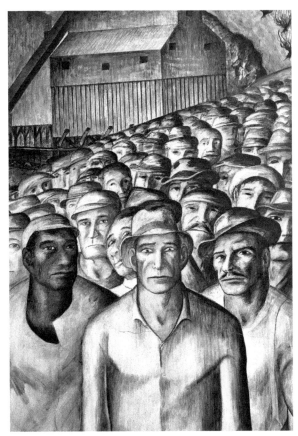

Fig. 7.2.4, 7.2.5. Political and social commentary in Coit Tower murals:
'Bookstore' by Bernard Zakheim; 'Industrial Scene' by John Langley Howard

Since Coit Tower's murals depict California during the Great Depression, in addition to themes such as agriculture and industry many also addressed issues like immigration, politics, capitalism, social class, and urbanism. The general feeling of desperation and malcontent they saw around them, caused by poverty and a lack of jobs, was reflected by some of the painters, who didn't hide their feelings about income inequality and their sympathy for leftist and Marxist ideals. This social realism caused some controversy. (Fig. 7.2.5)

As the newly decorated tower was about to open, the West Coast Waterfront strike broke out in San Francisco: longshoremen in every US West Coast port walked out, and the bitter conflict raised fears of communist agitation, which increased scrutiny of the social commentary depicted in some of the Coit Tower murals to the point that some of them were accused of containing "communist propaganda." The official opening was canceled, and the artists were told they would receive no pay until the offending symbols were painted over. Particularly contentious was the small Soviet hammer and sickle painted by Clifford Wight above one of the windows. Some of the artists sided with Wight, some others (including Moya) were afraid of being branded as communists and came out in favor of removing it. After a couple of months of contention, a compromise was reached and only two of the graphics were removed: the above-mentioned hammer and sickle, and the banner of the communist periodical *Western Worker* in John Langley Howard's mural. With those items painted over, the tower finally reopened on October 12, 1934.

Coit Tower was inscribed in the National Register of Historic Places in 2008, and an extensive restoration of its murals was executed in 2014; it is open to the public and in the visit it is easy to find the mural painted by José Moya del Pino, which is in good condition (some of the others can only be seen by pre-arranged guided tour).

7.3. Aztec Brewing Company and Acme Brewery

Shortly after finishing the Coit Tower mural, Moya del Pino was hired to work in San Diego, California, to decorate the main hall of a new brewery. The artist was developing a reputation as a muralist, but it is also likely that his father-in-law E. Clemens Horst's knowledge and connections in this business sector had a hand in obtaining this work so far from the San Francisco Bay region.

The manufacture and sale of alcoholic beverages had been prohibited in the United States for the past decade, but public opinion was increasingly opposed to this situation, because Prohibition had not ended alcohol consumption and had actually caused an increase in crime through smuggling. In March of 1933 the newly elected president Franklin D. Roosevelt, in another of his historic decisions, annulled Prohibition and legalized the manufacture and consumption of alcohol, arguing that the measure would reduce crime and, in addition, would provide an incentive for industry and commerce.

This deregulation facilitated the creation of new companies in the sector, and the Aztec Brewing Company which had been operating in Mexicali (just south of the border with Mexico) since 1921, took this chance to open a new production facility in San Diego. The brewery also wanted to create a unique and culturally relevant "destination" tasting room, which became later known as the Rathskeller (the German word for a basement watering hole). They hired artisans of different specialties to outfit it with hand carved tables and stained glass windows, and brought José Moya del Pino down from San Francisco to decorate its walls and oversee the work.

The resulting murals were vibrant and exotic, depicting themes and images from Aztec and Mayan eras, some hewing to Spanish colonial styles and others reflecting the '30s-era Mexican and US mural movements. *"José Moya del Pino drew artistic inspiration from Mexican muralists, citing Diego Rivera as a major influence. So, when he was selected to contribute the artwork for the Rathskeller, he aimed to create a traditional and culturally relevant theme of artwork for the tasting room."*[132] And indeed, in the words of Fran Cappelletti, a historian and current director of the Moya del Pino Library, the work is *"a beautiful piece of history portraying ancient cultures, indigenous peoples and local landscapes from the past."*[133] On the main wall behind the tiled serving bar, under a vaulted ceiling supported by carved wooden beams, Moya painted the centerpiece mural representing the ancient Aztec ritual of human sacrifice, with a high priest extracting a man's heart; on the two sides, one mural reproduces scenes from pre-Columbian history and the second has scenes from the time of the Spanish colonization. Local landscapes were included, with Mount San Miguel featuring prominently (though reimagined as a volcano). Moya del Pino also oversaw the rest of the Rathskeller's decoration, which included painted and carved tables and chairs and ceiling beams, chandeliers, tiled mahogany cabinets, stained glass windows and doors, and a 9-foot replica of the Aztec calendar. (Fig. 7.3.1 – 7.3.5)

Hiring a Spanish painter was an interesting choice, given that it was precisely the Spanish conquest that led to the demise of the Aztec empire. However, *"While Moya del Pino did not grow up in Mexico and was educated in Spain, he painted the murals in accordance with Aztec and Mayan traditions. The result was an astonishing collection of monumental-style murals that depicted the region's landscapes, people, and culture. It is indeed slightly ironic that, of all people, a Spanish artist was summoned to Aztlán to create artwork celebrating the area's rich cultural history. However, Moya del Pino was mindful of this, and his artwork was renowned for years to come."*[134] With his dramatic murals, painted in the Mexican muralist tradition, the artist also became a pioneer of the presence of Aztec and Mayan culture in the United States, since thousands of immigrants were already arriving into the San Diego area from Mexico, giving rise to the Chicano movement in California.

The San Diego Union Tribune commented that *"It is indeed gratifying to know that such true mural painting as fresco, and, more important still, that good fresco work, is at last being done in San Diego. Senor Jose Moya del Pino's compositions (...) have a vitality and strength that is in keeping with the building which serves a utilitarian*

[132] Chicano Park Museum, *www.chicanoparkmuseum.org/logan-heights-archival-project/aztec-brewery*

[133] CAPPELLETTI, F. *The Moya Brewery Murals: From Acme to Aztec.* In *Brewery History*, The Brewery History Society, 2016, #164, pgs. 33-36.

[134] Chicano Park Museum, *ibid.*

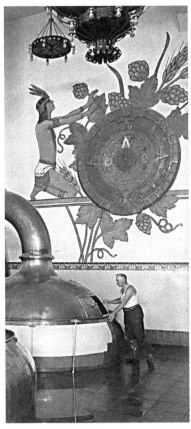

Fig. 7.3.1. Aztec calendar

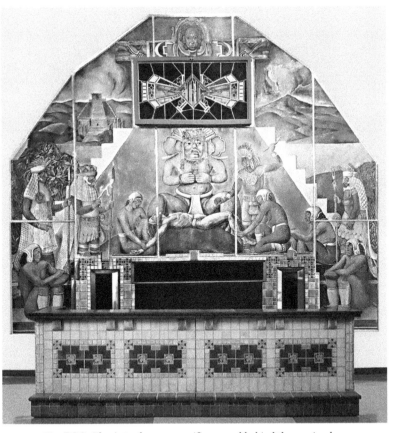

Fig. 7.3.2. The Aztec human sacrifice mural behind the serving bar, after being cut into pieces and rescued from demolition

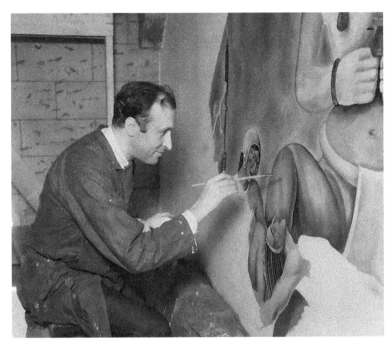

Fig. 7.3.3. José Moya del Pino painting the human sacrifice mural

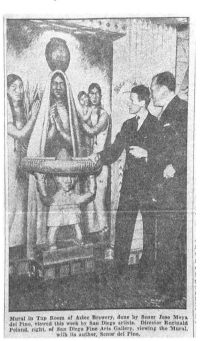

Fig. 7.3.4. Photo in the San Diego Union

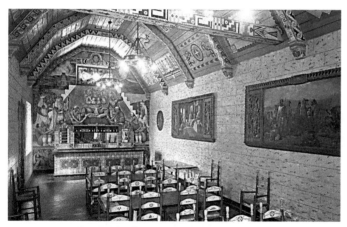
Fig. 7.3.5. The interior of the "Rathskeller"

purpose and with Mexico and the Mexican people."[135] Decades later, as the building was about to be demolished, Salvador Torres (a muralist himself, who was instrumental in the preservation of these murals, as we will recount in the last chapter of this book) *"felt he'd discovered something of an artistic phenomenon, a missing piece to a connection between a Spanish artist and the Mayan and Aztec tradition in Aztlán. Here it was, a contribution from a nation long associated with conquering this territory, and yet Torres, rather than seeing it as an adversarial relationship, saw it as a beautiful event. Torres could see that it was a celebration of the rich history of Aztlán, and so he welcomed the artwork of Jose Moya del Pino."[136]* To him, the Rathskeller was *"like walking into a temple."*[137]

A year after his work for the San Diego brewery, Moya del Pino was asked to create murals for another beer company, this one based in San Francisco. The Acme Brewing Company had been established in 1907 and had its factory near Telegraph Hill, in the heart of San Francisco, but during Prohibition had been limited to making ice cream, soft drinks and "near-beer." When it was able to resume the brewing activity in 1934, it built a new art deco-style building to house its offices, sales department, and tasting room. For the latter, the brewery commissioned three murals painted in fresco, to describe pictorially the stages that make up the manufacturing and consumption of beer.

Moya del Pino's first Acme mural represents the agricultural work of collecting and crushing hops and barley. The second shows the several steps involved in the beer manufacturing process—boiling, laboratory testing, barreling, bottling. And the third, also known as *A Family Picnic*, represents " *'typical Americans' enjoying the bounty of farming and brewer's arts while they share the joy of family and the Bay Area's incomparable vistas"*.[138] Always attentive to the environment, the painter includes the same motifs in the backgrounds of this mural as those in Coit Tower: the marvelous landscapes of the Bay, with Mount Tamalpais in the background. The model for the central figure, reclining on a picnic blanket with several beer bottles being enjoyed by the group, was the artist's wife, Helen. (Figure 7.3.6, 7.3.7, 7.3.8)

These murals were commented on in *The Wasp* with much praise: *"The manner in which Moya del Pino has handled his frescoes gives a new dignity to the brewery industry. The artist has lifted his subject to his height, has made of it something which is at once beautiful as an art work, informative and entertaining as a record of that industry. It is accurate in description; in most instances it is quite poetical in conception, and it is broad and vigorous in presentation."* The article continues: *"These frescoes by Moya del Pino qualify as work of outstanding merit on every ground. They are interesting and lively in subject matter. Their color scheme is rich, varied and pleasing. In size they admirably fit in with the dimensions of the room."* Of interest is the fact that *"the texture of these murals differs greatly from that of frescoes painted on fresh plaster. Moya del Pino has here followed the Spanish tradition. He has painted on dry plaster, covered with caseine."*[139]

After the brewery closed, the building became the African American Art & Culture Center and the murals have been preserved there to this day.

[135] *San Diego Union Tribune,* July 22, 1934.

[136] Chicano Park Museum, *www.chicanoparkmuseum.org/logan-heights-archival-project/aztec-brewery*

[137] CARONE, A. and BENNET, K. *A Brewery's Vivid Artwork, Mothballed for years.* In *Voice of San Diego,* April 2012.

[138] HOLT, T. *The ACME Brewery Murals.* In *Brewery History,* The Brewery History Society, 2014. 160, pgs. 35-40

[139] *The News Letter and Wasp,* November 23, 1935.

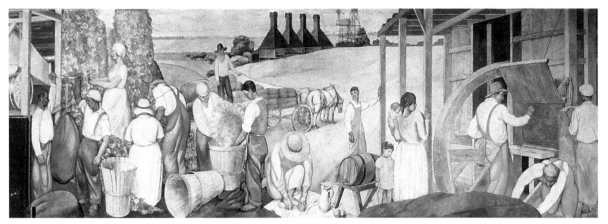

Fig. 7.3.6. Collecting hops and barley

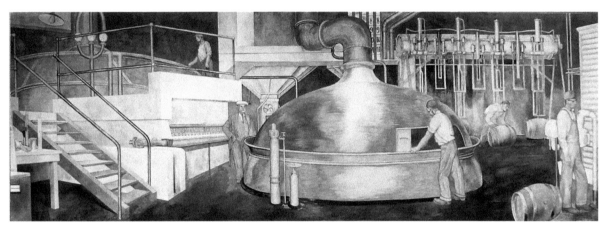

Fig. 7.3.7. The beer-making process

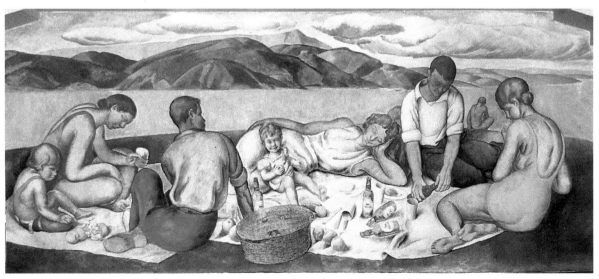

Fig. 7.3.8. 'A Family Picnic"

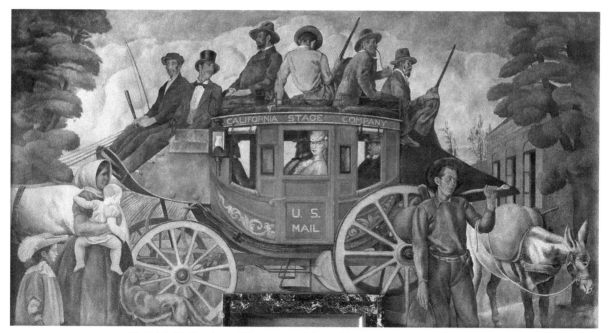

Fig. 7.4.1. 'Mail and travel by stagecoach' mural for Stockton Federal Building

7.4. In the Shadow of the "New Deal"

After the success of his work for the Acme and Aztec breweries, which were private companies that did not depend on public programs for artists, it wasn't hard for Moya del Pino to integrate further into the Federal Art Project (FAP). Post offices in particular were being built all over the country under the public investment program.

The assignment of murals for public federal buildings was awarded after a contest in which painters would present a sketch that was sent to the FAP department of the government in Washington. Those who were awarded the work were paid in three installments, the last one after proving the mural was complete by sending in either a photograph of the finished work or a certificate from the post office administrator.

Judging from the sketches preserved by Moya del Pino's heirs, he must have applied to several of these. In 1936 he won the contest for a mural in the Stockton Post Office Federal Building; the title was *Mail and Travel*

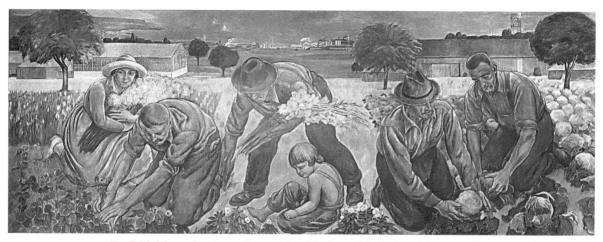

Fig. 7.4.2. 'Flower farming and vegetable raising' mural for Redwood City post office

by Stagecoach, and it depicted the early days of California mail delivery, when passengers and mail traveled on the same coach; *"something like old Wells Fargo,"* the artist recalled later. Men, some of them armed, sit on top of the vehicle, while wealthier passengers enjoy seats in the coach's interior. In the center, the direct gaze of the woman in blue seems to acknowledge the presence of an external viewer. The measurements were 118" high by 220" long it and was placed above the door of the office postmaster. (Fig. 7.4.1)

In 1937 he painted a mural for the Redwood City post office; this town, which nowadays is quite active and considered in some ways the northern gateway to Silicon Valley, at that time was a small town on the edge of the bay, where floriculture proliferated. The theme of the mural was selected to be relevant to the local community and therefore focused on horticulture, gardening and the flower trade, with the title *"Flower farming and vegetable raising."* (Fig. 7.4.2)

Moya was a runner-up in the competitions for murals for the Washington, D.C. Justice Department and the Los Angeles Post Office, but did not get those commissions. In 1940 he applied for a mural for the San Antonio, Texas post office, intending to paint the story of the Alamo and of General Sam Houston. He did not get the commission, but as the runner-up in the contest he was assigned Alpine, Texas, instead. His mural for that post office raised some controversy, although it was also a well appreciated work.

When the painter set to work on his sketches for that mural, he didn't even know where Alpine was. His usual procedure was to visit the site before completing his sketches, to check the placement and dimensions of the space and to get to know the city; but in this case he discovered that Alpine was almost 1,500 miles away from San Francisco. Finding such a long trip too burdensome for his research, he wrote a letter to the postmistress of the Alpine post office asking for information.[140] Moya recalls the exchange: *"The letter was very curious. She gave me all the information about what Alpine wasn't. She told me that Alpine was a very progressive city, Alpine was situated between two towns, it was on the railroad line, halfway between San Antonio and El Paso, and that the town is noted for its famous college called the Sul Ross, a state college, and that the town is famous for long-horn cattle. Then I asked for more details. She sent me a pamphlet of the Chamber of Commerce describing the sights to see in Alpine. Two hundred miles from Alpine, they said, there are the famous Carlsbad caves. Four hundred miles, near San Antonio, there is something there. A famous ranch. Alpine's slogan was 'the biggest town in the biggest county in the biggest state in the Union.' I think there were about 800 people in the town."*[141]

With this information, Moya del Pino painted the mural. The center is occupied by two long horn oxen with reddish hide; in the background is the "city," a small town, and near it a herd of cattle; the upper part of the mural is occupied, from east to west, by a mountain range under a cloudy sky. In this rural environment, the close-ups are surprising: on the left, a young man leans against a boulder reading a book, and at his side,

[140] *https://livingnewdeal.org/biggest-post-office-mural-biggest-town-biggest-state*
[141] Oral history interview with José Moya del Pino, September 10, 1964. Archives of American Art, Smithsonian Institution, Roll no. 3949.

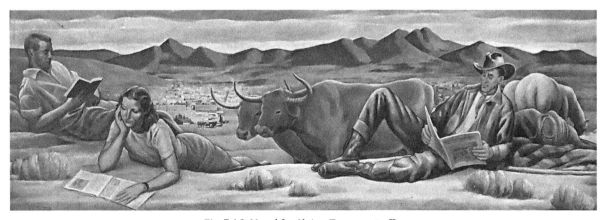

Fig. 7.4.3. Mural for Alpine, Texas, post office

a woman comfortably stretched out on the ground leafs through an illustrated magazine. On the right, a cowboy with riding boots, a bandanna around his neck and a Texan hat, is absorbed in reading a newspaper. The books and magazines symbolized how proud the city of Alpine was of their "university" (which at the time had fewer than 500 students). (Fig. 7.4.3) It is interesting to note that out of all of the post office murals in Texas, Alpine's is the only one that represents an intellectual pursuit rather than local industry.

What was otherwise a positive portrait of the American West, raised some comments when the artist traveled to Alpine to install it. The landsmen who attended the inauguration told him what they thought: that the mural was very beautiful, that the mountains were just right, but... the cattle never get so close to the population, they stay out in the range ... and if any inhabitant wore *"blue jeans like the ones they wear in California, the whole town of Alpine would be after [them]"*[142] ... and above all ... who's ever seen a cowboy reading a book?

But in the end, *"Alpine's post office mural reinforced the community's strong sense of identity and the belief that Alpine was the perfect place to live. The mural combines the advantages of both rural and urban life present in this beautiful West Texas mountain community."*[143] The mural has an area of ten square meters; it was made in oil on canvas and was placed above the door to the postmaster's office. It is still in the same place to this day.

In 1941 Moya painted a mural for the Lancaster, California post office, a city located in the Mojave Desert, near Los Angeles. In this case, his heirs have retained the contract that was signed between the Government of the United States and José Moya del Pino, therefore we can get a good idea of the details of these contracts and the procedure that was generally followed. The mural was to be done in oil on canvas and be placed above the door of the postmaster's office, in the public hall of the building. It was to measure 13'9" wide by 4'9.5" high, and the theme to be developed would be *Hauling Water Pipe through Antelope Valley*. The artist had a period of 212 days to carry out his work and would be paid in three installments: the first, of $150, when the final sketch, at a scale of 2" to the foot, was approved by the Commissioner; the second, of $250, when a full size cartoon of the mural was produced and approved; and the third, of $350, upon presentation of a photograph proving that the final mural had been completed and installed in the post office. The artist would be responsible for all materials costs and installation.

Moya painted a wide desert scene, punctuated by Joshua trees (a type of yucca palm quite prevalent in the southern California desert), with a long line of mules pulling a wagon that carries the pipes to bring drinking water and irrigation to the desert surrounding Lancaster. (Fig. 7.4.4) While researching and performing this work, the artist found particularly interesting the contorted shapes of the desert's Joshua trees, and explored them again frequently in future oil paintings.

[142] Oral history interview, September 10, 1964. Archives of American Art, Smithsonian Institution, Washington, DC.
[143] PARISI, P. The *Texas Post Office Murals: Art for the People*. Texas A&M University Press.

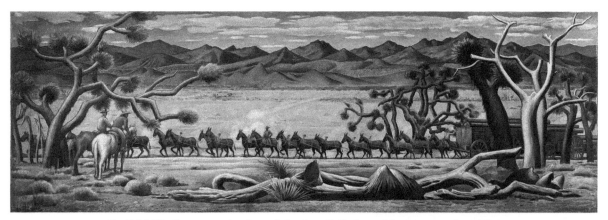

Fig. 7.4.4. 'Hauling water pipe through Antelope Valley' mural for Lancaster Post Office

The artist had no reservations regarding government art sponsorship in this country. When questioned, he shared these thoughts: *"Oh, I think it's wonderful. [...] I have heard artists say, 'You don't want the government in art. You don't want art subsidized. You don't want the government to tell you what to paint.' But they have the wrong idea. A bad government will sponsor bad art, of course. But many good things have been accomplished through government-sponsored art. The pyramids could not have been built without being financed by the Pharaohs. Michelangelo's Last Judgment was sponsored by the Pope who forbade Michelangelo to criticize him. [...] Government-sponsored art is bad if administered with ignorance, put in unsuitable buildings, or forced for the sake of propaganda. But all art has some propaganda and propaganda is not bad, per se. If the ends are ignoble, then of course everything comes out ignoble."*[144]

7.5 The Golden Gate International Exposition

The activity as a muralist gave Moya the opportunity to meet and deal with influential artists, some of whom were already authentic legends. One of these for example was the Mexican Diego Rivera, whom Moya had met years earlier in Madrid when they were both still unknown. When Rivera came to California in 1931 to paint a mural for the San Francisco Stock Exchange, they rekindled their friendship and saw each other frequently. They did not share the same political views, but they respected each other as artists and enjoyed each other's company. Moya had a very positive image of Rivera, whom he considered a cultured and moderate man, who earned a lot of money but who lived simply. He stated years later: *"Rivera, he had a tummy, a paunch, was always full of paint and grease, and cigarette butts. But at the same time Diego had enormous culture. [...] He had been married to a Russian woman in New York. I used to say about Diego, Diego changes his artistic style depending on his marriages. [...] Usually we had lunch together in the cafeteria.*[145] *[...] He was a fellow of immense culture. He liked intellectual discussions, but not political, you know. About non-political matters you could talk with him by the hour. Sometimes I would visit him when he was painting the mural in the Stock Exchange, and I would climb the scaffolding because he liked to talk sometimes when he was painting. I would tell him that I didn't want to distract him, and he would say, 'Oh, Moya, I like to talk. You don't distract me. Let us talk.' And we would talk about anything that came to mind."*[146]

Friendships lead to connections and often collaboration. A very influential connection was the architect Timothy Pflueger. In 1939, along with Rivera and other prominent muralists, sculptors and architects of the area at that time (Fig. 7.5.1), Moya del Pino was called upon by this friend to contribute to a project of epic proportions, and our painter created the biggest murals of his career—though very little from this monumental artwork has survived to this day.

The huge public investments undertaken with the New Deal had started to bear fruit, and in 1937 two highly anticipated projects crossing the San Francisco Bay were completed: the Golden Gate Bridge, the longest single suspension span in the world; and the Bay Bridge, with its tunnel boring through Yerba Buena Island in the middle of the bay—at the time, the longest structure of its kind in the history of man.

To celebrate in some fitting manner these monumental accomplishments, a World Fair was proposed: the Golden Gate International Exposition of 1939-1940; and to host it, a wide, flat artificial island was built on the shoal off of Yerba Buena Island. It was a massive undertaking. The newly created Treasure Island was also intended to serve as San Francisco's municipal airport after the end of the fair; this plan was never realized, as the United States Navy took over the island with the advent of World War II.

The theme chosen for the fair was "Pageant of the Pacific." Moving away from the usual Euro-centric undertones of previous world fairs, it aimed instead to show the world the socioeconomic vitality and cultural variety of the countries and island nations surrounding the Pacific Ocean, promoting their unity

[144] Oral history interview, September 10, 1964. Archives of American Art, Smithsonian Institution, Roll no. 3949
[145] On-site cafeteria at the Golden Gate International Exposition, when both artists were working on independent murals.
[146] Oral history interview, September 10, 1964. Archives of American Art, Smithsonian Institution.

Fig. 7.5.1. A gathering of San Francisco artists and patrons at The Family Farm in 1940. Sitting on the left, Diego Rivera. Standing in the center (the tallest), José Moya del Pino. Artists Lucien Labaudt, Antonio Sotomayor, Otis Oldfield and Phil Little also appear, as well as the president of the San Francisco Art Istitute, William Gerstle, and architect Timothy Pflueger standing at far right.

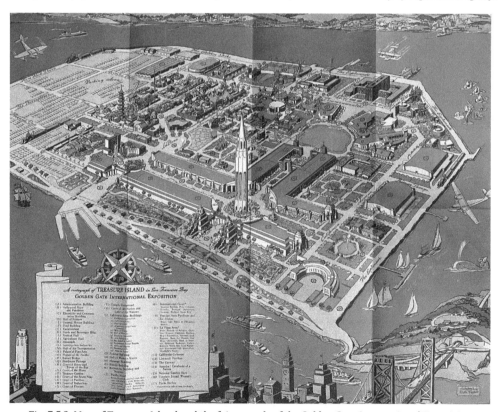

Fig. 7.5.2. Map of Treasure Island and the fairgrounds of the Golden Gate International Exposition, from the official guidebook to the fair

(naturally led by the United States). A number of different buildings, plazas, gardens, monumental sculptures and international pavilions were built, forming a veritable village nicknamed "the Magic City" (Fig. 7.5.2).

Architect Timothy Pflueger was chairman of the committee responsible for the design of the Exposition, and personally selected Moya to create one of the largest of the murals at the World Fair, for the Temple of Religion building; at the same time the architect John Bolles also required some murals for the California building, so the artist had to work on several murals simultaneously. For this he enlisted the collaboration of John Bolles himself, as well as several members of the Marin Society of Artists. The timeline was tight, so painting real frescoes on location was not possible; in fact, most of the artists' murals for Treasure Island (with some notable exceptions) were painted off-site on canvas or masonite. Moya del Pino's murals where painted in sections in a San Anselmo warehouse and then reassembled in their respective places at Treasure Island.

For the largest of the murals in the ballroom of the California building—130 x 30 feet[147]—Moya del Pino evoked the culture of his homeland with the theme *A Spanish Fiesta*. (Figs. 7.5.3 and7.5.4). The ballroom had a black floor, rose walls and a *"ceiling of cello-glass tinted by hidden colored lights."* Eugen Neuhaus, in his book *The Art of Treasure Island*,[148] describes the mural like this: *"The theme (...) seems appropriate in every way to a room devoted to recreation and merry-making. The artist, himself a Spaniard by birth, has drawn upon the store of picturesque customs and traditions of his native country, so rich in color, gallantry, and romance.*

He has translated these into a design exuberant in form and has steeped them in a glowing, somewhat theatrical, but emotionally effective coloring. Caballeros, dancers, señoras playing guitars and

[147] There is some uncertainty about the exact measurements of this mural, as it is inconsistently reported. Moya del Pino described it, in his interview for the Archives of American Art, as being 190' x 44'; John Bolles, who collaborated on the mural, stated in a 1969 speech that it was 120' x 40'; the official guidebook to the fair lists it at 130' x 30'. We have chosen here to use the dimensions from the official guidebook.

[148] NEUHAUS, E. *The Art of Treasure Island*. University of California Press, Berkeley, California, 1939. Pgs. 116, 119.

Fig. 7.5.3. Interior of the California Building showing part of the "Spanish Fiesta" mural

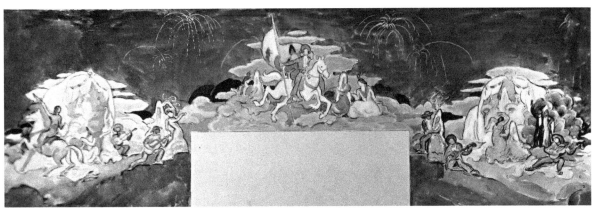

Fig. 7.5.4. Concept rendering for "A Spanish Fiesta" for the California Ballroom, with cutout for the central stage

señoritas in gorgeous shawls and laces have supplied the materials for a grand fantasia of color and form. Of all the settings for a mural, this ballroom with its overpowering red color scheme offered a difficult problem. The artist has executed it as well as could be expected."

But the mural Moya del Pino created for the pavilion called "The Temple of Religion" was the widest mural he ever made: it measured 196 feet wide by 12 feet tall, and for this the artist chose as the theme *The Hand of God*—a series of striking portrayals in an abundance of warm red-brown colors, accompanied by texts from the bible, graphically representing God's role in man's life: birth/creation, understanding, parenting, the sanctity of marriage, hard work, sickness, death, and eternity.[149] (Fig. 7.5.5 and 7.5.6 A – D)

Eugen Neuhaus describes the contents of the mural: *"In subject, color, and treatment it is the direct antithesis of the 'Spanish Fiesta.' The theme is 'The Hand of God,' and the work is a symbolic frieze presenting man's course on earth as directed by a divine power. Here man is progressively depicted from infancy to maturity, engaged in play and in work, engrossed in love, in his family, and finally in his physical decline and death. The guiding hands of the Creator are seen at the beginning, the middle, and the end of this extensive painting, ushering him into this world, blessing his efforts, and receiving him at the end of his earthly career."*

And regarding the formal aspects, the historian gives this assessment: *"It takes an artist of sound academic discipline to deal simultaneously with two so divergent themes, but in spite of this and the handicap of time, Mr. Del Pino has succeeded well. In the 'Spanish Fiesta' the technique is free, unrestricted, joyous, impressionistic, the color is gay and emotionally appealing to heighten the idea of the theme. In "The hand of God" a sober fresco technique is employed, linear, restrained, and dignified, and the color is restricted to the simple range of earth colors of the fresco painter and the total effect is compatible with the setting and the story."*

In the 1964 oral history interview for the Smithsonian Institution's Archives of American Art, the artist himself describes these murals: *"In '39 I did the murals of the Fair on Treasure Island. First I did all the ballroom of the California Building. (...) I did two of the largest murals there. (...) The murals of the ballroom were huge. 190 by 44 feet high. And there was another large one in the Temple of Religion. 195 by 12 feet. That one was called the Hand of God."* A detailed description follows, matching the one by Neuhaus. *"So the hand of God appeared three times in the mural."*

[149] HUNTER, Stanley A. *Temple of Religion and Tower of Peace.* Published by Temple of Religion and Tower of Peace, Inc., San Francisco, 1940.

Fig. 7.5.5. The Temple of Religion; Moya's mural is on the wall at left.

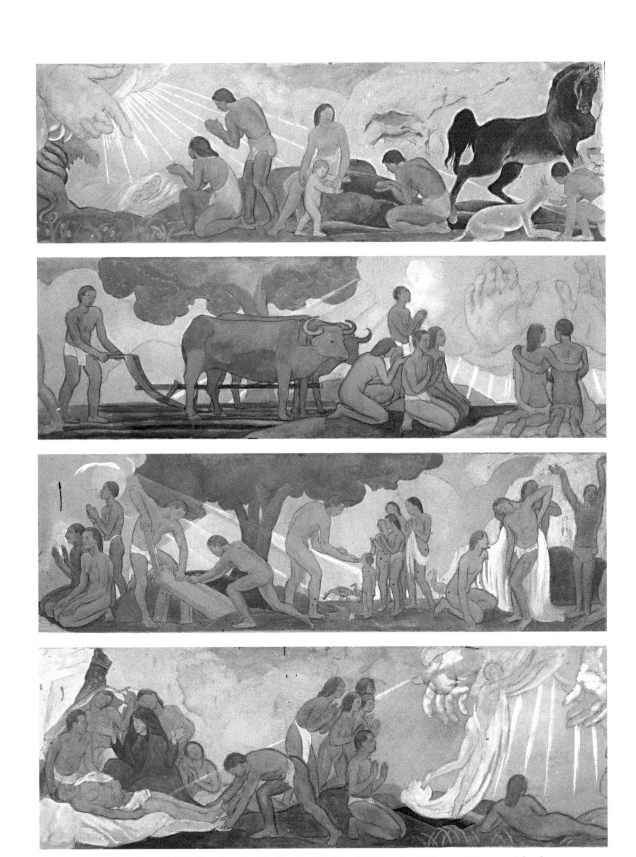

Fig. 7.5.6 A, B, C, D. Sketches for "The Hand of God" for the Temple of Religion at Treasure Island

Over ten million people visited the Golden Gate International Exhibition. Unfortunately on August 24, 1940, a fire broke out in the California Building. Thousands of visitors had to be evacuated and 13 firefighters were injured fighting the blaze; there was extensive damage, and Moya del Pino's murals were destroyed, along with a mural by Lucien Labaudt, a prized electric pipe organ and other artwork.[150] Most other artists' artwork also disappeared at the end of the Golden Gate International Exhibition: no matter how convincing the buildings of an exposition may be, they are not intended to be permanent, and most of what was custom built for the World Fair was demolished at the end of the event. Only a few of the murals were preserved and moved to other locations—notably Diego Rivera's *Pan American Unity*, completed three months after the close of the exhibition: Pflueger had always intended for it to be relocated to a new library at City College of San Francisco, of which he was the principal architect (due to wartime shortages of steel and concrete this project didn't happen until after his death, in 1957).

Fig. 7.5.7. "California," for the California Building at Treasure Island

There are few actual photographs that remain of these murals. However, the Moya del Pino Library has preserved four panels with detailed sketches for the Temple of Religion mural, which coincide exactly with the descriptions made by Neuhaus and Moya himself (Fig., 7.5.6 A, B, C, D); and in the files kept by the artist's heirs are a rough sketch of the *Spanish Fiesta* mural (Fig. 7.5.4), and a photograph of *California*, which had been painted in collaboration with the architect John S. Bolles (Fig. 7.5.7).

7.6. Other Murals

José Moya del Pino continued to paint murals for the rest of his life. In 1947 he painted murals for the art deco tap room of the Great Western Malting Company in Vancouver, Washington, representing farm workers hand-harvesting and soaking barley; that building has since been demolished but the murals were preserved and moved to the new building. And in 1949 he was commissioned to create a mural for the Rossi Brothers pharmacy in San Anselmo, north of San Francisco.

In its day, the Rossi Brothers pharmacy was hailed as one of Marin County's most modern structures, and became the region's leading source for luxury beauty and fragrance products. The almost life-sized mural spanned the entire back wall of their newly constructed drugstore and depicted the historic evolution of pharmacology (Fig. 7.6.1 and 7.6.2 A & B). It was meticulously researched, beginning with the early Egyptians (represented by Hermes Trismegisto, personification of Toth, the Egyptian god of science and learning), going through Babylonian times (Urlugaledinna), Greek and Roman alchemists (Hippocrates and Galen), and medieval times (Avicenna and Roger Bacon). The alchemist Nicolas Flamel follows; Paracelsus is represented by the books *Paragranum* and *Paramirum*, the Renaissance by Johann Glauber. There being too many discoveries and notable pharmacists in modern times, only some highlights are represented; singled out are

[150] *New York Times*, August 25, 1940. Pg. 36.

Fig. 7.6.1. The Rossi Brothers pharmacy when it first opened, with Moya del Pino's mural on the back wall.

Fig. 7.6.2 A & B. "History of Pharmacology" mural for the Rossi Brothers pharmacy in San Anselmo

Karl Wilhelm Scheele and "father of American pharmacists" William Proctor. The mural ends with one of the Rossi brothers preparing a prescription, and on the side of his counter is tacked a parchment with the pharmacist's oath.

This too, like many of Moya's other murals, was "fresco secco," meaning painted on dry plaster, usually on casein or with casein paints: casein can resemble oil painting more than most other water-based paints, works well as an under-painting, and dries to an even consistency, making it ideal for murals. The pharmacy was demolished in 2013 but the mural was carefully taken down and has been preserved.

In 1958, the Paul Masson Winery and Distillery hired Moya's friend, the architect John Savage Bolles, to design and build the new Paul Masson Champagne Cellars in Saratoga, California. The architect designed a spiral walkway leading to the entrance of the second floor, and commissioned Moya to decorate the interior of that ramp with a mural, proposing that it should look like a mosaic and that the theme be the history of winemaking. The painter's work was widely commented on and described in detail in the February 1960 issue of the magazine *Tile & Architectural Ceramics*; and the book *Gift of the Grape* included a photo by Ansel Adams and Pirkle Jones of Moya del Pino working on the mural (Fig. 7.6.3).[151] Unfortunately the building was demolished in 1990 and the lot was subdivided, part of it dedicated to the extension of Highway 85, and part to a townhome housing development; the mural was destroyed along with it.

Paul Masson manufactured not just champagne, but also wine, brandy and other liquors; and Moya demonstrated that his artistic skills could also shine in other genres of the plastic arts, designing a series of brandy decanters that can still be found and purchased online today. (Fig. 7.6.4)

[151] REEVE, L.E and REEVE, A.M. *Gift of the Grape*. Filmer Brothers Publishing, San Francisco, 1959.

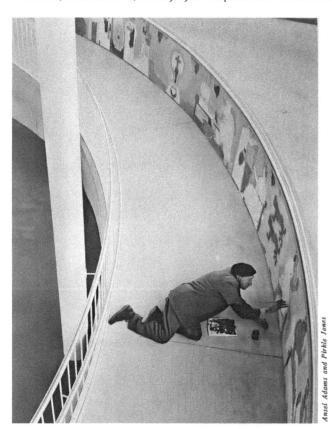

Fig. 7.6.3. Moya del Pino painting the "History of Winemaking" mural for Paul Masson Champagne Cellars.

Fig. 7.6.4. Brandy decanters for Paul Masson Wineries; authorship on bottom of decanter

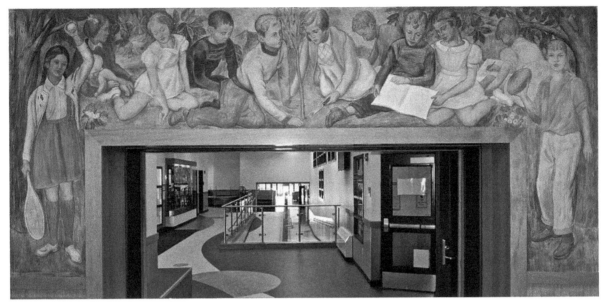

Fig. 7.6.5. Mural for the Elementary School in Ross, California. All the children depicted were pupils at the school, including the artist's children Tina (third from left), Mickie (in the background wearing a blue shirt) and Yana (third from right). For more on the artist's family see also pages 110 – 112.

Moya del Pino also painted several murals for other individuals and private institutions. Among them are a large Joshua tree for the home of the Burns family; and children studying and at play for the elementary school in Ross, where his own son and daughters as well as several of their schoolmates acted as models (Fig. 7.6.5). For the Bolles family dining room, he painted a 10' x 18' night-time view of the San Francisco skyline and bay (Fig. 7.6.6): *"a spectacular original San Francisco Cityscape (...). Along with Treasure Island, the Bay Bridge, Alcatraz, the Ferry Building, Coit Tower and the Golden Gate Bridge are just a few of the San Francisco landmarks easily identifiable in the mural."*[152] When ownership of the Bolles property changed, the new owners appreciated the value of the mural enough to add a condition to the deed of the house stipulating for future owners that the art may be covered over if undesired but may never be destroyed, painted over or removed.

He also painted a whimsical cabaret scene on all four walls of the den in the Bosco family home (Fig. 7.6.7 A & B). The artist approached mural painting differently depending on whether the subject was intended for private viewing or for the broader public. He never neglected the theoretical aspects of what he was doing, and wrote an interesting article entitled *Mural Painting* in the magazine *The Wasp*, in which he highlighted the value of this specialty by stating that murals should not only have a decorative function but should be an integral part of the buildings they are created for. As for their contents, he affirms: *"I conceive two systems of mural painting: that designed for public and official buildings that for their civic character require the heroic mood, equivalent in poetry to epic form; and that destined for private homes, intimate in character corresponding to the lyric form. In both moods nature should be governed, and the representation of natural images subordinated to the plastic element of the composition, to the architectural structure of the design."*[153]

[152] *Pacific Heights Architects, #11 – John S. Bolles.* David Parry, September 2002. *https://150290062.homesconnect.com/ AccountData/150290062/NF11Bolles.pdf*
[153] *Mural Painting.* In *The Wasp*, May 6, 1933.

Fig. 7.6.6. San Francisco Cityscape for the dining room of the Bolles' family home

Fig. 7.6.7 A & B. Cabaret scenes for Bosco residence

Professor and Influential Artist

8.1. Moya del Pino's Work as a Teacher

By the end of the 1930s, José Moya del Pino had become a recognized artist in California on his own merits. He was even an influential intellectual in some cultural circles, since, in addition to his increasingly valued artistic work, he taught courses, gave lectures, published articles and essays that gave him prestige, and participated in forums and juries where his opinion was held in high regard.

He was first hired as an instructor in 1935 by the San Francisco Art Students Association, where he taught mural composition, still life, and painting in general. By the 1940s he was teaching mural painting at the California School of Fine Arts (now called San Francisco Art Institute), and taught painting and art history at the Katharine Branson School in the city of Ross. He also taught painting at the College of Marin; perhaps it was in this latter institution where his mark was most felt, because he was a professor there for over 15 years (from 1947 to 1963)—after which, and after an affectionate farewell, his name no longer appears in the college's published documents.

Moya del Pino also taught portrait painting in his home studio, located in a lush setting at the back of the garden of his home in Ross, California.

8.2. New Exhibitions and Prizes

In parallel with his teaching, Moya's artistic work continued. Let's get back to his series of exhibitions and awards, a discussion that was interrupted by our chapter on murals after describing the success Moya del Pino had achieved in 1933 with the painting *View from Telegraph Hill*, for which he had won a prize at the California State Fair held in the state's capital, Sacramento.

This prize was important for Moya because until then his portraits had been highly valued but his landscapes hadn't achieved much recognition. Encouraged by this success, and alternating with creating murals and contributing paintings to group shows, the painter prepared a one-man exhibition to present his landscapes and still lifes, which opened at the San Francisco Art Center in the first days of February 1935. On this occasion, the critic Junius Cravens, who had previously been rather critical of Moya's work, openly stated that the 20 canvases hanging in the exhibit showed that *"that capable Spanish-American painter is to be ranked among the foremost artists of California."* His analysis was unequivocally complimentary: *"...his experiments with various styles are based upon fundamentals. (...) There is no monotony in Del Pino's show. He makes a different approach to the painting of each canvas, yet he succeeds at the same time in maintaining his integrity. It is seldom that one sees a finer landscape than his 'Downieville,' or a more luscious still-life than 'Majolica Vase,' or a more whimsical, beautifully painted head than that of 'Christmas Child.' No three paintings by any one artist, could be more diverse in style, yet they are all completely and unmistakably his own."*[154]

[154] *San Francisco News*, February 16, 1935.

Fig. 8.2.1. "Christmas Child" *Fig. 8.2.2. Still life* *Fig. 8.2.3. Still life*

In August of the same year he participated in a collective show at the Artists Cooperative Gallery in San Francisco with eight paintings; on this occasion the press highlighted two works in particular: *"Eight fine paintings by Moya del Pino in the current exhibition at the Artists' Co-operative Gallery, 166 Geary Street, make one regret that he is not having a one-man show. His large genre painting: 'Peasant's Funeral in Spain,' the picturesqueness of which does not detract from the solid painting of the figures, and the spirit embodied in the subject, displays the brush-power of this artist, as well as his whole-hearted responsiveness to fine subject matter. 'Sleeping Child' is not so much a potent work as it is lovable. The careful modeling and the delicacy of the drawing are, in themselves, elements of beauty, not often conceived and created as beautifully as they are here."* [155]

Similar to the *Peasant's Funeral* is a painting from 1937 titled *Procession*, and both works clearly must be a remembrance from his youth. Here a double scene unfolds over a strange landscape that could be somewhere in northern Spain at the beginning of the twentieth century: at the top, just outside a chapel, a procession forms and the Virgin carried on a litter starts her pilgrimage following a guiding cross; below, men and women in typically regional dresses wait around the cross of a medieval-looking shrine. (Fig. 8.2.4)

In September of that year Moya won the Anne Bremer Memorial Purchase Prize in the first Graphic Arts Exhibition of the San Francisco Art Association. The winning work was *Saints and Sinners*, which the San Francisco Museum of Art purchased for $100. The News Letter and Wasp commented: *"When you see the prize winning painting, 'Saints and Sinners,' by Jose Moya del Pino, so overwhelmingly excellent, all the rest of the show perforce takes second place. Here is a work which transcends everything else in the exhibition. The content is big; the colors are rich and subtle; the drawing is beautiful. It*

[155] *The News Letter and Wasp*, September 7, 1935.

Fig. 8.2.4. "Procession"

Fig. 8.2.5. "Saints and Sinners"

is sculptural, so strong is the modeling of the figures, and yet it is fluent, easy and natural in its manner. No 'Old Master' will put this watercolor to shame, anywhere, at any time.[156] (Fig. 8.2.5)

Saints and Sinners depicts the scene of the burial of Christ, a relatively frequent theme in the history of art in the Christian world. Looking at Moya del Pino's painting, a similar image immediately comes to mind—a composition we thought we had seen somewhere before. Intuition took us to the Museum of Fine Arts in Granada,

Fig. 8.2.6. "Burial of Christ" by Jacopo Torni

[156] *The News Letter and Wasp*, September 21, 1935.

precisely that city where Moya del Pino had his first period of serious learning. That museum holds the *Burial of Christ* by Jacopo Torni, a carved polychrome wood relief of 195x255 cm. dated around 1526 (Fig. 8.2.6). We cannot help but think that during his years in Granada, Moya del Pino contemplated this work, whose composition, with the disciples and the mother of Christ surrounding the body, is not frequently seen; and it is very possible that its great drama had a strong impact on him. Thirty years later, the image emerged again in the artist's memory and became a transcendent work.

In 1937 the artist won first prize and guest of honor at the Oakland Art Gallery for his *Self-Portrait* (the first one shown in the Appendix). In 1938, out of a selection of paintings presented at the "San Francisco Annual," the *Sacramento Union* highlighted *Monks* (Fig. 8.2.7) with a large photo spanning two columns.

Fig. 8.2.7. "Monks"

Fig. 8.2.8. "Farm Woman"

Fig. 8.2.9. "The Shepherd"

Fig. 8.2.10. Still Life

Fig. 8.2.11. Landscape

The same year, Moya del Pino participated in an exhibition of watercolors at the Kingsley Art Club at Crocker Gallery in Sacramento, and the press clearly stated that, out of the 13 paintings presented, the only two works *"that seem to have come off"* are by Moya del Pino and one other artist. *"Del Pino's portrait of a farm woman, who is as tawny in coloring as the dry California hills that serve as her background, remains in the mind's eye after much of the exhibit is forgotten"* (Fig. 8.2.8), while the works by some of the other painters that had worked on Coit Tower with our artist fall short: Oldfield *"sacrifices good draughtmanship,"* Berlandina *"loses her light touch"* and Lucien Labaudt is *"disappointing"* and his work *"remains sterile."*[157]

The work of his fellow-muralists however did have some influence on Moya del Pino, at least on his willingness to address social or political issues. This is evident in two cartoons for murals that he made probably around 1939 or 1940, illustrating labor relations and women's suffrage (Fig. 8.2.12 & 8.2.13). It is not known what building these were intended for. Other sketches have been found among his papers that show his support for women's rights.

Moya del Pino's exhibitions continued, and his assistance was often requested as a member of the jury in contests for the selection of artistic work for different exhibitions. He had first been tapped to sit on a jury in 1936, for the San Francisco Art Association Anne Bremer Purchase Prize, the same prize he himself had won the previous year with *Saints and Sinners*.[158] The Kingsley Art Club of

Fig. 8.2.12. Lady Justice arbitrating a dispute between workers and employers

Fig. 8.2.13. Emancipation of woman through suffrage

[157] *Sacramento Bee*, October 22, 1938.
[158] HAILEY, Gene. *California Art Research,* volume XIII. Works Progress Administration, San Francisco, 1937.

Sacramento asked him to be part of the jury of a painting contest in March 1938, and in August of the same year it was the San Francisco Museum of Art to ask him to participate in the selection committee for their Rental Gallery. He continued to serve on juries until his retirement; the last one was for a murals competition sponsored by Marin General Hospital and the Marin Society of Artists in 1963.

"Boys with Cat," one of the canvases by T. Moya del Pino, in the one-man exhibit of del Pino's paintings now showing in the Kingsley room at Crocker Art gallery, has a delectable freshness and charm.

Fig. 8.2.14. "Boys with Cat"

On the national level, in the 1930s and '40s Moya del Pino took part in exhibitions such as the Corcoran Biennial in Washington, D.C. (1937, with *Boys with Cat*, Fig. 8.2.14), the Richmond, Virginia, biennial (*Christmas Child*, Fig. 8.2.1), and the Pepsi Cola Painting of the Year (with *Joshua Tree Arabesque* in 1947, Fig. 8.3.10, and *Tree, Sea and Rocks* in 1948). Also worth mentioning is a series of landscapes the artist painted in the late forties and early fifties, after visiting the Mojave Desert to paint the mural for the Lancaster post office in 1941 (Fig. 8.2.15 – 8.2.18). In this series, titled *Joshua Tree,* Moya plays with the contorted and parched shapes of the trees that live in the desert. The painting *Joshua Tree Arabesque* was prominently featured in the *San Francisco Chronicle*. The *Chronicle*'s critic, Alfred Frankenstein, was unimpressed with most of the work by Bay Region artists on show at the San Francisco Museum of Art, but commented: *"In every exhibition of this sort, some of the old timers are always included because some of the old timers are always included, and that seems to be the reason for the presence of some of them here. A marked exception to this is José Moya del Pino, whose 'Joshua Tree Arabesque' is an extraordinarily dramatic affair."* A large photograph of Moya's painting was included with the article.[159]

From a lecture on theory of art that Moya gave at the Kingsley Art Club, another newspaper[160] explained his approach to painting: *"Del Pino sketched his own life, because no artist could be an impersonal critic of the work of others, able to look at it without the prejudice of his own likes and dislikes. 'I am glad that my childhood was spent in a small town in the south of Spain,' he said. 'Europe and Spain in particular form a better background for an artist, as there it is a part of the lives of the people. They are unsophisticated but they love and enjoy art. In America art is like the potatoes,' the artist illustrated. 'It is taught in your schools and exhibited in your museums, but it is bought and sold like the potatoes, not with a real love of the people.' The American art school cannot do the work that apprenticeship to a craftsman, the practice of European countries, is able to, according to del Pino. 'I am now a California artist,' he said. 'Sincere art is like a seed— whatever its origin it takes on the characteristics of the soil in which it is placed.'"*

8.3. World War II

Perhaps because of this new self-identification as a Californian, a parenthesis in Moya's artistic work is observed between 1942 and 1945, motivated by a significant episode in the painter's life related to World War II. Just as he did in Paris in 1914, when he volunteered for the French army and performed support work for World War I, he showed the same attitude at the time when the United States declared war on Japan and intervened in Europe against Germany. Wanting to help the war efforts, Moya intended to enlist in the US Navy, but was rejected because he was already over fifty years old. He then presented himself to the US Army at Marinship, not far from his home, where the "Liberty ship" warships and tankers were built; he offered himself as a painter, thinking that he could work in the "mold loft" (the casts and molds department) and contribute

[159] The *San Francisco Chronicle*'s Music and Art Section actually published, on different occasions, large photos of two different *Joshua Tree* compositions —the first of which was on show at the San Francisco Museum of Art (August 15, 1948) and the other on exhibit at The City of Paris (October 16, 1953).

[160] The exact publication is unknown, as the masthead is missing from the newspaper clipping retained by Moya del Pino's heirs.

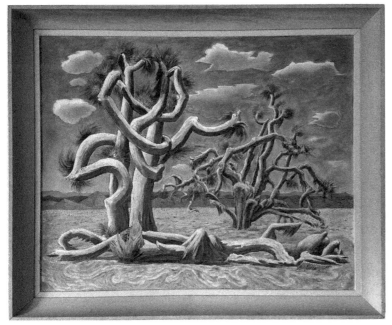

Fig. 8.2.15. "Joshua Tree"

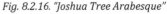

Fig. 8.2.16. "Joshua Tree Arabesque"

Fig. 8.2.17. "Joshua Tree"

Fig. 8.2.18. Joshua Tree mural for Marin Art and Garden Center

to the drafting of schematics for ships or naval machines. Those responsible for hiring misunderstood what he meant by "painter" and assumed he was an industrial paint worker; they asked him to join a workers' union, gave him a bucket of red paint and hired him to paint the hulls of the new ships: *They put a brush in one hand, a bucket of paint in the other, and I went around that way for the next three years.*"

This work immersed him in a different type of society from what he was used to by now. But he enjoyed good camaraderie with his coworkers at Marinship. They called him "Swede," despite his protests that he was Spanish, because they saw him as a tall and light-skinned man, with piercing blue eyes—not the Hispanic type they were used to. They must have misunderstood the nationality: eventually they arranged for a "Spanish reunion" so Moya could meet his fellow countrymen—three Mexicans and two Filipinos.[161]

[161] *I Call It My 'Red Lead' Period.* Interview by Amber Eustus in the *Independent Journal*, June 13 1959. Another episode was recounted in the San Francisco Chronicle by popular local color columnist and humorist Herb Caen: every morning Moya's wife Helen prepared for his lunch pretty sandwiches with the crusts neatly cut off—elegant but probably better suited to a cocktail party than to a work lunch; one day a burly coworker took pity on him and, fearing he would go hungry, offered Moya his own hefty hoagie: "Here, Moya, you need this more than I do."

Fig. 8.3.1. Moya del Pino painting part numbers on steel beams at the Marinship shipyard

Unfortunately this proved to be extremely hard work. Moya would leave home early in the morning and return home after dark, often too tired to talk with his family. At the shipyard he had to lie on his back squeezed between the double hulls of the ships, holding a buffing machine over his head to buff off the rust; breathing in these rust particles, combined with the fumes from the lead paint, caused him to fall ill with bronchitis. He took a leave to recover and as soon as he felt better he did not hesitate to return to work—this time painting part numbers on steel components (Fig. 8.3.1). However, he continued to have respiratory difficulties the rest of his life.

Despite the fact that his work was hazardous to his health, had no use for his artistic ability and offered no opportunities for creative expression, he remained determined to do his part to contribute to the war efforts; in fact, when a Swedish tile worker saw him at the shipyard and recognized him for the well-known painter that he was, and protested to the supervisors, Moya demurred and continued working. Years later, he commented on this wartime episode with humor calling it his "red lead period"—a reference to the "blue period" so prominent in Picasso's early 1900s work.[162]

Many of Moya del Pino's friends were doing what they could to aid in the war efforts as well. Otis Oldfield, who had also been teaching at the California School of Fine Arts at the time, recalled that *"the boys were all going into the Marines and the girls were going into the WACS or WAVES"* while many instructors went to the shipyards where they could serve as draftsmen.[163] But deep down, Moya showed a very clear facet of his personality: his attitude of service and generous and grateful commitment to the country that had welcomed him and which now felt like his new homeland. This attitude was shared by his wife Helen, who signed up to be Air Raid Warden for their neighborhood. The mid-forties were dire times and everybody contributed in whatever way they could.

This was a very difficult period for Moya del Pino also from a professional point of view. He had been teaching at the California School of Fine Arts (CSFA) before taking his leave of absence to aid with the war efforts; and he expected to return to teaching at the end of the war. However, during that time Douglas McAgy became director of CSFA and proceeded to hire as new professors Clyfford Still, Hassel Smith, David Park, Elmer Bischoff and Richard Diebenkorn, inviting New York artists Mark Rothko and Ad Reinhardt to teach summer sessions as well. The school soon became a hub for American Abstract Expressionism. This rupture movement had been initiated by W. de Kooning, Jackson Pollock and other New York-based artists, and was spreading rapidly not only in the United States but also in Europe. The works of these painters were

[162] *I Call It My 'Red Lead' Period*. Interview by Amber Eustus in the *Independent Journal*, June 13, 1959.
[163] Oral history interview with Otis Oldfield, May 21, 1965. Archives of American Art, Smithsonian Institution.

characterized by the execution of energetic, gestural, even violent strokes and by a drastic reduction in the range of colors, seeking to provoke visual sensations of anguish and conflict. Suddenly, representational painters such as Moya were considered old-fashioned and were ousted from the school one by one. Clyfford Still, in particular, who painted huge canvases with a paint roller rather than paintbrushes, wrote numerous articles ridiculing representational painters; this added insult to injury for Moya, who had not only lost his main source of income but now had his entire artistic identity brought into question.

8.4. Approach to Abstract Expressionism

Perhaps in an attempt to expand his style, in the late 1940s and early 1950s Moya tried his own hand at abstract expressionism. Some of the artist's paintings that are representative of his approach to this movement are those titled *Starry Night, Movement of Water over Rocks, Mountain pass, The Swimmers, In the Forest, The River* (Figs. 8.4.1 – 8.4.7). Several paintings of this era employed a theme of water or rocks, and were made during the summer vacations that the family took near the Truckee River in the mountains of the Sierra Nevada, in northern California.

This phase didn't last very long. Years later, when putting together some notes for an interview or autobiography, Moya del Pino wrote: *"Like other Spanish artists of my generation that had, thorough academic training and in Paris, joined forces with the Cubists painters, I have always been torn between abstraction and realism. At my return to Spain,[164] the contact with the traditions of El Greco, Velasquez and Goya made me abandon cubism, but cubism left its imprint in my thinking. When I came to America and established myself in California I felt that I had been transplanted too often and to too many soils. Only recently have I begun to feel that I am taking roots here. I painted before the last war a few abstractions but have come back more and more to the interpretation of reality in a direct simple way. The only residual of cubism left on me is my desire to recreate nature in terms of ordered design. To me the strength of the school of Paris has been spent. The latest antics of Picasso, whom I once greatly admired, made me think of him as the 'Lucifer' in the mystery plays of the middle ages, writhing in contortions at the sign of the Cross."[165]*

[164] When the artist returned to Spain after years in Paris following his trip financed by the Prix de Rome.
[165] Moya del Pino's own writings, preserved in the Archives of American Art, Smithsonian Institution, Washington, D.C.

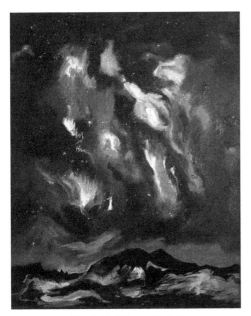

Fig. 8.4.1. "Starry Night"

Fig. 8.4.2. "Movement of Water over Rocks"

Fig. 8.4.4. "The Swimmers"

Fig. 8.4.3. "Saint John of the Cross"

Fig. 8.4.5. "River Rocks"

Fig. 8.4.6. "In the Forest"

Fig. 8.4.7. "Mountain Pass" (also known as "Korean War")

If this last statement feels somewhat harsh, Gary Scales, former Trustee of the Moya Library/Ross Historical Society, proposes an interesting explanation. In 1957 Picasso had recreated, in his characteristically cubist form, 45 interpretations of the work *Las Meninas* by Velázquez, consisting of isolated figures, heads and groups of characters as well as interpretations of the whole (the complete series of 58 works also included nine scenes of doves, three landscapes and a portrait). And even before doing this work, Picasso had commented:

"If someone wants to copy Las Meninas, entirely in good faith, for example, upon reaching a certain point and if that one was me, I would say...what if you put them a little more to the right or left? I'll try to do it my way, forgetting about Velázquez. The test would surely bring me to modify or change the light because of having changed the position of a character. So, little by little, that would be a detestable Meninas for a traditional painter, but would be my Meninas." [166]

To Moya del Pino's eyes, this might have seemed almost blasphemous. Moya had been so dedicated to maintaining the purity and integrity of Velázquez's spirit, including grinding the pigments according to 17th century recipes and exactly duplicating the dimensions of the original works to achieve a result as close as pssible to the original; and Picasso's extreme reinterpretation of the great master's most famous work would have seemed profoundly arrogant. (Moya del Pino's daughters on the other hand believe their father would have been most receptive to Picasso's reinterpretations of the classics—Moya simply didn't like Picasso's self-aggrandizing personality.)

Explaining his point of view more generally, Moya also gave a lecture at the Kingsley Art Club in Sacramento, entitled *"Abstraction or representation: the future of the artist"* in which he explained: *"...the art of today, for the first time since the cave man, has become completely out of touch with visual reality. What's more, this type of art is gradually being accepted and understood by more and more people, and thus is becoming slightly old hat. The moment something gets old, the artist wants a change,"* which is why the current *"advance guard among artists"* is now turning again towards realism—but a new kind of realism from the pictorial kind.

It is also at this time that another memory resurfaces from Moya's homeland, Spain—a memory that it is reflected in only two paintings. The first (Fig. 8.4.8) has a sufficiently clear title: *Sigüenza* (1949). The second is entitled *Remembrance of My Village* (1952) and represents a town with its houses lined up and perched on the edge of a cliff that occupies the lower two thirds of the picture; anyone who knows the area south of Córdoba will recognize Priego, Moya del Pino's birthplace. (Fig. 8.4.9)

[166] Picasso to Jaime Sabartés, 1950; from *https://en.wikipedia.org/wiki/Las_Meninas_(Picasso)*

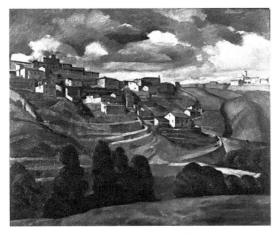

Fig. 8.4.8. "Sigüenza"

Fig. 8.4.9. "Remembrance of My Village"

Fig. 8.5.1. Helen and José Moya del Pino
with newborn daughter Beatrice Diana

Fig. 8.5.2. Helen with daughters
Beatrice Diana and Clementina Elena

Fig. 8.5.3. Moya with daughters Beatrice Diana
and Clementina Elena and sister
Maria Desposorios ("Tia Esposíta")

Fig. 8.5.4. Beatrice Diana ("Yana"), Clementina Elena ("Tina"),
and Clemente Miguel ("Mickie")

8.5. Moya del Pino's Family

We have given much attention to José Moya del Pino's artistic career; but like any artist, his personal life greatly influenced his work. Many of his paintings are portraits of his family members and landscapes visited during their vacations, so it seems appropriate to touch on his family life here as well.

After their marriage in 1928, Helen and José Moya del Pino had three children. On January 9, 1934, their daughter Beatrice Diana ("Yana") was born; on August 7, 1935, Clementina Elena ("Tina") and on March 22, 1938, Clemente Miguel ("Mickie") (Figs. 8.5.1 – 8.5.4). For their first child, the couple painted a cradle with nativity scenes on three sides and Noah's Ark on the back, with Yana's name on the rim and this inscription: *"Este niño chiquito no tenía cuna / su padre es carpintero y le ha hecho una."* Helen, an accomplished painter herself, actively contributed to the work; her daughter points out that it's easy to determine which scenes were painted by whom, as Helen's are populated with cheerful figures and animals while her husband's are rather more solemn. As the other children were born, their names were added to the rim of the cradle; and later, the names of each grandchild were added as well. This heirloom is still kept by Moya del Pino's heirs. (Fig. 8.5.5)

Fig. 8.5.5. Hand-painted cradle with chidren's names and nativity scenes

In 1938 the family moved into their newly built house on Laurel Grove Avenue, in Ross, a town in the San Francisco Bay Area located north of the Golden Gate. The house was designed and its construction directed by the architect Gardner Dailey, who had originally introduced Helen and José to each other, and who later would also collaborate on several projects for the Marin Art and Garden Center, as we will see next.

Moya painted a lovely mural in the living room of his new house. Under the branches of a tree in full bloom, two girls and a boy play, clearly Helen and Moya's children, dressed in white, the color of innocence; the little one, Clemente Miguel, whom they called Mickie, must be no more than two years old. There is also a little white dog, and on the ground are flowers from which a basket on a red cart has been filled. It is a small, intimate world, the peace of home, the unforgettable happiness of childhood. (Fig. 8.5.6)

Beatrice Diana (Yana) graduated from Stanford University and married Giovanni Coda Nunziante, an Italian national descending from a long line of that country's nobility. Shortly after the wedding they went to live in Italy where they had four children: Paola, Carlo, Anna and Elena, the first three born in Naples and the last in Siena.

Clementina (Tina) studied in Vienna and married Ernest Kun, a leading biochemist and cancer researcher. Like their son, Albert, she resides in California.

Clemente Miguel (Michael, or Mickie) became an engineer, married Anne Casey (who took the surname Moya del Pino after their wedding) and they had two children, Anita and Nicolas. Michael died in 1984; his son Nicolas, married to Brittany Conetta, has three children named Michael, Katie and Natalie Moya del Pino—this branch of the descendants of the painter is the only one that will keep carrying forward the Spanish surname of their grandfather. (Fig. 8.5.7)

Moya del Pino had united his family in California with his mother and sister, who traveled as exiles from Spain in 1937 to escape the civil war. His sister Esposíta earned some money by teaching Spanish, supplemented by an allowance that Helen passed to them. The family remembers that Carmen, the mother, never learned English; she died of natural causes in 1948.

Moya's home and social life were an extension of his ebullient personality. He was known as an enthusiastic storyteller, and genuinely loved people, both as subjects for paintings and as friends. He preferred to be called "Moya" than "José," loved good food and good wine, and according to a letter kept among his papers, he had a reputation for making great martinis.

Fig. 8.5.6. Mural in the dining room of Helen and José Moya del Pino's house in Ross, California

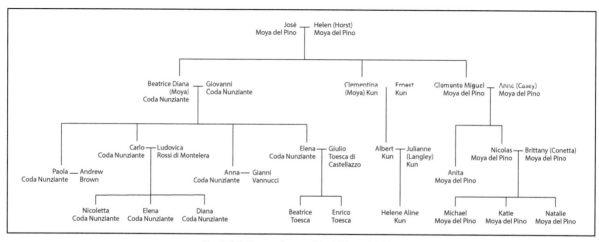

Fig. 8.5.7. Descendants of José Moya del Pino

8.6. Social Life: The Marin Art and Garden Center

The Marin Art and Garden Center is today an important cultural institution in Marin County, north of San Francisco. Since Helen and José Moya del Pino's family was from the beginning one of the engines of its creation, and since their social life was closely involved with this center from around 1945 on, it is worth delving into its history with some detail.

Between 1860 and 1930, the estate that is occupied today by the Marin Art and Garden Center, with an approximate area of 10 acres, was property of the Worn and then Kittle families; it was used as a residence and place of recreation. In 1931 a fire caused the abandonment of the property; few buildings were left standing, among them a barn that had been converted into an automobile garage, and the octagonal-shaped water tower. The post-World War II population boom and a trend to suburbanization drove people from nearby San Francisco into the suburbs, and the property risked being subdivided and urbanized, as was happening more and more frequently in that area. Given that the location had exceptional natural value in terms of trees and garden plants and a stream of clean water, it attracted the attention of the Marin Garden Club, a group of citizens dedicated to the preservation of public lands and the beautification of local towns. A movement emerged to acquire the estate to preserve it for community use, led by Caroline Livermore (Fig. 8.6.1), an energetic

Fig. 8.6.1. Portrait of Caroline Livermore by José Moya del Pino

woman who was also instrumental in establishing the Point Reyes National Seashore and other state parks in the area.[167] Helen Horst and José Moya del Pino participated from the beginning.

One of the goals of the center was to provide permanent quarters for the Marin Society of Artists; but artists alone could not support such a project. Moya del Pino had an idea. While exhibiting the Velázquez copies in Philadelphia years earlier, he had been impressed by the structure of the Philadelphia Art Alliance, an organization composed not just of artists but also various cultural associations including musicians and literary people. Moya sent for their constitution to use as a model, Caroline Livermore gave financial backing, Helen contributed her passion for landscaping, and Moya put at the service of the project his capacity for initiative and his prestige, both as an artist and as President of the Marin Society of Artists. Art, music and theater organizations were invited to join, and the center was officially inaugurated in 1945 with the name of Marin Art and Garden Center, with Caroline Livermore as its President and José Moya del Pino as Vice President. A long process of rehabilitation, creation of entities and programming of activities began.

The old nineteenth century barn that had survived the fire had been converted into a theater hall; the Ross Valley Players group, one of the center's founding guilds, is still based there. A building to serve as the headquarters of the Marin Society of Artists was added by Gardner Dailey in 1948. This building also served as an art gallery and as studio or workshop for amateur painters in the area; Moya del Pino managed it from the start and remained as an advisor until the last years of his life. The Pixie Park playground was inaugurated in 1952, with the Pavilion (a playroom and indoor space for children's activities) added the following year. A new building was erected in 1957, and today serves as a conference and reception hall honoring the name of Caroline Livermore.

[167] Much of this information derives from a detailed history of the Marin Art and Garden Center compiled by Carol Roland Nawi.

Two of Marin's leading artists, Ida May Degan, sculptress and Moya Del Pino, painter, with examples of their art, plan the Marin Society of Artists' participation in the Fifth Annual Marin Art and Garden Show to be held next weekend, September 15, 16, 17 in Ross. Mrs. Degan holds "The

Grasshopper" a piece of garden sculpture, and Moya stands before his recent portrait of the Marin architect, John Bolles who is also a member of the Society. Mrs. Degan will exhibit at the show a large reclining figure of marble and mosaic which she has made for Moya's garden and pool in Ross.

Fig. 8.6.2. Newspaper clipping about Marin Art and Garden Show

An example of the continued social engagement that Moya and his wife maintained in Ross and especially around the Marin Art and Garden Center is a photo published in a newspaper of this time (Fig. 8.6.2): *"Two of Marin's leading artists, Ida May Degan, sculptress, and Moya del Pino, painter, with examples of their art, plan the Marin Society of Artists' participation in the Fifth Annual Marin Art and Garden Show to be held next weekend, September 15, 16, 17 in Ross. Mrs. Degan holds 'The Grasshopper,' a piece of garden sculpture, and Moya stands before his recent portrait of the Marin architect, John Bolles, who is also a member of the Society. Mrs. Degan will exhibit at the show a large reclining figure of marble and mosaic which she has made for Moya's garden and pool in Ross."*[168]

In 1968, when José Moya del Pino was already very affected by the illness that would lead to his death, Caroline Livermore, president of the Marin Art and Garden Center, sought a way to honor him for his many contributions. When this was proposed, Helen and José Moya del Pino suggested the establishment of a library that could serve as the cultural and educational heart of the Center; apparently the couple was disturbed that the organization was veering towards the commercial, and they hoped to guide it back to its original conception as a non-profit, non-commercial cultural entity.[169]

One building stands out among all the structures that are now part of the Marin Art and Garden Center. The two-story "Octagon House" had been built in the nineteenth century to house the water tank of the well that provided water and irrigation to the original estate; it was one of the few buildings that survived the fire of the 1930s and held special architectural value (Fig. 8.6.3). Over the years since the establishment of the Center it had served alternately as a workshop, storage, office, antique shop and lunch room, and Moya's artistic sense appreciated the excellent

[168] The newspaper clipping among the papers retained by Moya del Pino's heirs doesn't show the name of the newspaper or the date of publication; but the typeface used for the headlines matches the style used by the *Independent Journal*, and the year must have been in the early 1960s. The quote is transcribed literally even though it isn't entirely correct: the statue created by Ida Degan was in stone rather than marble, and was placed in the fish pond of the Moya del Pinos' garden in Ross.

[169] Remarks by Board of Directors President Carla Ehat at the Moya Library annual meeting, September 9, 1988.

Fig. 8.6.3. The "Octagon House" at the Marin Art and Garden Center, home of the Moya del Pino Library and Ross Historical Society

craftsmanship of the builder. It seemed like the appropriate tribute. Moya's wife Helen helped get the dream off the ground with an initial contribution, and the building was rehabilitated to be converted to a library in honor of the painter who had done so much for art in Ross, Marin County and throughout California. The project was commissioned to architect Roger Hooper and interior designer Carla Flood, who moved it to a new foundation, replaced the second floor with a balcony (giving full view of the original wood beam ceiling), and restructured it with custom-made furniture to suit its new function. Thus the José Moya del Pino Library was created, whose collection specializes in works related to art, gardening and local history. Many of the original volumes of the collection had been part of the library of the Moya-Horst family, and were supplemented over the years with donations from other prominent local families.

Unfortunately, the painter did not live to see the opening of the library that bears his name.

8.7. Moya's Last Years

Moya del Pino's social and cultural activities remained active until diabetes started impacting his visual ability, slowly impeding his activity as a painter. In the last years of his professional life as an artist, he enjoyed the social status he had achieved, and appeared frequently in the press in long and generously illustrated reports in which he recounted different episodes and anecdotes of his life. The artist was an active member of the California Chapter of the Artists Equity Association, and had been elected an honorary member for life of the Merchants Exchange Club, an exhibiting member of the Foundation of Western Art, an Honorary member of Sigma Delta Pi Hispanic Honor Society, and was founding vice president of the Marin Art and Garden Center. In addition to his teaching responsibilities at the San Francisco School of Fine Arts he had also joined their board of trustees. He had been on the advisory committee for the San Francisco Museum of Art and on the board of the San Francisco Art Association; and he was a member of the San Francisco Society of Mural Artists, the National Society of Mural Painters, the Foundation of Western Art, the San Francisco Art Association, and of course President of the Marin Society of Artists.

In June 1950, Marin's *Independent Journal* described Moya del Pino as a successful California artist and art historian, dedicating to him almost an entire page, with a large photo and an extensive summary of his artistic career since the birth of his vocation in Spain.[170] The same newspaper published a long interview with him in 1959, essentially a summary of his life in two pages of tight newsprint. He was 69 years old and, by now at the peak of his life, he remembered how he had started painting in a small town near Granada, when he was only 6 years old. But his vision of Spain has become tragic compared to his life in America: *"Americans have been very good to me. If I had remained in Spain, I would have had to go into exile or they would have cut off my head. (...) Life in America is good for an artist. And I have been here long enough to see the consciousness of art grow."*[171]

In 1962 the *Independent Journal* reported on an exhibition that was to open the next day in Sausalito, and did so by focusing the information on Moya del Pino, including a photo—because according to the newspaper, it was Moya who brought prestige to the jury of which he was a part, along with Nympha Valvo, curator of the De Young Museum, and George Culler, director of the San Francisco Museum of Art; the jury had selected 40 paintings by Marin County artists for an exhibition entitled *Art in the afternoon*.[172]

And in 1964, by this point considered an historic figure of California artistic culture, Moya del Pino sat for an exhaustive interview conducted by Mary Fuller McChesney on behalf of the Archives of American Art, the oral recording and written transcript of which are preserved by the Smithsonian Institution in Washington, DC. Along with the biographies by Gene Hailey and Yvonne Greer-Thiel, much of the information for some chapters of this book was extracted from that interview. But when he answered Mary Fuller McChesney's questions, the artist was already affected by the illness that would lead to his death.

[170] Report by Dorothy G. Connor in the *Independent Journal* of June 17, 1950. Pg. 16.

[171] *Independent Journal*, June 13, 1959.

[172] *Independent Journal*, March 17, 1962.

In 1962 your author Paola Coda Nunziante, daughter of Beatrice Diana Moya, was born in Italy. Proud grandparents José and Helen Moya del Pino traveled across the ocean to meet their first granddaughter. Moya had been feeling ill for some time, but had avoided getting a diagnosis because he suspected he had cancer and feared a confirmation. While in Italy, he developed uremia and discovered that he did not have cancer but an obstruction of the prostate. He returned to the United States for surgery, but on the ship during the trip back he contracted pneumonia. When he finally made it to a hospital he was very ill, and underwent an operation during which his heart stopped; the doctors were able to revive him, but his brain was damaged. After this episode he never fully recovered his cognitive abilities, and his vision and ability to concentrate were very limited. Accustomed to fighting adversity, Moya tried to continue painting, but was never again able to complete a new work. In 1968 he suffered a leg amputation as an effect of diabetes.

As soon as his illness was known at the Marin Art and Garden Center, a way was sought to pay tribute to him. That attitude is expressed with emotion in a letter dated November 18, 1963, sent to him by the center's president, Mrs. Norman B. (Caroline) Livermore, in which she informed him that the board of directors of the Marin Art and Garden Center had approved a resolution to make him an honorary board member for life. *"This is*—says the letter—*a small tribute to your unselfish devotion to the Center since its founding in 1945. You have been an important factor in the accomplishment of our purpose to establish a meeting place in Marin for enjoying and performing the arts. From our small beginning, your advice and extensive knowledge of the world of art has been of invaluable service to me and to all who served with you. We will always welcome you to future board meetings where we will continue to benefit from your association as we have during the past 18 years of exciting and successful expansion of our beautiful center."*

When he received this letter, Moya was vice president of the Marin Art and Garden Center.

He died on March 7, 1969. He had just turned 79 years old.

A few months later, the renovation work on the Octagon House and the installation of the José Moya del Pino Library were completed. At the opening ceremony, the architect John Bolles, a great friend of the painter, read an emotional speech. We reproduce the text in its entirety as it is difficult to give a life a more beautiful epitaph:[173]

> *"This library is being dedicated to the memory of José Moya del Pino, "Moya" to those of us who were so fortunate to have known him. Moya came to us with a vast knowledge and heritage of the past; and lived with us to enjoy the life of today. He was a man who enjoyed life, living, art, people, politics and family. We often speak of Renaissance men—Moya was one of them.*

[173] Retrieved from José Moya del Pino Papers, Archives of American Art, Smithsonian Institution, Washington, D.C.

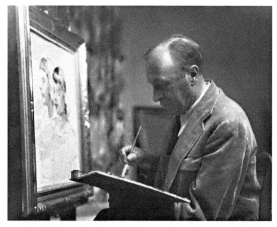

Fig. 8.7.1. José Moya del Pino in his studio, ca. 1940s

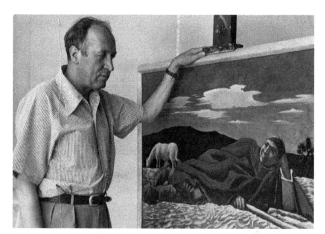

Fig. 8.7.2. José Moya del Pino in his studio

From his birthplace in Priego, Spain, he went on to the glories of Madrid under the last of the monarchists, Alfonso. Then to Paris to join with the "new" school of painters such as his compatriot, Picasso. Back in Madrid he painted the famous Velásquez copies which he brought to this country under the auspices of the monarchy. That was in 1927, and the end of Alfonso.

But Moya was young then, and was always young—so he readily adopted San Francisco, and San Francisco adopted him. All artists were his friends, and many were his students—all admired and loved him.

His connections in art are innumerable—the San Francisco Art Association, now the San Francisco Art Institute, the Family Club, and the Marin Society of Artists all looked to him for advice and guidance. Those of you who are artists recall his tremendous inspiration. Many of you knew him for his portraits—unquestionably the finest in our area.

It was my good fortune to meet and get to know Moya about 1937, when he and Helen lived in the Coppa house in Lansdale,[174] and we in Fairfax. From then on our friendship and respect grew—over art, over politics, over people, and always over a "tragito"[175]... or two or more. And our last visit was in the same vein, only a few days before his death, when we violated all doctor's orders and shared a bottle of champagne.

My life with Moya was one of joy and happiness and sharing, and as time permits I shall describe some of our "episodes". But before that I must say that Moya led me and guided me deeper into the field of art than I had ever dreamed of. It was with Moya as my instigator that I became the young rebel president of the Marin Society of Artists, and our shows set a pattern for excellence and forward thinking that would do credit to any gallery today.

One of Moya's great friends was Tim Pflueger, San Francisco's great architect of the 1930s and former president of the San Francisco Art Association. Small wonder that not long after Tim's death I followed in his footsteps at the Art Institute, again with Moya's guidance.

Perhaps the Golden Gate International Exposition of 1939 was one of our great highlights. As an embrymic [sic] architect I had several commissions, and Moya had the huge 40-foot by 120-foot mural to do for Tim Pflueger in the California State Building. But I too needed Moya for a mural, 13 high by 190 feet long. Moya collapsed—it was impossible. So I became his assistant and we did both murals—and with more humor, more problems, and more art packed into a few months than anyone can dream of. Both murals were painted in sections in the old Nelson

[174] A temporary house rental while the couple supervised the construction work on their new house in Ross.
[175] A nip or little drink, in Spanish.

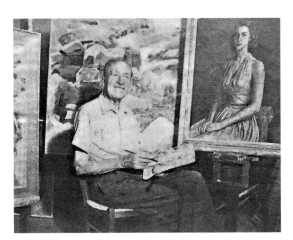

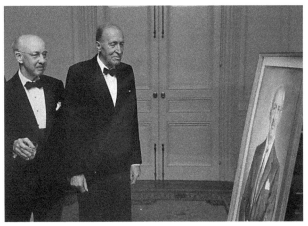

Fig. 8.7.3. Moya in 1959, portrayed in the Independent Journal Fig. 8.7.4. Moya del Pino showing Dr. Emile Holman his portrait

building in San Anselmo, and then applied to their places at Treasure Island—but not until we became members of the Painters Union.

It would take hours to tell the stories about the murals. The governor's disapproval of the Spanish troubadours and my rather scrawny bear on the Great Seal[176]—the uplift hands with thumbs on the wrong sides—deer with kangaroo tails—and above all Lucien Lebaud [sic] and Moya dancing and laughing and instructing me on my precarious scaffolding thirty feet off the floor.

I hope that in time this library, which was his dream, will grow in volumes and in service to the artists and the public. Perhaps some of his beautiful paintings will find their way here. There are many in this area. After all, he was not only Alfonso's court apprentice, but he was the Bolles family painter, and for Stanford Medical School, and dozens of families here in Marin.

But for my selection I would have difficulty in deciding for second place between the portraits of Mary Bolles, Dr. Addis, the bartender at the University Club—but always number one would be the fresco of Helen Horst Moya whom he married in San Francisco in 1928."

Today, the Octagon House serves the community as the Moya del Pino Library / Ross Historical Society. José Moya del Pino is buried in the Horst family plot in Olivet Memorial Park (formerly Mount Olivet Cemetery) in Colma, California.

[176] Referring to "The Great Seal of the State of California" that was painted in the mural. The bear was "fattened" and the hand was righted following this compaint. See Fig. 7.5.7.

The Current Situation of Moya del Pino's Work

While working on the different chapters of this book, the need became increasingly evident for a final chapter giving an account of the current situation of Moya del Pino's work throughout the world. As we've seen, Moya was an artist whose life was divided into two completely separate halves; the first one took place in Spain between 1890 and 1925; the second began in 1925 (when he was 35 years old) with his trip, without return, to America, and ended with his death in 1969.

Those who contemplated the first part of his life almost completely ignored what happened in the second, to the point that some biographical notes published in Spain end in 1925, as if our painter had disappeared from the universe without a trace. Even in the artist's hometown nothing was known about him until your author Miguel Forcada Serrano published an article in Moya del Pino's hometown of Priego, in a minor magazine entitled *Legajos*; and nothing was known by the general public until the same author delivered a conference on this little-known artist in 2019.

On the other hand, those who shared the second stage of Moya del Pino's life, in the area around the San Francisco Bay of California, only knew about his work in Spain that he had copied the works of Velázquez and had made the portraits of Alfonso XIII and the Duke of Alba. Because of this, it is not enough to simply give an account of his life, but it seems important to also make known where his work is today, how it can be seen and studied.

9.1. The Illustrations

Illustration, in the field of visual arts, is a genre of flexible content that always depends on the text that accompanies it or on a more or less explicit commercial objective. Moya del Pino came to the field of illustration at a peak of that artistic genre; but he was not as lucky as his compatriot Adolfo Lozano Sidro, for example, whose originals for *Blanco y Negro* are perfectly cataloged and preserved.

Finding Moya del Pino's original illustrations, instead, is extremely difficult since the publishers that printed the first editions of the books illustrated by him ceased to exist decades ago. However, it is relatively easy to see his drawings and covers in those books that exist in libraries, or for sale in second-hand bookstores, or in facsimile reissues.

To give just one example, for 18 Euros one can now buy *La Lámpara Maravillosa. Ejercicios Espirituales*[177] in a facsimile edition of the one published in 1916, with 35 illustrations and many decorated capital letters by Moya del Pino; the edition, published by Alvarellos, includes a magnificent introductory study by Olivia Rodríguez-Tudela, which also talks about Moya del Pino.

From the Valle Inclán Museum of La Pobra do Caramiñal, in Galicia, Joaquín del Valle Inclán, grandson of the writer, has replied to our queries saying that they don't have any original portraits or illustrations made by Moya del Pino, but they do have the ornamentations he made for *La Lámpara Maravillosa*. And the library of the University of Málaga has copies of *Sonata de Primavera*, 1914 edition, and *La Lámpara*

[177] *"The Wonderful Lamp. Spiritual Exercises"* by Don Ramon de Valle Inclán.

Maravillosa, 1916 edition. In both books the penultimate page, before the printing seal, is occupied by an inscription that says: "JOSEPH MOJA ORNAVIT." Some original editions occasionally appear online for sale by book aficionados, and your authors have purchased a few in order to scan illustrations.

You can also find comments about our painter and reproductions of some of his drawings in the doctoral studies and theses that are listed in this book's bibliography.

9.2. The Copies of Velázquez

As we've seen in chapter 5, the Velázquez copies made by Moya del Pino were removed from the library of the University of California at Berkeley in 1959, when the ceiling of the main hall was dropped down in order to improve lighting, which left no room for the paintings that had been hung on the upper walls since 1926. Most of the paintings went into storage in the basement of the university's gym; some of the smaller ones were placed on the walls of the Spanish department.

After Moya del Pino passed away, his heirs requested to have the paintings returned if the university was not interested in exhibiting them. The leaders of the university studied a plan to reinstate the paintings, but in the end they decided not to put them back on the walls of the library and since they didn't have any other suitable permanent place for the collection they chose to facilitate their return to Moya's family.

Perhaps the efforts were made too slowly; unfortunately, when the time came to collect the copies, several of the paintings couldn't be found. It appears that at some point the responsible parties at the university lost control of the collection so that on unspecified dates some of the paintings may have been sold without the knowledge of the family. Throughout the years senior faculty members from the Spanish department were given permission to select certain of the Velásquez paintings to decorate their offices; some may have unwittingly brought them home with their other belongings when they retired. The paintings in storage had wheels affixed to the frames to facilitate their relocation, which may have made them tempting to steal, since they were easy to wheel out and there hadn't seemed to be much interest in them over the years. Among the paintings that were never retrieved was *Las Meninas*.

In 1976, before returning the paintings to the painter's heirs, the University of Berkeley requested in writing to keep some of them and negotiated the assignment of the *Portrait of Martínez Montañés, Unknown Gentleman* and *Philip IV in old age*. They are likely to still be in the university's Spanish Department.

The rest of the recovered paintings were returned to Moya's three children, who sold some at auction in 1976 and 1977, and distributed among themselves the remaining ones. Beatrice Diana Moya, now a resident of Italy, was awarded thirteen of these paintings, including *Christ on the Cross, King Philip IV in Hunting Dress* and *The Drunkards (Los Borrachos)*, to be shipped to her in Italy. This last painting, one of the most successful copies of the collection for its extraordinary similarity to the original, was mistakenly registered with a different title: "Baroque scene with figures" or "Bucolic scene;" this caused some confusion that hindered future efforts to locate it because of what happened next. The shipment of these paintings to Italy was organized by boat, from the port of Richmond in California to the port of Naples in Italy; but after a few months, when they didn't arrive, Beatrice and her husband filed a complaint with the police in Siena, with such bad fortune that the complaint coincided with the kidnapping of Italian Prime Minister Aldo Moro by the Red Brigades (March 16, 1978). The police responded that they had no time to deal with anything other than the kidnapping of the prime minister. When the kidnapping ended with the murder of Aldo Moro and the police started to look into the loss of the paintings, the works had disappeared without a trace. It wasn't possible to even verify whether they had ever left the port of Richmond; in any case, they were stolen either in Italy or in the United States and probably sold to collectors.

Interestingly, *Los Borrachos* recently resurfaced: in 2019 an art collector in Hawaii contacted the Moya Library in Ross to inform that he intended to sell a Moya del Pino painting that he had purchased from an art collector in San Francisco many years before, and before doing so he wanted to see if the

Moya Library would be interested in buying it.[178] He provided photographs that show unmistakably that it is *Los Borrachos* that Moya copied from the Prado Museum. It is unclear how the San Francisco art collector obtained this painting; according to the accompanying information, he had purchased it at a "badly botched" auction and had also purchased three other key paintings of the collection, for two of which Moya's heirs actually do have auction documentation. The Hawaiian art collector did not seem aware of the fact that the Moya del Pino heirs consider this painting as stolen. This thickens the mystery, which is very hard to solve more than 40 years later.

The supporting documentation from the Hawaiian art collector states that the other three paintings the San Francisco art collector had purchased were *Las Hilanderas* (The Spinners), *La Fragua de Vulcano* (Vulcan's Forge) and *La Rendición de Breda* (Surrender at Breda, also sometimes called "the spears"); and that *Las Hilanderas* was sold for $25,000 in 1983 to a Toyota dealership in Tokyo.

Moya's heirs' notes confirm the sale at auction of *The Spinners* and *Surrender at Breda*. The copies of *Mercury and Argos*, *Mars*, and the portraits of *Philip IV as a young man*, *Philip IV in hunting dress*, *Antonia de Ipeñarrieta* and *Prince Balthazar Carlos* were also sold at auction in 1976-1977, along with two other unidentified portraits (the current location is unknown as California auction houses do not disclose buyers' identities).

At present, the only Velázquez copies of which the location is known are as follows.

Beatrice Diana Moya (Coda Nunziante) has in her possession in Siena (Italy) the four dwarfs or jesters: *Don Sebastián de Morra*, *Don Luis de Acedo el Primo*, *El bobo de Coria* and *El Niño de Vallecas*. Elena Coda Nunziante, Diana's daughter and resident in Italy, owns *Villa Medicis II*; the painting titled *Villa Medicis I* was lent to a Catholic school in Mill Valley, California, from which it was subsequently stolen.

The portrait of *Juana de Pacheco* is in a private collection in Sebastopol (California).

In 2016, two of the paintings that had been auctioned in 1977 were donated by their buyers to the Moya del Pino Library in Ross. They are *La Fragua de Vulcano* and *La Rendición de Breda*. Fran Cappelletti, Moya Library trustee and librarian, has published an interesting article in which he gives news of the donation and reports on the state of the paintings that appear to be *"damaged and worn, but not beyond rescue"* (Fig. 9.2.1). Although at this moment they are in storage, their restoration is being explored so that they can be displayed to the public.[179]

We presume that *Las Hilanderas* is still in Tokyo, and *Los Borrachos* is still in Hawaii, per the information above.

Moya del Pino's portraits of King Alfonso XIII and the Duke of

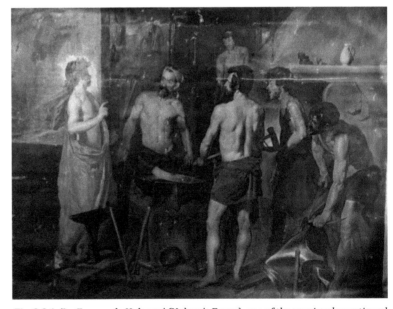

Fig. 9.2.1. 'La Fragua de Vulcano' (Vulcan's Forge), one of the previously auctioned paintings now donated to the Moya del Pino Library, with visible signs of wear

[178] Names withheld for privacy.

[179] CAPPELLETTI, F. *Rediscovering Velázquez*, retrieved from *www.moya-rhs.org/uploads/2/9/5/3/2953392/rediscovering_moya_velazquez_paintings.pdf*

Alba, which accompanied the Velázquez collection in America, were auctioned: that of the King in 1994, and of the Duke on a previous unknown date and then again in 2004. We have verified that neither portrait is at the Royal Palace of Madrid or in the Casa de Alba Foundation. There is no information about the portrait of Ambassador Alexander Moore which also accompanied the exhibition.

9.3. The Murals

Most of the murals that Moya del Pino painted are preserved today and many of them can be seen without much difficulty. The best guide to the murals that exist in the vicinity of the San Francisco Bay is probably Timothy W. Drescher's book entitled *San Francisco Bay Area Murals. Communities Create their Muses, 1904-1997*.[180] The author gives a detailed history of the murals in this area of the United States and provides an inventory of them including a description and their location; for the murals attributed to Moya del Pino we enter in brackets below the numbering from that catalog. A good online source for the murals done under the New Deal (PWAP, FAP, WPA)[181] is *https://livingnewdeal.org*.

MURALS SITUATED IN THE SAN FRANCISCO BAY AREA
Coit Tower: *San Francisco Bay, North*. 1934. PWAP. Elevator lobby, north wall. 9' x 54" Oil on canvas, framed [Catalog No. 50]. Coit Tower, located on Telegraph Hill in San Francisco, is open to the public during regular tourist hours and this painting is readily viewable (although some other murals along the stairs and on the second floor are only viewable by reservation).

ACME Brewing Company: *San Francisco Brewing*, 1935. African American Art and Culture Center (former location of Acme Brewing Company), third floor, 762 Fulton Street, between Webster and Buchanan Streets, San Francisco [Catalog No. 134]. Two panels of approximately 6' x 18' representing the picking of hops and the manufacture of beer, and a third, known as *A family picnic*, of 6' x 12'. Fresco. Recently the CAAAC has published a brochure to promote tourism to visit these murals; the title reads: *José Moya del Pino at the Center for African and African American Art and Culture*. With abundant photographs, the theme of the murals (which were restored by Anne Rosenthal prior to their exposure to the public) is explained along with their significance at the time of their completion; a small biography and a photo of Moya are included. There is also a quote from an article published in *The Wasp* in 1935, which is a real compliment to Moya's work.

Merchants Exchange Club: *The Age of the Dons (Indians, friars, sailing ships)*, 1933. 7' x 24'. Oil on canvas. [Catalog No. 599]. *The Golden Days of San Francisco*, 1933. 7' x 24'. Oil on canvas. [Catalog No. 600]. *Financial District, Yerba Buena Island and Bay Bridge*, 1933. 7' x 24'. Oil on canvas. [Catalog No. 601]. The Merchants Exchange Building downstairs club was closed in 1997 and leased to a fitness center, which promised to keep the murals; however, at that time they were reported to be *"covered (...) with the film of 60 years of tobacco smoke. The sky and sea are brown with soot. The edge of one mural is curling up, and on another the sea has been damaged by a leak."*[182] The fitness center did not attempt a restoration for fear of damaging them further. In 2013, the Merchants Exchange Club was reborn as a special events space, and *"employed 2013 technology"* to repair and digitally restore the damaged areas, stitching together a series of high resolution photographs of the original work. *"What currently flanks the eastern wall of the room is the result of that project, a digitally re-produced and restored version of the original artwork that completes the room while allowing the original to be appropriately stored and conserved."*[183] These three murals are in the

[180] Drescher, Timothy W.: *San Francisco Bay Area Murals: Communities Create Their Muses 1904-1997*. Pogo Press; third edition, April 1, 1998.
[181] "PWAP" indicates that the mural was made within the Public Works of Art Project program for public buildings promoted by the Federal Government. "WPA" stands for Works Progress Administration. "FAP" stands for Federal Arts Project.
[182] *Saving Murals is No Sweat*, San Francisco Chronicle, April 7 1997.
[183] *https://mxclubsf.com/historic-murals-emerge*

"Moya del Pino Bar and Lounge" of the Merchants Exchange Club, 75 California street at Leidesdorff, San Francisco; the lounge is available for special events or they can be visited upon request. *https://mxclubsf.com.*

United States Post Office, Redwood City: *Floriculture and Cultivation of Vegetables*, 1937. FAP. United States Post Office, Downtown Branch, 855 Jefferson at Broadway, Redwood City. 4' x 11', oil on canvas. The mural is in good condition and viewable during regular post office business hours. [Catalog P16]

Golden Gate International Exposition, Treasure Island: 1939. The murals in the California Building were destroyed by fire in 1940; however, it isn't likely they would have been preserved anyway, since most of the pavilions erected expressly for the exposition were demolished at the end of the event. The only records that remain are sketches and black and white photographs, as mentioned in chapter 7 of this book.

Rossi Brothers Pharmacy, San Anselmo: *History of Pharmacology*, 1949. The mural is no longer at the same location; the building was demolished in 2013 to make a park financed by film director George Lucas who is a resident of that area. The San Anselmo City Council resolved to save the mural from destruction because *"the mural (...) is a good example of an important artist, a good example of the style of the WPA muralists, and a heroic expression of the work and contributions of a type of worker often considered ordinary—the pharmacist"* and reported that *"because of the significance of the mural (...) it has been accepted by the Spain-USA Foundation in Washington, DC (... and) will be displayed in the Spanish Consulate in San Francisco."*[184] The Spanish Consulate General, lacking the space to display such a wide piece of art, delivered it to the Unión Española de California, a cultural center for Spaniards and people of Spanish origin; the center is a member of the California Federation of Spanish Associates and organizes monthly functions, networking activities for its members and scholarships for students. The mural is displayed on a wall and viewable by the association's members or by appointment. 2850 Alemany Blvd, San Francisco, *http://unionespanolasf.org.*

MURALS SITUATED IN CALIFORNIA, OUTSIDE OF THE SAN FRANCISCO BAY AREA

United States Post Office, Stockton: *Mail and Travel by Stagecoach*, 1936. FAP. Federal Building and Post Office, 401 N. San Joaquin St., Stockton, California. The San Joaquin County Office of Education took over the building when the U.S. Postal Service moved out in 2008; the building is currently a remedial school and closed to the general public, but a visit to the atrium is possible with permission.

Biltmore Hotel, Santa Barbara: *Heroic mural*, 1937. *"An heroic mural composition, depicting the history of the Spanish conquest of California in the days of the Dons, the Padres and the roving Conquistadores"*[185] for the auditorium of the Biltmore Hotel in Santa Barbara. Hotel ownership changed in 1976 and again in more recent years, and has undergone extensive renovation; the mural no longer exists and no photographs of it have been found.

United States Post Office, Lancaster: *Hauling Water Pipe through Antelope Valley*, 1941. FAP. This mural is still in place and in good condition, and is viewable during regular post office business hours. 567 W. Lancaster Boulevard, Lancaster, California.

Aztec Brewing Company, San Diego: As we have seen in Chapter 7, Moya del Pino did one of his first works as a muralist at the Aztec Brewing Co. in San Diego in 1934, to great success. But in 1948 the brewery was sold to a new brewing company and five years later closed for good, leaving the building abandoned. When it was "rediscovered" thirty-five years later, it was in very bad condition, and a demolition project had already been approved by the City Council. A social movement rose to promote conservation of the building because of its historical and cultural value, led by Salvador Roberto Torres, Chairman of the Chicano Park Arts Council and an instrumental force in the establishment of the Chicano Park in Logan Heights. The fight

[184] Town of San Anselmo Planning Commission Staff Report, Agenda Item D-2, Case No. UP-1206, DR-1210, GP-1206. January 7, 2013. Retrieved from *www.townofsananselmo.org/ArchiveCenter/ViewFile/Item/3159*
[185] HAILEY, Gene. *California Art Research, Volume 13.* Originally published by the Works Progress Administration, San Francisco, California, 1937; Updated by Ellen Halteman Schwartz, 1987.

was long, as three alternatives were considered: the restoration and integral preservation of the building as a historical monument; the removal and conservation of only artistic elements (mahogany furniture, chandeliers, stained glass windows and of course the murals); or the demolition of the entire structure with everything that was inside. The Chicano population of San Diego, a city very close to the Mexican border, mobilized under the impulse of Salvador Torres, a muralist himself, who defended the case as fundamental to the maintenance of the Aztec culture in the United States and published in 1988 an *Ode to International Aztlán Museum*, in which these verses appear:

Your sensitive creator
José Moya del Pino—
Who lovingly formed
your royal faces,
crowned you in fantastic hats
and colorful plumed headdresses—
Has also passed.
We who have discovered him
now hold him dear,
like a vanished snow crystal
that wafted its gentle designs
on the shadow of our ancient history.
Yes, we who hold him dear
shall not let him
fade away forever.

(...)

We love you dearly,
José Moya del Pino.
Your creative spirit lives
in our hearts and the blood
of our ancestors' heroic tragic drama.
Your creative spirit lives
in our grandparents
and in our youths today.

(...)

Gold help us,
for if this is how
San Diego can forget
our Hispanic masters
of fine art,
how then will we be remembered?

Torres campaigned affirming that the hall of the old brewery was like a temple in which, as in a book, the history of Aztec art could be read. *"Torres felt he'd discovered something special, a missing link connecting a Spanish artist to the Mexican mural tradition, featuring Aztec and Mayan themes in a Chicano neighborhood."*[186] However, he admitted that the objective was very difficult because rebuilding the structure and rehabilitating the art could cost more than $250,000, money that the Chicano movement could not afford. Salvador Torres negotiated with the City Council and with other groups and clubs to ask for help.[187] Finally it was resolved to still demolish the building, but to remove the murals and furniture to preserve them. Some of the big, vibrantly colored murals went to the Balboa Art Conservation Center, which volunteered to store them for free. The city picked up the rest of the paintings, chairs, ceiling beams and stained glass windows, moving them wherever they had a free place to keep them. For a time, some of the pieces went up in a back room at Chuey's, a Mexican restaurant.[188]

In 2008, art appraiser Pamela Bensoussan assessed the collection; some of the massive murals were in fragments, she said—but even the pieces seemed like paintings on their own. *"They were stunning, very fresh in color, though damaged,"* she said. As-is, the collection was worth $205,000; fixed up and professionally restored, the value of the collection would jump to about $506,000. She recommended that all the pieces be kept together, because the ensemble was worth more as an unit than the sum of its parts; but the city didn't have enough money or space in the intended restaurant to pull every piece out of storage, and some pieces were in such disrepair that they were not worth fixing; so they went back into storage.[189]

[186] BENNET, K. and CARONE, A. *A Brewery's Vivid Artwork, Mothballed for Years.* In *Voice of San Diego*, April 16, 2014.
[187] *History on Tap: Barrio Artists Work to Save Long-Forgotten Brewery Murals.* Times of San Diego, March 13, 1988
[188] BENNET, K. and CARONE, A. Ibid.
[189] BENNET, K. *Long-Hidden Brewery Art to Emerge.* In *Voice of San Diego*, April 17, 2014. *https://www.voiceofsandiego.org/topics/arts/long-hidden-brewery-art-to-emerge/*

In 2012, city officials won a federal grant for more than $400,000 to have art professionals select and restore certain pieces of the murals, doors, stained glass windows, chandeliers, paintings and ceiling beams with the intention of installing them in the Mercado del Barrio, a mixed-use development located in Barrio Logan in San Diego, which was also intended to include a Cultural Center; but no commercial tenant could meet the requirements to exhibit the collection. However in 2014, after being in storage for over 25 years, the main wall behind the bar (the one with the human sacrifice) was finally installed in the Logan Heights branch of the San Diego Public Library and is now viewable during normal business hours. *"A lot of discussion has been had about the historic nature of the pieces and the value of the pieces, but I think people are going to be amazed at the sheer beauty of this work when they see it,"* said Dana Springs, executive director of the city's arts commission. 567 South 28th Street, San Diego, California.

MURALS SITUATED OUTSIDE THE STATE OF CALIFORNIA

United States Post Office, Alpine, Texas: In 2004, that is, 64 years after the mural was painted, in the *Desert Candle* magazine of the newspaper *The Desert-Mountain Times* (Galveston, Texas), an article signed by Denise Gamino lamented the poor state of the Alpine mural: *"The Alpine mural asks us for help. For more than 60 years, 'they' continue reading the same books, lying on a mound that overlooks the Alpine landscape. Since the three of them found that idyllic place—with the help of the one who painted the mural, José Moya del Pino—Alpine has left behind its quiet rhythm of cattle ranch and trade, to become a lively city, full of ideas and possibilities. 'They' are the happy cowboy and the two students, protagonists of the mural hanging in the old Alpine post office since 1940. Today, the building is the regional department of Brewster County, and the mural is still there ..."*

A study of the situation of the mural and its restoration was requested, considering it a work of art and pointing out that many other murals had already been cleaned and restored. Currently, the former Post Office building is the headquarters of the Brewster County Appraisal District office and the mural has become one of the town's tourist attractions. 107 West Avenue E, Alpine, Texas. WPA.

Great Western Malting Company, Vancouver, Washington: The three murals representing the gathering and malting of barley for brewing were painted in 1947 for the company's tap room and office building. The little information we have about them

Fig. 9.3.1 A, B, C. Murals for Great Western Malting Company

comes from Ellen Layendecker, grand-daughter of one of the founders, who was so kind as to send us photographs (Fig. 9.3.1 A, B, C). The Tap Room was torn down, but the artwork and bar were preserved and incorporated in the new building. The company is private; viewing might be possible with the permission of the owners. 1705 NW Harborside Drive, Vancouver, Washington.

9.4. Portraits, Landscapes and Other Works

As we've already suggested, usually only the portraits of very illustrious characters or those that, for whatever reason, have been acquired by museums, are available for viewing by the public. This is the case with the numerous portraits made by Moya del Pino. Most are held by family members of the person

portrayed (including those Moya made of his own family and relatives); of the others, only some are in public places.

The work *Chinese Mother and Child* was reported to be in the collection of the San Francisco Museum of Art[190] (which later became the San Francisco Museum of Modern Art, or MOMA) or, according to the artist's daughter, may be in a private collection. It was most recently exhibited at the Los Angeles County Museum of Art in 2000-2001.

Portrait of Yvonne Greer Thiel (1939, 26" x 20") is in the Oakland Museum of California; access number A.63.22.18.

The still life known as *Majolica Vase*, so praised by Junius Cravens, was acquired by Yvonne Greer Thiel who delivered it to the Art Gallery of Mills College, in Oakland; we've been unable to verify whether it is still there.

The landscape titled *Ávila, Castilla* was donated by the painter to the Museum of the Brooklyn Institute of Arts and Sciences in 1925; we've been unable to verify whether it is still there.

The landscape *Downieville Hills* was in the Bender Collection of the San Francisco Museum of Art (now MOMA). Albert M. Bender (1866–1941) was a leading patron of the arts in San Francisco in the 1920s and 1930s; by providing financial assistance to artists, writers and institutions he had a significant impact on the cultural development of the San Francisco Bay Area and beyond. A good part of the Bender collection was auctioned off in the 1970s, and with some controversy the artists or their families were not informed, so it is unknown if Moya del Pino's painting is still there.[191] Similarly, a painting titled *Still Life with Flowers* was reported to be in the Gerstle Collection of the San Francisco Museum of Art, though this has not been verified.[192]

Portrait of Frances Moore was exhibited in *American Figurative 2016* at Sullivan Goss Gallery in Montecito, CA.[193]

Beatrice Diana Moya (Coda Nunziante) has in her home in Italy a self-portrait of her father and two portraits of her mother as well as other portraits of herself, her husband and her siblings; also several landscapes and a number of studies for murals (including one for the *Family Picnic* mural Moya del Pino painted for Acme Brewery). Also in her property are some paintings from the Joshua Tree series, including *Joshua Tree Arabesque* that had received acclaim in newspapers at the time it was exhibited. She also has one of the two versions Moya painted of the praised work *Saints and Sinners* (1935); the first version was purchased by the San Francisco Museum of Art, and we've been unable to verify whether it is still there.

Tina Moya (Kun) owns several portraits of various family members and friends; these include a self-portrait of Moya made just before the start of his illness and a portrait of Barbara Mull. She also has some works from his stage close to abstract expressionism, a study for the mural on the cultivation of flowers for the Redwood City post office, and some sketches for the Merchants Exchange murals.

Paola Coda Nunziante and her siblings also have a few portraits and landscapes, including *Like Seals*, one of two versions of *The Swimmers*, some paintings in the *Joshua Tree* series, some still lifes and studies for murals.

The Moya del Pino Library in Ross, California, in addition to the copies of Velázquez that were recently donated, also has the portrait of Caroline Livermore, some other portraits, *Saint John of the Cross* and a number of sketches for murals, including those for the *Hand of God* mural for the Temple of Religion in Treasure Island.

In Spain, his homeland, we only know the location of two original paintings by Moya del Pino. The first is *Homenaje a Granados*, at the the Museo Nacional Centro de Arte Reina Sofía in Madrid (see page 40). The

[190] HOLT, T. *The ACME Brewery Murals.* In *Brewery History*, The Brewery History Society, 2014. 160, pgs. 35-40; this is also mentioned by the artist himself in a short biography dictated to his wife, preserved among the family's papers.
[191] *http://digitalassets.lib.berkeley.edu/roho/ucb/text/cravath_ruth.pdf*
[192] Personal biography dictated by the artist to his wife Helen, handwritten, preserved in the family's archives.
[193] *https://www.mutualart.com/Exhibition/American-Figurative--2016/F6D5DAA5F1D15338*

second is entitled *En la feria* ("At the fair"), oil on cardboard, 34x24 cm. Signed. It was taken to auction by the Sala Retiro of Madrid in December 2018, with a starting price of 400 Euros. In February 2019 it was acquired by Cristóbal Povedano Ortega, a painter himself, born in Priego and resident in Madrid. (Fig. 9.4.1)

The portrait of José de León Contreras was most recently sold at auction in Barcelona, so it is presumed to be in Spain. It is possible the portraits of Alfonso XIII and the Duke of Alba may also have found their way back to Spain, after being sold at auction in the United States. Some of the paintings by Moya del Pino that have appeared on auction records in recent years (though the identities of the buyer or the seller are unknown):

Fig. 9.4.1. "En la feria"

Procession, December 1993
King Alphonse XIII of Spain, May 1994
Portrait of the Duke of Alba, August 2004
Landscape, January 2010
Escena de Galanteo, December 2011
California Street, August 2014
Marin Hills, February 2015
The River, October 2016
Desert Mountains, 2016
Portrait of José de León Contreras, October 2016
Farm Scene, October 2018

9.5. The Marin Art and Garden Center and the Moya Library

The Marin Art and Garden Center and the Moya Library are also, in a way, works by José Moya del Pino that have survived him—similar to his paintings, murals and illustrations.

The Marin Art and Garden Center is located at 30 Sir Francis Drake Boulevard, Ross, California, 94957. Through its different departments it offers a varied recreational and cultural program of exhibits, conferences, concerts, theater, nature experiences, etc. This program can be easily consulted by searching the Center's website on the Internet.

The Moya Library, installed in the building called Octagon House, offers interested parties a collection of books focusing on the themes of art, decorative arts, architecture, gardening and local history. Many of the original volumes are from the personal collections of Moya's and other local families. The current director of the Moya Library is Fran Cappelletti; the library can be visited by appointment.

In 1982 the Ross Historical Society, which originally had its offices in the Ross City Hall, merged with the Moya Library and now shares the same building. The institution is dedicated to the study and dissemination of the history of Marin County (California) and has a vast collection of historic photographs.

The combined Moya del Pino Library – Ross Historical Society offers a monthly "First Friday Forenoon" lecture series, wonderful cultural programs covering diverse subjects related to arts, crafts, gardening, literature and local history. It has at various times during its existence offered a "Happy Hour Film Series" (slide travel-logs of members' travels to countries and exotic places around the world, including cocktails and dinner), and guided tours to museums, historic mansions and other local cultural treasures.

For more information: *www.moya-rhs.org*

Appendices

Selected portraits by José Moya del Pino

Ann Morrison

Augusta Dawson

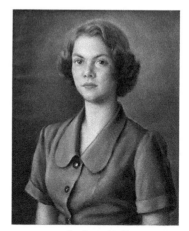

Barbara Mull

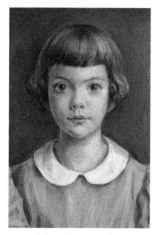

One of the Skewes-Cox children

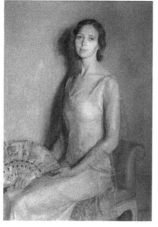

Helen (Horst) Moya del Pino

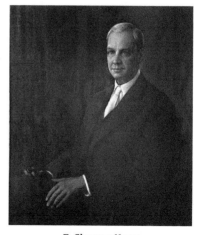

E. Clemens Horst

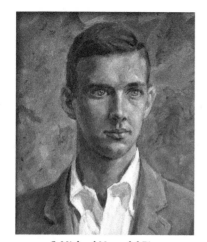

C. Michael Moya del Pino

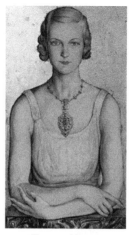

Frances Moore

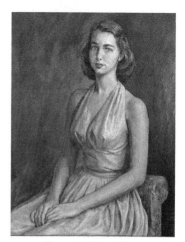

Beatrice Diana Moya

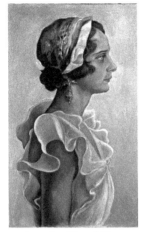

Beatrice (Horst) Thys

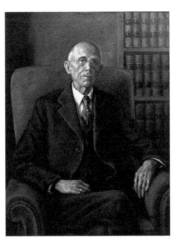

Superior Court Judge Malcolm Glenn

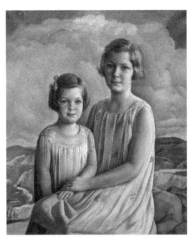

The Cramer Sisters

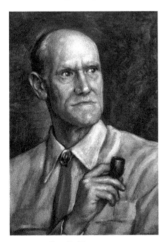

Louis Dessauer

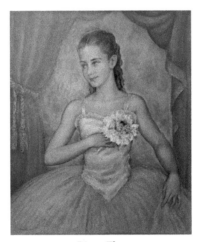

Diane Thys

Adele Miller

Dr. Ramón y Cajal

Clementina Moya

Diane Thys

Unfortunately we don't have color images for most of the portraits done by José Moya del Pino, as they are in private collections. The main documentation available consists of black and white photographs taken by Moya's friend and neighbor Emmet Smith before the paintings were delivered to their patrons. Here are some that we were able to identify.

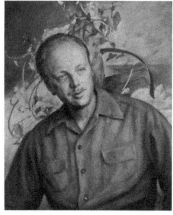
Emmet Smith, photographer

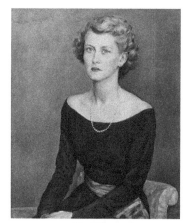
Lissi Blom

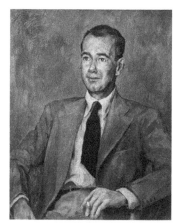
Dr. Ted Fender

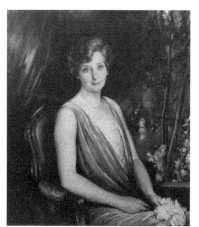
Daisy Brown Horst

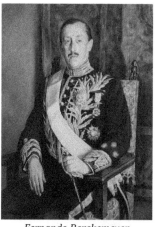
Fernando Berckemeyer,
Consul General of Peru

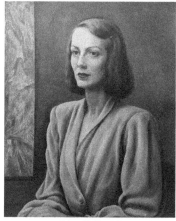
Mrs. R. Burns

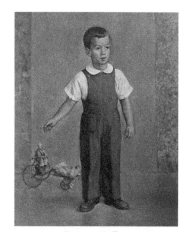
Tommy Bolles

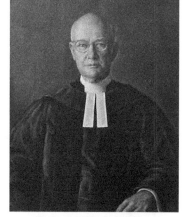
Dr. Lynn White, president,
Presbyterian Seminar

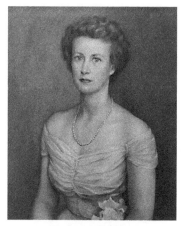
Katherine Dibblee

Self-Portraits by José Moya del Pino

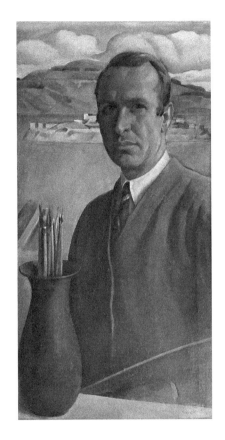
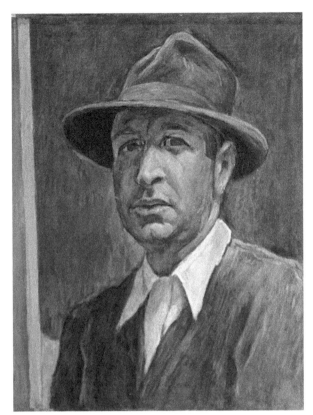
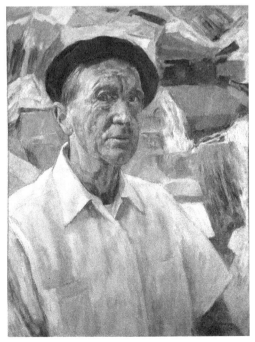
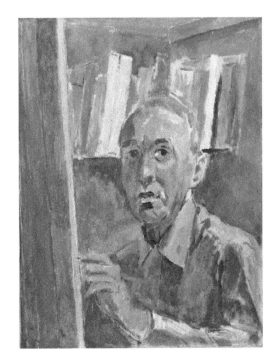

Sources

Archive of the Parish of Our Lady of the Assumption of Priego de Córdoba.
Archive of the Parish of Frailes (Jaén).
Civil Registry of Priego de Córdoba.
Family archives of the descendants of José Moya del Pino.
Municipal Archive of the City Council of Priego de Córdoba.
Archive of the Royal Academy of San Fernando in Madrid.
General Archive of the Administration, Alcalá de Henares (Madrid)
Archive of the Museum House of Valle Inclán in A Pobra do Caramiñal (La Coruña).
Archives of American Art. Smithsonian Institution, Washington DC.
Digital Newspaper Library. National Library of Spain. *www.bne.es/en/Catalogos/HemerotecaDigital*
José Moya del Pino Library: *www.moya-rhs.org*

Art auction sites with records on José Moya del Pino:
www.artnet.com/artists/jose-moya-del-pino
www.invaluable.com/artist/moya-del-pino-jose-6rv1uv2a6k/sold-at-auction-prices
www.askart.com/artist/Jose_Moya_Del_Pino/5578/Jose_Moya_Del_Pino.aspx
www.arcadja.com/auctions/en/moya_del_pino_jose/artist/111932

Historical research:
https://en.wikipedia.org/wiki/Coit_Tower
https://en.wikipedia.org/wiki/Emil_Clemens_Horst
https://en.wikipedia.org/wiki/Public_Works_of_Art_Project
https://en.wikipedia.org/wiki/Spanish_Civil_War
https://en.wikipedia.org/wiki/Treasure_Island,_San_Francisco

Bibliography

ALCOLEA ALBERO, F. *Pintores españoles en Londres. 1775-1950. El Siglo XX* (Spanish painters in London (1775-1950). The 20th century). CreateSpace Independent Publishers, 2016.

ARÓSTEGUI MEGÍA, A. and LÓPEZ RUIZ, J. *60 años de arte granadino* (60 years of Granada art). Granada. Anel, 1974.

BENNET, K. *Long-Hidden Brewery Art to Emerge.* In *Voice of San Diego*, April 17, 2014.

BENNET, K. and CARONE, A. *A Brewery's Vivid Artwork, Mothballed for Years.* In *Voice of San Diego*, April 16, 2014.

CAPARRÓS MASEGOSA, L. *Las Exposiciones de Bellas Artes en Granada, 1900-1904* (The Exhibitions of Fine Arts in Granada. 1900-1904). Cuadernos de Arte nº. 33 (2002). University of Granada.

CAPPELLETTI, F. *Rediscovering Moya's Velazquez. www.moya-rhs.org/uploads/2/9/5/3/2953392/rediscovering_moya_velazquez_paintings.pdf*

CAPPELLETTI, F. *The Moya Brewery Murals: From Acme to Aztec.* In The Brewery History Society. Brewery History, 2016.

CARONE, A. and BENNET, K. *A Brewery Vivid Artwork, Mothballed for Years.* In Voice of San Diego, April 2012.

COBOS RUIZ, J. and LUQUE ROMERO, F. *Exvotos de Córdoba.* Provincial Council of Córdoba and Machado Foundation, Córdoba, 1990.

CORREA RAMÓN, A. *Isaac Muñoz (1881-1925): Recuperación de un escritor finisecular* (Isaac Muñoz: Recovery of a late-century writer). Ed. University of Granada, 1996.

DRESCHER, T.W. *San Francisco Bay Area Murals: Communities Create Their Muses, 1904-1997.* Third Edition. Pogo Press, 1998.

FORCADA SERRANO, M. et al. *Adolfo Lozano Sidro: Vida, Obra y Catálogo General* (Adolfo Lozano Sidro: Life, Work and General Catalog). City Council of Priego and Cajasur. Córdoba, 2000.

FORCADA SERRANO, M. *La Industria Textil del Algodón en Priego de Córdoba* (The Cotton Textile Industry in Priego de Cordoba). Author's edition. Priego, 2016.

GARCIA FELGUERA, M. *Aspectos iconográficos del cuerpo en la publicidad en Galicia a principios del siglo XX* (Iconographic aspects of the body in advertising in Galicia at the beginning of the 20th century). SEMATA. Social Sciences and Humanities, No. 14. University of Santiago de Compostela, 2003.

GAYA NUÑO, J.A. *Bibliografía crítica y antológica de Velázquez* (Critical and anthological bibliography of Velázquez). Lázaro Galdiano Foundation. Madrid, 1963.

GHIRALDO, A. *El peregrino curioso* (The Curious Pilgrim). In the magazine *La Esfera*, nº. 516 of 24 November 1923.

GIACCIO, LM (2011) *La Opera Omnia de Valle Inclán y su relación con el mundo de las artes gráficas* (The Opera Omnia of Valle Inclán and its relationship with the world of graphic arts). X National Conference of Comparative Literature, August 17 - 20, 2011, La Plata, Argentina. In Academic Memory. Available at: *www.memoria.fahce.unlp.edu.ar/trab_eventos/ev.2424/ev.2424.pdf*

GÓMEZ DE LA SERNA, R. *La sagrada cripta de Pombo* (The sacred crypt of Pombo). Madrid, 1923. Library of Spanish Authors. Madrid, 1986.

GONZÁLEZ GIL, M.I. *Estética y poética de la contemplación en Valle Inclán: La lámpara maravillosa* (Aesthetics and poetics of contemplation in Valle Inclán: The wonderful lamp). Doctoral thesis at the Complutense University of Madrid. Madrid 2015. *https://eprints.ucm.es/29969/1/T36016.pdf*

GREER THIEL, Y. *Artist and People.* Philosophical Library, New York, 1959.

HAILEY, G. *California Art Research, Vol. XIII.* Works Progress Administration, San Francisco, California, 1937; Updated by Ellen Halteman Schwartz, 1987.

HOLT, T. *The ACME Brewery Murals.* In *Brewery History.* The Brewery History Society, 2014.

HUNTER, S.A. *Temple of Religion and Tower of Peace*. By Temple of Religion and Tower of Peace, Inc. San Francisco, 1940.

MOYA DEL PINO, J. *De arte decorativo. La ilustración del Libro* (About Decorative Arts: Book Illustration). In *La Alhambra*, 1910.

MOYA DEL PINO, J. *Mural Painting*. In *The Wasp*, May 6, 1933.

MOYA DEL PINO, J. *Valle Inclán y los artistas*. In *La Pluma*, volume IV, Nº 32. January 1923.

NASH, S.A. *Facing Eden. 100 Years of Landscape Art in the Bay Area*. The Fine Arts Museum of San Francisco. University of California Press, 1995.

NEUHAUS, E. *The Art of Treasure Island*. University of California Press. Berkeley, California, 1939.

PARISI, P. *The Texas Post Office Murals: Art for the People*. Texas A&M University Press, 2016.

REYERO, Carlos. *Los "Velázquez" del Prado en América. Crónica de una exposición de copias en 1925* (The "Velázquez" of the Prado in America. Chronicle of an exhibition of copies in 1925). Bulletin of the Prado Museum. Vol. 26, nº 44, 2008.

RODRÍGUEZ BECERRA, S. and VAZQUEZ SOTO, JM. *Exvotos de Andalucía: milagros y promesas en la religiosidad popular* (Ex-votos of Andalucía: miracles and promises in popular religiosity). Andalusian editions Argantonio. Seville, 1980.

RUBIO JIMÉNEZ, J. *Valle Inclán retratado por José Moya del Pino: la melancolía moderna* (Valle Inclán portrayed by José Moya del Pino: modern melancholy). In *Moralia*, magazine of Modernist Studies. Gran Canaria, November 2009.

RUBIO JIMÉNEZ, J. *Valle Inclán y Moya del Pino: buscando el fiel de la balanza* (Valle Inclán and Moya del Pino: searching for the perfect balance). In *Anales de la Literatura Española Contemporanea*, vol. 37, n. 3, 2012.

SANTOS MORENO, Mª. D. *Un pintor de Priego en la Cofradía del Avellano de Granada* (A painter from Priego in the Brotherhood of the Avellano of Granada). Ed Granada Artística, City Council of Priego and CajaGranada. Granada, 2004

SCALES, G. *José Moya del Pino: His Life and His Works*. Lecture at Marin Arts and Garden Center, September 20, 2013. Unpublished.

URREA, MJ. *Los frescos de Moya del Pino* (The frescoes of Moya del Pino). In *Hispano-América,* July 29, 1933.

VALLADAR, FP. *Artistas Jóvenes: Moya del Pino* (Young Artists: Moya del Pino). In magazine *La Alhambra* nº 302, October 15, 1910.

VILLARMEA ÁLVAREZ, C. and CASTRO DELGADO, L. *Valle Inclán frente a la industria del libro* (Valle Inclán and the book industry). Annals of Contemporary Spanish Literature. Vol. 29, no. 3. 2004.

Photography and Figure Credits

We are grateful to the individuals and institutions that helped enrich this book with images.

Chapter 1
Images provided by Miguel Forcada Serrano except:
1.1.1 – Paola Coda Nunziante
1.1.2 – Courtesy of Maria Teresa Murcia
1.3.1 – Wikimedia commons by Michelangelo-36,
 https://commons.wikimedia.org/wiki/
 File:PANORAMICA.jpg

Chapter 2
All images provided by Miguel Forcada Serrano

Chapter 3
Most images from Miguel Forcada Serrano, except:
3.1.1 – Wikimedia commons, public domain
3.2.4, 3.2.5, 3.2.6, 3.2.17, 3.2.33, 3.3.5, 3.4.2, 3.5.1, 3.5.2,
 3.5.3 – original documents in family archives
3.5.4 – www.museoreinasofia.es

Chapter 4
All images from Miguel Forcada Serrano except:
4.1.5, 4.1.6, 4.3.1 – family archives

Chapter 5
All images are from the Moya del Pino family
archives except:
5.1.3 – Moya del Pino Library / Ross Historical Society
5.3.1, 5.3.2 – Bancroft Library, University of California,
 Berkeley

Chapter 6
All images are from the Moya del Pino family
archives except:
6.1.2 – Gary Scales, former Board Member of the Moya
 del Pino Library/Ross Historical Society
6.3.4 – Retrieved from the internet

Chapter 7
All images are author's photos from originals or
from items in family archives except for:
7.1.4 – Reproduced from the Merchant's Exchange
 website: *https://mxclubsf.com/venue-details*
7.2.1 – Licensed royalty-free image
7.3.1, 7.3.3, 7.3.5 – San Diego Historical Society
7.3.2 – Courtesy of Kathryn Johnson, Manager, Logan
 Heights Branch, San Diego Public Library
7.4.3 – Retrieved from the Internet
7.3.6, 7.3.7, 7.3.8, 7.5.6, 7.6.2, 7.6.5, 7.6.6 – Gary Scales
7.5.1 – © Moulin Studios, retrieved from Lucien Labaudt
 papers, Archives of American Art, Smithsonian
 Institution
7.5.3 – Western Neighborhoods Project, opensfhistory.org
7.5.5 – © Moulin Studios, reproduced from Temple of
 Religion and Tower of Peace by Stanley A. Hunter
7.6.3 – Reproduced from Gift of the Grape by L.E and A.M
 Reeve with permission from the Ansel Adams
 Publishing Rights Trust

Chapter 8
All images are author's photos from originals or
from items in family archives except for:
8.2.4, 8.2.6 – Retrieved from the Internet
8.5.6, 8.6.1, 8.6.3 – Gary Scales

Chapter 9
9.2.1 – Gary Scales
9.3.1 – Ellen Laynendecker, grand-daughter of one of the
 founders of the Great Western Malting Company
9.4.1 – Miguel Forcada Serrano

Appendices
Images are from family archives except the following
by Gary Scales:
 Ann Morrison, Augusta Dawson, the Skewes Cox
 child, the Cramer Sisters, Adele Miller, Dr. Ramon
 y Cajal, and two of Moya del Pino's self-portraits
Frances Moore was retrieved from the website for
 Sullivan Goss Art Gallery: *www.sullivangoss.com/*
 artworks/jose-moya-del-pino-1898-1973

About the Authors

PAOLA CODA-NUNZIANTE is José Moya del Pino's granddaughter, and has been fascinated with her grandfather's life and works ever since moving from Italy to California many years ago. She holds a degree from Stanford University, and runs a graphic design company.

Paola has a passion for art and photography and is an avid traveler. She is the author of a history book about her family's castle in Tuscany, Italy: *"Montalto, Castello di Frontiera"* (in Italian), and the photography book *"Montalto Castle, One Thousand Years of History"* (in English).

MIGUEL FORCADA SERRANO is a member of the Royal Academy of Córdoba and the Official Chronicler of Priego de Córdoba in Spain (Moya del Pino's birthplace). He has a degree in educational sciences and a master in cultural management.

Forcada Serrano has published a dozen books among which stand out: *"Historia de la Hermandad de la Santa Vera Cruz y Nuestro Padre Jesús en la Columna"*, *"La Industria Textil del Algodón en Priego de Córdoba,"* and *"Zamoranos, historia y vida."*